THE

FACE

OF

TEXAS

THE
FACE
OF
TEXAS

PHOTOGRAPHS BY Michael O'Brien

STORIES BY Elizabeth O'Brien

UNIVERSITY OF TEXAS PRESS, AUSTIN

FOR
JESSE,
OWEN
&
SAM

Acknowledgments

We expected a lazy yawn when *The Face of Texas* was first published in 2003. Instead, Elizabeth and I were amazed by the warm reception that the book received. The book has enriched our lives beyond measure. We have many people to thank for getting us there.

Thanks to our good friend DJ Stout, who assigned many of the photographs in the book while he was the art director of *Texas Monthly*. DJ has championed our work from the beginning, and he designed the first edition with his associate, Julie Savasky.

Our heartfelt thanks to Rue Judd of Bright Sky Press for believing in the photographs and stories from the moment she first saw them and for launching us on this voyage with the publication of the first edition in 2003.

A special thanks to Dave Hamrick for caring about the work from the beginning, when he first saw it in rough form in 2002. He has stayed with us all the way, wisely guiding us on the journey from concept to publication. It is appropriate that Dave has stewarded this new edition.

I also want to thank Matt Lankes and David Zickl, two good friends and photographic hands who have assisted me on many of the pictures in the book.

Finally, I appreciate the friendship and help of Brian Lanker, Bill Wittliff, Betty Layton, Todd Wong, Tamara Thompson, Brent Buford, Kathy Marcus, Nancy McMillen, Evan Smith, John Loengard, Leslie Baldwin, TJ Tucker, Jake Silverstein, David Friend, Suzi Bittles, Roy Flukinger, Bill Albrecht, Mathew Sturtevant, Robert Baumgardner, George Brainard, Will Phillips, Ardon Judd, Laura Fowler, Margaret Blagg, Arnold Van Den Berg, and Peter Williams. As always, I appreciate the support and help of the good people at the University of Texas Press: Allison Faust, Abby Webber, Ellen McKie, Gianna LaMorte, Brady Dyer, and Lindsay Starr. ★

Michael O'Brien

Introduction

I don't have a cowboy hat, my boots give me blisters, and I've never shot a gun. I'm nervous around horses, and I can't lasso a steer. But I love big clouds, wide spaces, mythic characters, and the Western spirit. I've fallen in love with Texas. It's my home.

I have loved the state from the start. In 1985, when I was still in New York, *Life* magazine sent me to photograph Willie Nelson. He was on his ranch in Spicewood, outside Austin, making the movie *Red Headed Stranger*. I knew right off I'd found an extraordinary place—though I guess anywhere around Willie is special. After hanging around Willie and the boys making the film about a preacher gone mad and his ultimate redemption, I knew I'd had enough of New York. I needed some redemption of my own. I felt like a tick embedded in the thick of Brooklyn. I needed to pry myself free and claim Texas soil.

But in the meantime, stuck up north, I worked in Texas as often as I could. Hasselblads, Swedish cameras that are built like anvils, were my cameras of choice. They were tough enough to take on Texas, devouring rolls of film. Armed with the "Blads," a couple of Nikons, and a 4 × 5, I rolled across Texas, moving from assignment to assignment. Any job here was adventurous . . . rugged cowboys, wily politicians, big-haired beauty queens, crazy musicians, eccentric artists, city people, country folk. I got up early and stayed up late, driving across the state in a beat-up Chevy Suburban filled with fumes from a leaky gas generator that powered the strobes on remote locations. I blasted away, and I was on a roll.

It took me eight more years to escape New York. But I finally got here in 1993. I continued my work, now closer to home.

Now, it's thirty years later and more than a decade since *The Face of Texas* was first published. You'll love the characters just by their names: Ran, Obie, Sloan, Ruby, Darden, Troy, Roosevelt, Willie, Red, Ty. Bull riders, preachers, athletes, ranchers, churchgoers, ropers, farmers, singers . . . they all dance across the pages. Elizabeth tells their stories, and they come to life. Yep, it's Texas, and it's larger than life. ★

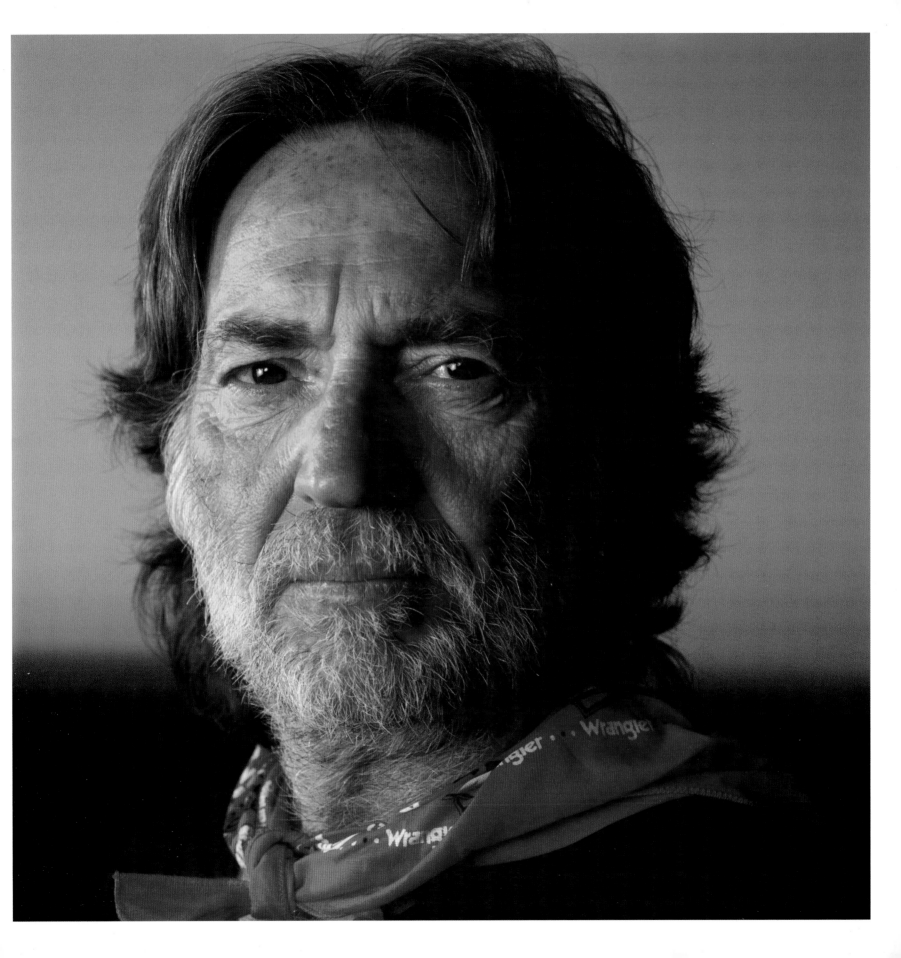

THE

FACE

OF

TEXAS

Willie Nelson

SPICEWOOD

1999

Willie Nelson is a man who has paid his dues. He's risen from a guitar-playing farm boy with a dream—who got his start playing local honky-tonks—to a renowned songwriter and ultimately one of the most beloved entertainers of our time. Along the way, Nelson sold vacuum cleaners, encyclopedias, and Bibles; worked as a disc jockey; labored for years in songwriting obscurity in Nashville—and wrestled with the IRS over millions of dollars in back taxes. Though it was his accounting firm that had steered him wrong, it was Willie who took the rap.

In addition, Nelson has weathered three divorces and is now on his fourth marriage. Regarding marriage and divorce, he has said, "The reason divorces are so expensive is they're worth it."

Nelson, of English, Irish, and Cherokee extraction, has fathered seven children and, tragically, lost one son to suicide.

Throughout it all, Nelson has managed to stay true to his dream and to give back more to the world than he has ever gotten. One of his greatest contributions, besides his music, is Farm Aid, a series of rock concerts he helped organize that has raised millions of dollars to help the plight of independent farmers. He has also been a tireless activist for the reform of marijuana laws, and has been arrested numerous times for possession.

Nelson was born in Fort Worth and grew up on a farm in nearby Abbott, where he was raised by his grandparents. His grandfather, a blacksmith, bought him his first guitar at six. He wrote his first song a year later and joined his first band at nine. Later, he came back full circle to his rural Texas roots. "Luck, Texas," as he calls his Hill Country ranch in Spicewood, outside Austin, features an old Western movie set that was the location for the film *Red Headed Stranger*. For years, he hosted a famous Fourth of July rock picnic on the ranch for his fans. He now spends much of his time at his home in Maui, Hawaii, where his neighbors include Kris Kristofferson, Owen Wilson, and Woody Harrelson.

Nelson, author of such timeless American ballads as "Crazy," "Hello Walls," and "Funny How Time Slips Away," was inducted into the Country Music Hall of Fame in 1993. In 2013 he celebrated his eightieth birthday. ★

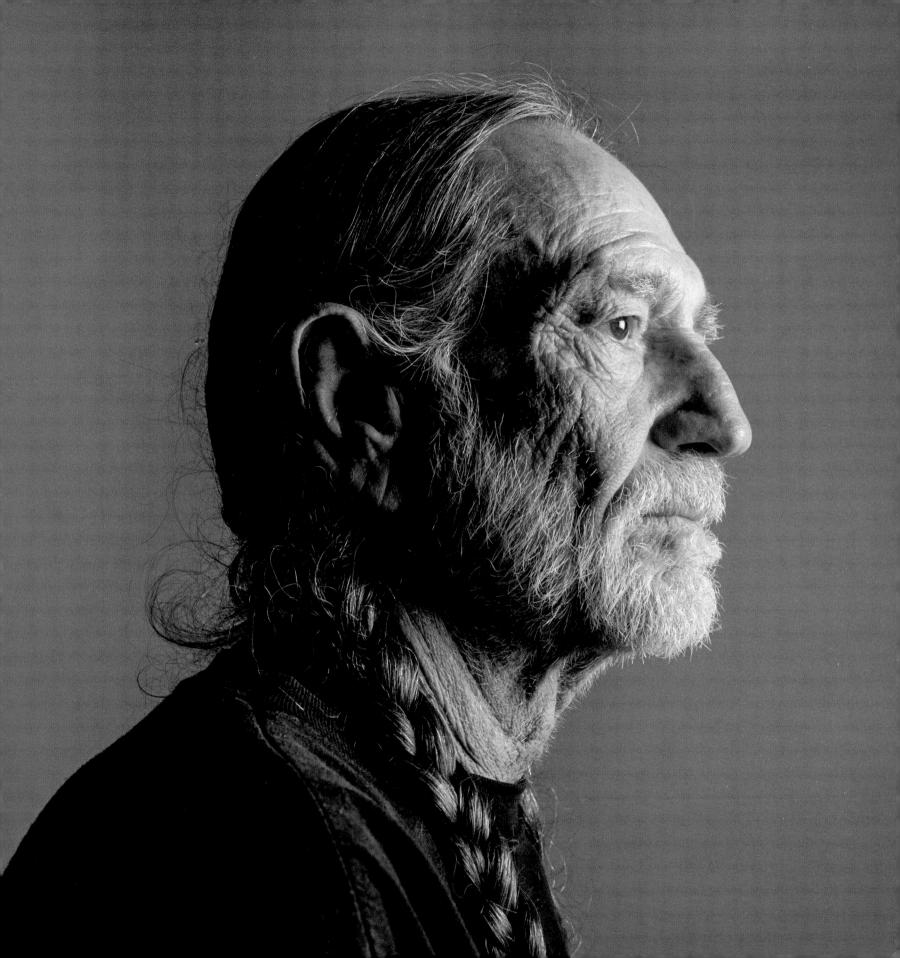

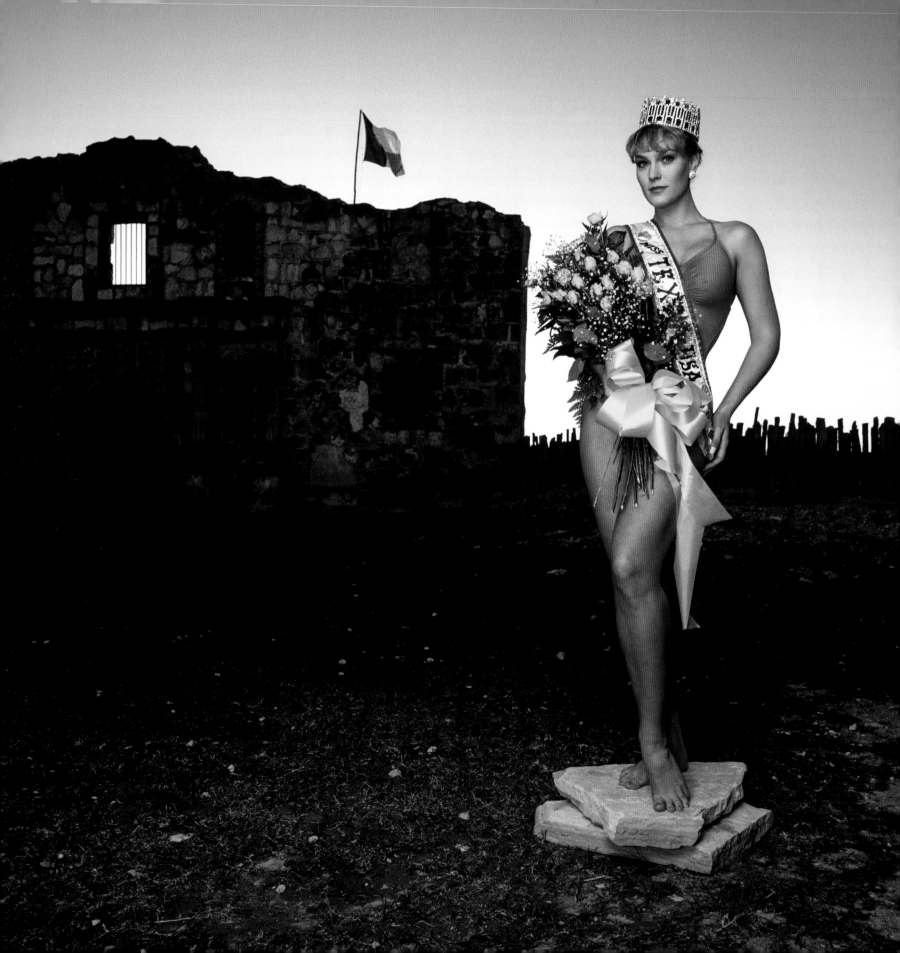

Stephanie Kuehne

Stephanie Kuehne's great-grandmother, Kate Rogers, was one of the first female mountain lion hunters in Texas.

"She was hired with her daddy to hunt down wild mountain lions who were killing livestock," said Kuehne. "She rode sidesaddle and broke horses and was a true frontier woman."

Stephanie Kuehne of Houston reigned as Miss Texas USA in 1990. She appeared in a cover story on beauty queens in *Texas Monthly* magazine in February of that year. The Miss Texas winner goes on to compete in the Miss USA pageant; Kuehne was a top-twelve semifinalist. Texas remains the most successful state ever to compete in the Miss USA pageant, the launchpad for the Miss Universe competition. The state boasts nine winners, more than any other state thus far.

Kuehne was photographed in Brackettville, Texas, in front of Alamo Village, a movie set and onetime tourist attraction on James T. "Happy" Shahan's ranch. Shahan originally built Alamo Village for John Wayne's film *The Alamo*. In 1995 Governor George W. Bush named Shahan "The Father of the Texas Movie Industry," as Alamo Village was the first movie location built in Texas.

Although she is a wife and mother now, Kuehne, now Kuehne Kissner, has enjoyed a long career as a model and actress. Her extensive beauty pageant experience led to a string of work for various charities in the United States, Taiwan, and China, and served as a launchpad for her acting career. Her favorite role, among many in film and television, was a recurring one as a reporter on the television series *Diagnosis Murder*. She has also worked as a television host and a corporate and motivational speaker.

Kuehne, who now lives in Houston, said that even with all her exposure to international cultures, Texas reigns supreme in her heart.

"Throughout my life I've been blessed with the opportunity to travel all over the world to many beautiful places," she said.

I've loved learning about different cultures and meeting interesting people. Nowhere in my travels have I ever come across a place as special as my beloved Texas. . . . Texans are very diverse yet have a common pride in our state that is unmatched.

My childhood memories include going to our family ranch in Uvalde, swimming in the creek, and listening to the stories about my great-grandmother, Kate Rogers. My Texas pride always goes back to the memories of the people, young and old, who have been a part of my life who make this amazing state so special to me. Texans have hearts as big as . . . well, *Texas*!

Speaking of heart, Kuehne devotes much of her free time now to K-9 Rescue Angels in Houston, which rescues dogs from local kill shelters and adopts them out to loving homes. ★

Laura Wilkinson

Before a competition, Laura Wilkinson generally had a smile on her face. It was her trademark. When other platform divers were stressing out, wearing game faces or faces taut with anxiety, Wilkinson was happily acknowledging family members and teammates in the stands. Her smile communicated her philosophy.

"I smile because I love what I do," said the Houston native. "I make a commitment before the competition to enjoy the experience, however it turns out."

It was a critical strategy—a hallmark of positive psychology—and key to her mental game. She is, in a word, resilient.

In her athletic career, Wilkinson came back against impossible odds. Shortly before the 2000 Olympic Trials, she shattered her right foot in a training accident. With only three weeks to go, she and her coach, Kenny Armstrong, created a special regimen that focused on keeping her head in the game. She made the team, and then made history three months later in Sydney, Australia. Clad in a protective shoe to climb up the ladder to the platform, she proceeded to execute a breathtaking dive, coming from eighth place to win the Olympic gold.

When she started diving at fifteen, a teacher tried to discourage her, telling her she was too old to begin a new sport. She persevered. Nine months later, she was kicked off her high school team for being a "waste of space." Yet the following year, she won her first U.S. national title, made the U.S. national team, and earned a bronze medal at the World Cup. In 1998 she became the only American diver in history to win a Goodwill Games gold medal. Other accomplishments followed: in 2004 she won gold in the World Cup platform competition, and in 2005 she won gold again in the World Championship.

Wilkinson writes a lively blog on her web page, titled "Learning to fly . . . But I ain't got wings." In describing her athletic career, she blogs, "Once upon a time I was an elite athlete. I enjoyed throwing myself repeatedly off a three story building and trying to go in the water without making a splash."

The University of Texas graduate *is* making a splash now in Houston. Married and with two daughters, she is focusing on family and on promoting platform diving through her Laura Wilkinson Foundation. Her dream: for the United States to reemerge as the world leader in diving. ★

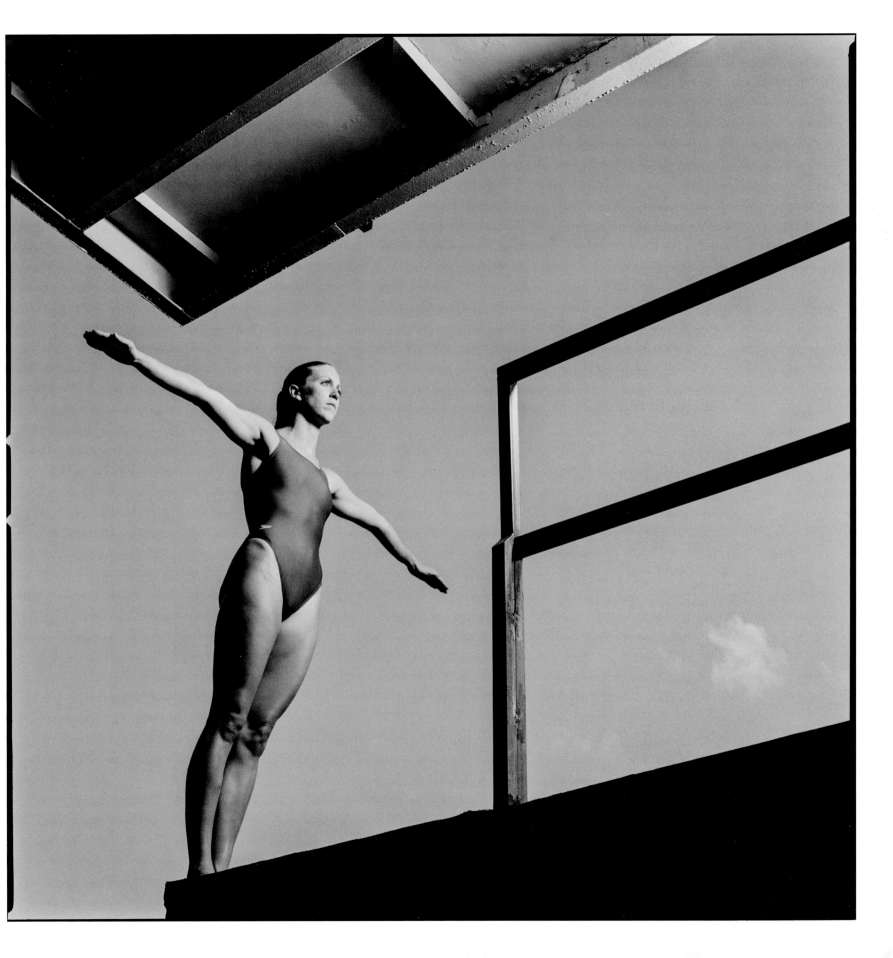

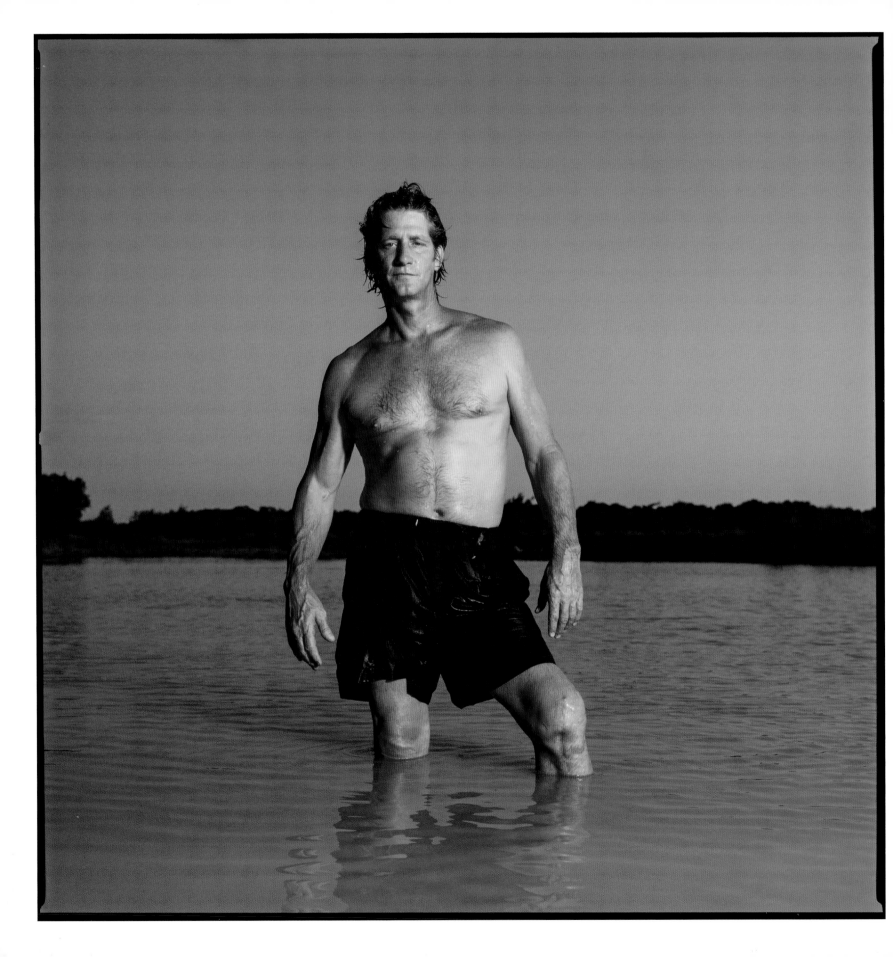

Kevin
Von Erich

He was known as "The Barefoot Boy" in wrestling circles for his trademark of storming the ring barefoot, eschewing the requisite high-topped wrestling boots. No matter that this practice began by accident early in his career, when someone stole his boots before a match, leaving him no choice but to wrestle bootless. He wowed audiences with his good looks and athleticism, particularly his personal, albeit derivative, version of the "Superfly," an intimidating self-catapult from the top rope, and the "Iron Claw," his father Fritz's classic finishing move: a disabling head-grab with his genetically massive hands.

Born Kevin Adkisson, he wrestled under the family name Kevin Von Erich. He is the last surviving son of Fritz Von Erich, the notorious wrestler and longtime wrestling promoter who created World Class Championship Wrestling (WCCW), headquartered in Dallas. The family was a wrestling dynasty: four of his five brothers were also wrestlers. The Von Erichs are longtime Hall of Famers.

A former fullback on scholarship at North Texas State University, Von Erich took up wrestling when a knee injury dashed his hopes of going pro with the National Football League. At a sculpted six foot three, he excelled and won many championships as both a singles and a tag-team wrestler, particularly in the seventies and eighties. His highest profile partners were always his brothers, Kerry and David. The Von Erichs gained notoriety over the years through their longtime friendship and then media feud with the Fabulous Freebirds, a trio from Georgia with whom they sparred for years.

Although he has been retired from wrestling since 1993, Von Erich, father of four children and grandfather of five, is still remembered fondly in the wrestling world. In fact, Mattel has introduced action figures in their WWE Legends line of both Kevin and his brother Kerry. ★

Ben Crenshaw

When Ben Crenshaw was just eight years old, he paid a visit to golf pro Harvey Penick at the Austin Country Club. Penick cut off a seven iron for him, showed him a good grip, and took him out to the course. Looking at a green seventy-five yards away, Penick told young Crenshaw to tee up a ball and hit it onto the green. Crenshaw did as he was told. Once on the green, Penick told him to putt it in. Crenshaw turned to him and said: "If you wanted it in the hole, why didn't you tell me the first time?"

This anecdote, from *Harvey Penick's Little Red Book*, sums up Ben Crenshaw, who considers Penick his greatest influence. Though he never took formal lessons from the famed golf teacher, "Gentle Ben" Crenshaw—so called for his easygoing manner and seemingly effortless game—always went to him with problems. Penick, for his part, considered Crenshaw's swing—natural, long, and smooth, using mostly the shoulders—one of his all-time favorites.

Ben Daniel Crenshaw was born in Austin on January 11, 1952, to Pearl Johnson Crenshaw, an elementary school teacher, and Charles Edward Crenshaw IV, an attorney who worked as assistant to State Attorney General Price Daniel. It was from Daniel—who became a U.S. senator and governor of Texas—that Crenshaw got his middle name. He learned golf early from his father, a scratch golfer.

Not long after his first session with Penick, Crenshaw won his first tournament, in fourth grade—the Casis Elementary Open—with a score of 96. He went on to rack up the stats: he shot a 74 for eighteen holes at the age of ten; qualified three years later for the state junior tournament, with a score of 69; won the state junior championship at fifteen, and again in 1968; won the first of three consecutive Austin city championships, also in '68; and won his first national title, the Jaycees Junior Championship, again in '68.

In high school Crenshaw was an accomplished athlete: he played quarterback in football, point guard in basketball, and catcher in baseball, and participated in the broad jump. But golf occupied him most intensely; he played up to thirty-six holes a day for ten months a year. He won a golf scholarship to the University of Texas in 1970, and in '71 he was named to the All-American College Golf Team. He turned professional in 1973.

But it took a decade of frustration before Crenshaw won his first major championship title, in 1984, when he took the Masters. His second victory, at Augusta in 1995, secured his place in golf history. In 1999 he was captain of the American team that won the Ryder Cup.

Crenshaw is now on the senior tour. He has a golf course architecture business that builds championship courses across the United States and does restoration work at some of the country's finest courses.

His honors include the Bob Jones Award, the highest honor bestowed by the United States Golf Association, and induction into the World Golf Hall of Fame. He attributes some of his success to his Texas birthright.

"There is a long line of outstanding golfers that have come from our state, and I think this goes back to the fact that Texans have always been risk takers, and that we grew up dealing with harsh elements," said Crenshaw, a noted golf historian who grew up playing alongside Tom Kite. "Wherever I travel around the world to play golf, I'm always proud to talk about Texas being my home." ★

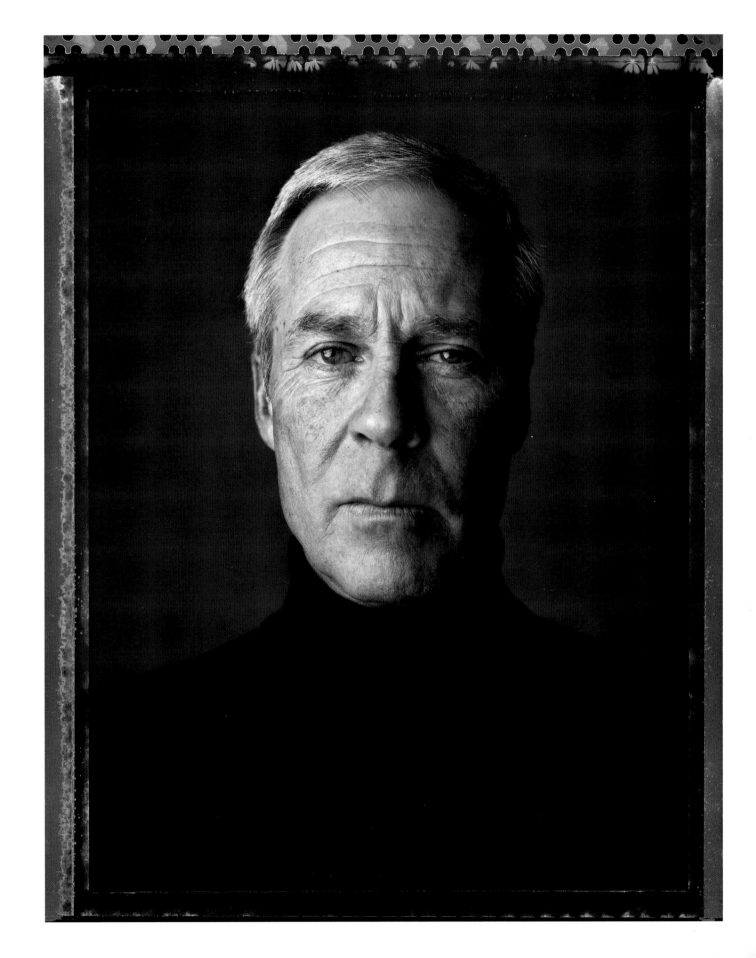

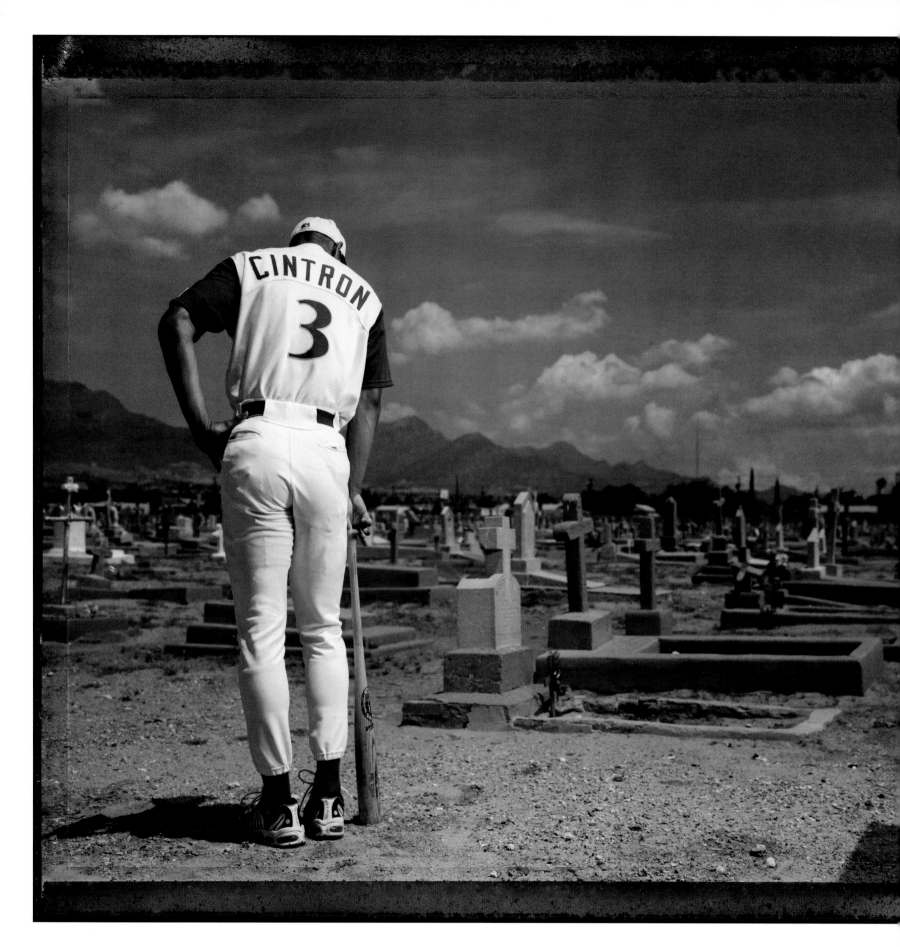

Alex
Cintrón

Alex Cintrón was a shortstop for the Double-A El Paso Diablos when this photo was taken for *ESPN* magazine in 2000. The photo was taken at Concordia Cemetery, where gunslinger John Wesley Hardin is buried—a fitting backdrop for a player who was determined not be "buried" in the minor leagues.

Cintrón, a native of Puerto Rico, did go on to play for the major leagues as an infielder for the Arizona Diamondbacks, Chicago White Sox, Baltimore Orioles, and Washington Nationals. He had a brush with fame in 2001 when the Diamondbacks won the World Series against the New York Yankees, winning the best-of-seven series four games to three. It was the first World Series ever played in Arizona.

Although he retired from baseball in 2011, Cintrón came out of retirement the following year to play for the Sugar Land Skeeters, a minor league team located in the Houston suburb. Now he is a hitting and defense instructor at The Baseball School in Spring, Texas. ★

Sissy Spacek

QUITMAN

1990

When Sissy Spacek read the script for *Carrie*, she understood the part: she vividly remembered a poor girl at her school in Quitman, Texas, who lived in a shack and was ostracized by the popular kids. For the audition, Spacek—whose proper name is Mary Elizabeth and who was elected homecoming queen—donned an old blue sailor dress her mother had forced her to wear to a seventh-grade party, and she matted her long strawberry-blond hair with Vaseline. She spoke to no one and disappeared inside herself, focusing solely on the character of the high-school outcast who possesses psychokinetic powers. Director Brian De Palma, who wanted another actress for the part, had an instant change of heart.

Spacek doesn't live in Texas anymore, but she will always claim it as her home, and she makes a point to visit her hometown of 1,818, midway between Dallas and the Louisiana border, whenever she can. Her father, Ed, widowed in 1981, lived there until his death in 2001, but there are other relatives; and she has kinfolk in Central Texas, too.

"My husband laughs and says whenever I get anywhere near Texas, my accent thickens, and I begin to feel very safe," she said.

In 1980 Spacek won an Academy Award for her portrayal of Loretta Lynn in the film *Coal Miner's Daughter*. She has been an Oscar nominee for her work in several other films, including *Carrie* and most recently *In the Bedroom*, in which she gives a wrenching performance as a tightly wound wife and mother struck by tragedy.

Spacek has made a career of playing ordinary people thrust into extraordinary circumstances. She grew up happy and normal, the daughter of the county agricultural agent, cruising the Dairy Queen, participating in 4-H, vying for Dogwood Queen (she came in second), taking guitar lessons, and serving as homecoming queen. She left home at seventeen—after her older brother Robbie died of leukemia—and tried her luck in New York, where her cousin, actor Rip Torn, lived with his wife, actress Geraldine Page. Spacek was seduced by the lives they led, and though her original goal was to be a singer, she wound up pursuing acting until she landed parts, first in *Prime Cut*, then *Badlands* and *Carrie*. Her other big films include *Raggedy Man*, *The River*, *Marie*, *Crimes of the Heart*, and *'night Mother*. She has done a string of TV movies in recent years.

Spacek, who has been inducted into the Texas Hall of Fame—the honors having been conferred by cousin Rip Torn—is a recluse by Hollywood standards. Married to the film director Jack Fisk, she lives with him and raised their two daughters, Schuyler and Madison, on a 210-acre horse ranch in Albemarle County, Virginia, preferring a rural oasis where she was known mainly as "Schuyler and Madison's mom."

In 2012 Spacek published a memoir, *My Extraordinary Ordinary Life*. ★

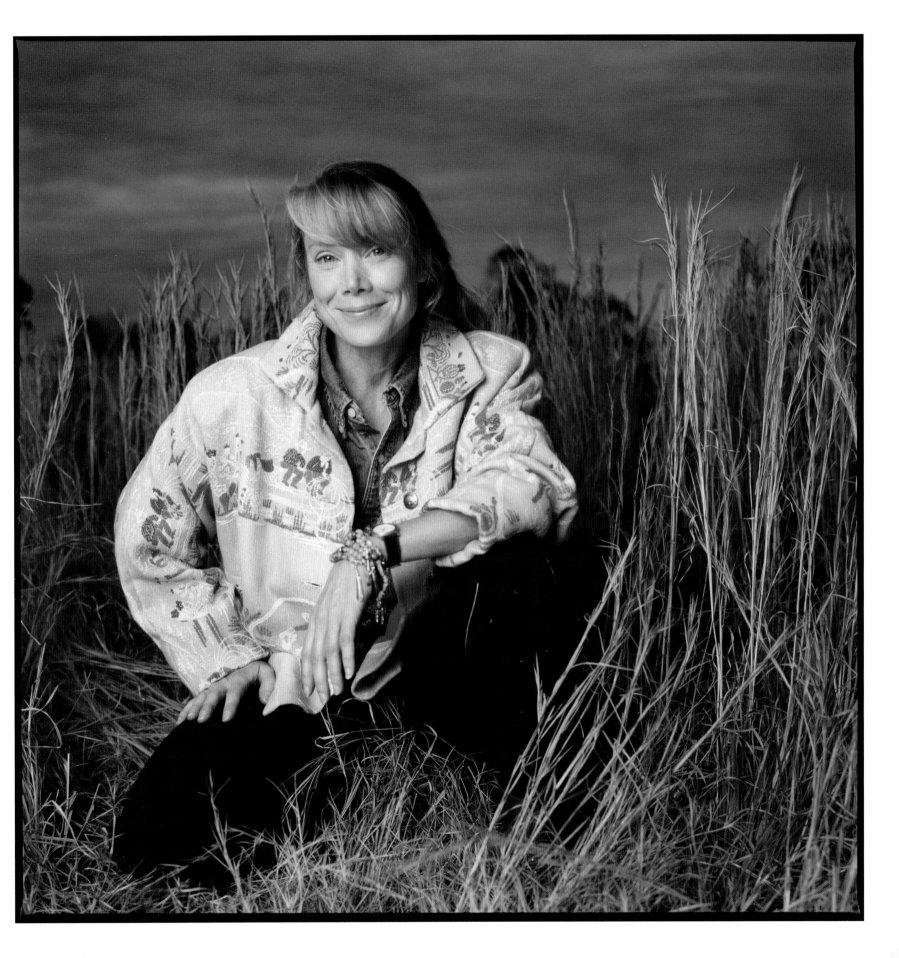

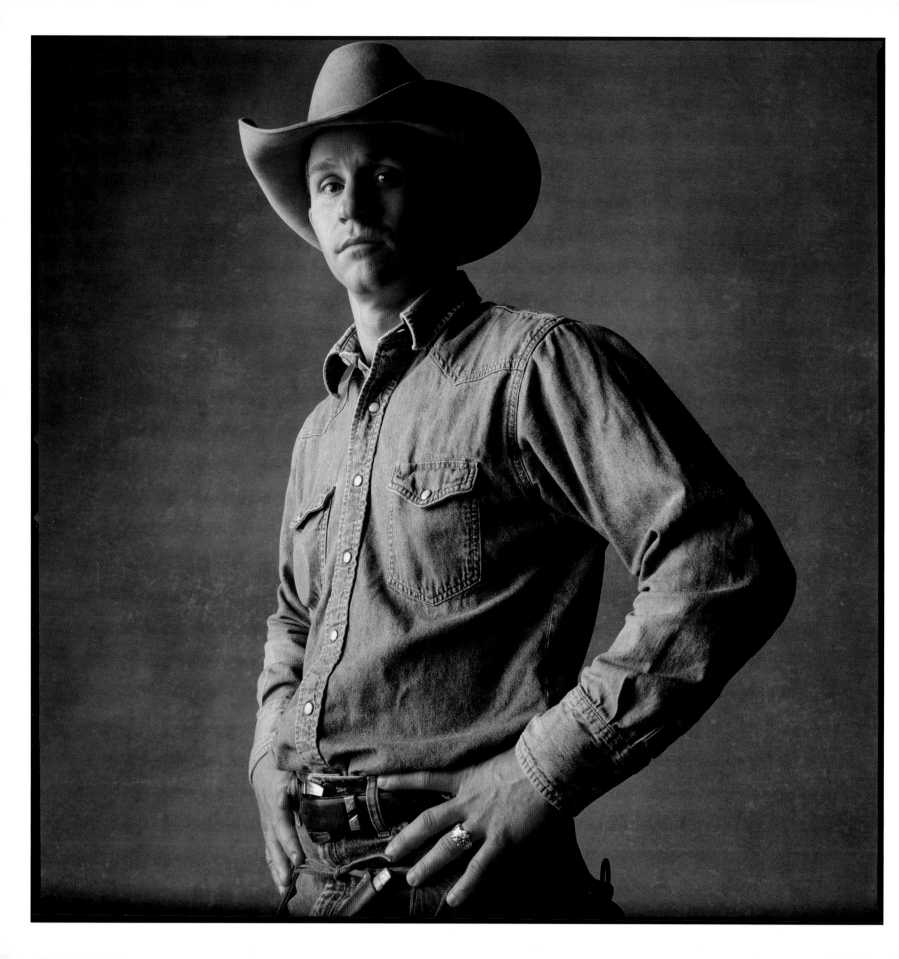

Ty Murray

Ty Murray saved up enough money by breaking colts when he was twelve to buy his own mechanical bull. By the end of that day, he had nearly worn it out.

Ty "King of the Cowboys" Murray—bareback rider, saddle-bronc rider, and bull rider—has earned his moniker with flesh, blood, and bone. He has been pieced back together numerous times, only to ride again. A nine-time world champion, he was one of the most prominent figures on the rodeo circuit. With his dominance of not one but three events, he has been critical in promoting the longevity and success of the rodeo in the United States.

Murray came to his profession genetically. His mother, Joy, was a young bull rider in the National Little Britches Rodeo Association, and his father, Butch, was a former rodeo hand and racetrack starter. As a toddler, Murray rode calves for fun, and by the age of eight he was helping his dad break wild horses. He won his first rodeo in grade school. In fifth grade, when he had to write an essay on what he wanted to be when he grew up, he asserted, "I want to beat Larry Mahan's record." Mahan was the six-time all-around world rodeo champ who was Murray's idol.

As the years passed, Murray became obsessed. He honed his stamina and coordination by practicing—by every means possible: tirelessly walking fence lines, juggling, riding a unicycle, and working out with the high school gymnastics team. At Odessa College in West Texas, he broke every possible rodeo record. And at twenty, he became the youngest rider ever to win the Professional Rodeo Circuit Association All-Around World Championship. By twenty-three, he had become the youngest millionaire in rodeo history.

In recent years, Murray has gained fame of a different kind by marrying the pop star Jewel and by competing in ABC's wildly popular *Dancing with the Stars* TV show, in which he was a semifinalist.

Murray, who has suffered a host of injuries and reconstructive surgeries, has retired to his ranch in Stephenville, Texas. But he keeps a connection to his old life by appearing as a frequent announcer at Professional Bull Riding (PBR) events and serving as PBR's president. He says he cares little about being remembered for his various individual titles. Instead, he has said, "I hope people will remember me as a great cowboy." ★

George Dawson

To the day he died, George Dawson (1898–2001) couldn't abide the taste of peppermint. He associated it with a tragic day a long time ago. When he was just a boy, Dawson accompanied his father into town—Marshall, Texas—to sell ribbon syrup and pay off some debts. His father bought him a peppermint for his day's work mashing sugar cane. While they were in the general store, they heard a commotion outside and watched in horror from the doorway as a gang of white men surrounded a teenage black boy—a friend of Dawson's family—and hung him from a tree. The youth had been accused of raping a white girl.

"After we got home, I found the peppermint was still in my pocket," Dawson says in his book, *Life Is So Good*. "I scraped off the lint and the dirt. I gave it to one of my little sisters. My taste for it had disappeared. Ninety years later, I still don't like peppermint."

Six months later, when the girl gave birth to a white baby, no one said a thing.

Yet Dawson, who learned to read and write at the age of 98, managed to maintain a happy outlook; and at 102, he became an author. *Life Is So Good*, written in collaboration with Richard Glaubman, an elementary school teacher from Port Townsend, Washington, is Dawson's life story and embodies the philosophy his father taught him: that life is a gift and each moment is precious.

"Life is so good," Dawson's father told him as a young boy. "I do believe it's getting better."

George Dawson, the grandson of slaves, grew up poor on a small farm in Marshall. The oldest of five children, he started working full-time for his father when he was just four, hauling water from the well, working the cotton fields, hand-combing the cotton, and feeding the family's few chickens and lone mule. They lived in a three-room cabin, with an outhouse out back and a small barn. School was not an option.

"We had almost nothing," said Dawson, who lived in Dallas until his death at 103. "But we had each other and nobody told us we were poor. I never felt lonely. Ever since I remember, even on the cold mornings when the fire had burned down, I would wake up under a blanket, always with some brothers and sisters next to me. We were warm and cozy."

Dawson went on to experience monumental world changes—wars, political upheaval, a succession of presidents, natural disasters, and the advent of automobiles, television, airplanes, spaceships, computers, and cell phones. He worked for over seven decades, laboring on farms, driving spikes for railroads, breaking horses, building levees on the Mississippi River, and working at a sawmill. At the age of 98 he decided to learn to read and write, and enrolled in a literacy program at the Lincoln Instructional Center in Dallas, where he excelled. But he was already a very wise man.

"Yeah, I've seen it all in these hundred years, the good and the bad," said Dawson, who fathered seven children. "My memory works fine. I can tell you everything you want to know." ★

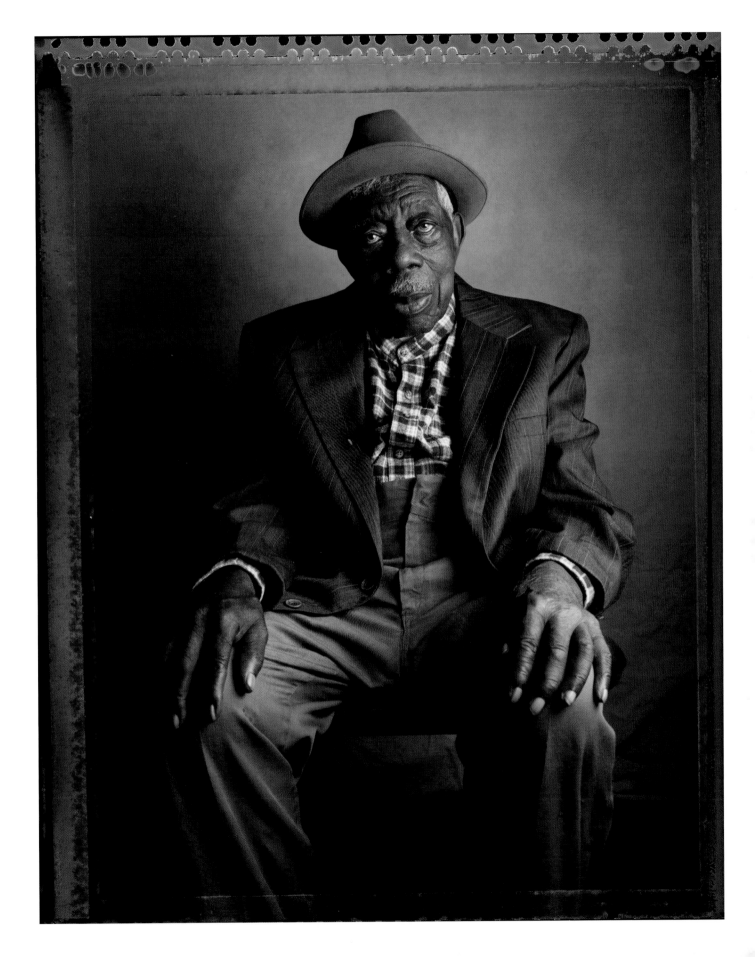

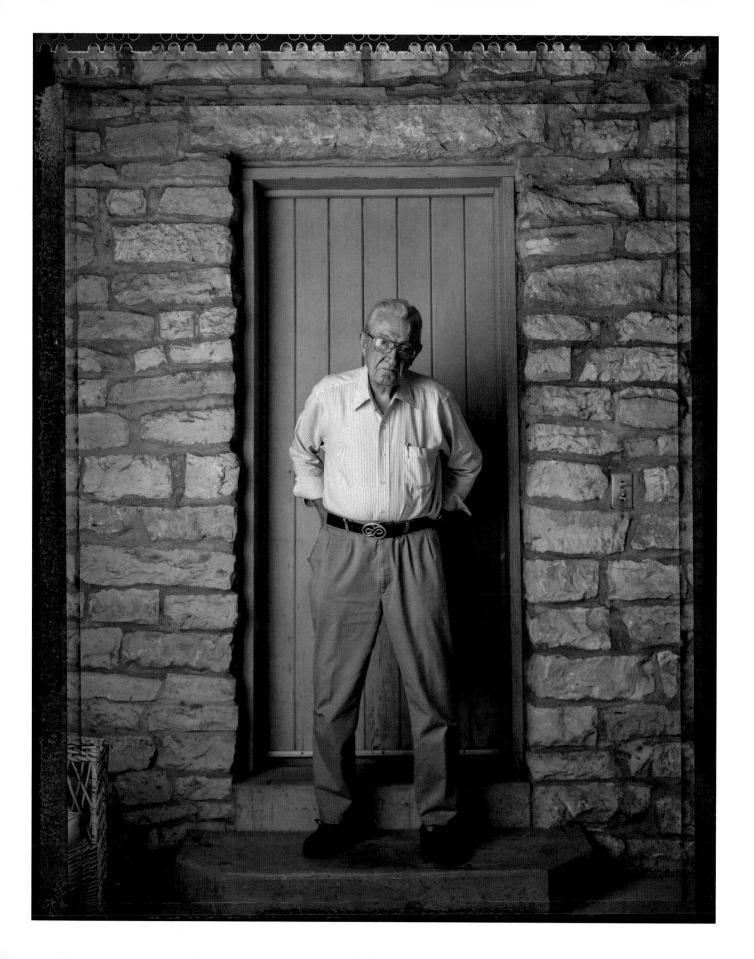

John Graves

GLEN ROSE

2006

John Graves (1920–2013) wrote eloquently about Texas—the land, the rivers, the trees, the heat. Graves was especially sentimental about the Texas Hill Country. In a 2003 essay for *Texas Monthly*, he wrote that while he had become a "pessimistic accepter" of the changes besetting the Hill Country, he remained grateful "for having experienced the hills earlier, when the change was slight. Grateful too for corners and stretches . . . barely yet touched."

Fishing, guns, and dogs figure prominently in his work. In one of Graves's best-known books, *Goodbye to a River*, the writer chronicled a three-week canoe trip he took down the Brazos River with his dog (a six-month-old dachshund whom he dubbed "the passenger") in October 1957—the best month, he says, for the journey: "Snakes and mosquitoes and ticks are torpid then, maybe gone if frosts have come early, nights are cool and blue and yellow and soft of air, and in the spread abundance of even a Texas autumn the shooting and the fishing overlap and are both likely to be good."

He paints a picture so vivid and resonant that Texas is rendered a rough and mythical landscape, a country unto itself. His sense of place is visceral.

Graves was born in Fort Worth in 1920, and grew up there and on his grandfather's ranch in Cuero. He graduated from Rice University (then called Rice Institute) with an English degree and afterward served as an officer in the Marine Corps. He lost an eye from a Japanese grenade when he was stationed on Saipan Island. After his military service, he enrolled at Columbia University, earning his master's degree. While there, he published his first short story, "Quarry," in the *New Yorker*; and he continued to publish his writing in magazines including *Texas Monthly*, *Esquire*, the *Atlantic*, and the *New Yorker*.

Graves—who died at his home, Hard Scrabble, a wild, four-hundred-acre spread near the town of Glen Rose—taught at both the University of Texas in Austin and Texas Christian University in Fort Worth. He has published several noteworthy books, including *Goodbye to a River*, *Hard Scrabble*, *From a Limestone Ledge*, and *Myself and Strangers*.

Among his many awards, Graves won the Bookend (now Texas Writer) Award for lifetime achievement at the 2000 Texas Book Festival. He was a beloved past president of the Texas Institute of Letters. His papers reside in the Wittliff Collections at Texas State University in San Marcos as part of the Southwestern Writers Collection. He leaves behind his wife, Jane, and two daughters, Helen and Sally. ★

Ila Johnston

SPUR

1998

Retired schoolteacher Ila Johnston (1905–2009) renewed her Texas driver's license when she turned ninety-seven. It didn't hurt that she had a friendly patrol officer for a next-door neighbor.

"He said he'd help me," said Johnston, who piloted an '88 Olds. "I've never had a wreck or a ticket."

Johnston, born October 5, 1905, lived in Spur, Texas, for almost nine decades. She was born in Van Zandt County, in a small town called Rast, which is no longer on the map. Her father, whom she described as a "jack-of-all-trades," worked at many things, including filling prescriptions, farming, ranching, and carpentry. Her mother taught high school.

Johnston earned an education degree from West Texas Teachers College; and she considered her greatest contribution to be teaching and working with young people.

"I learned to understand them," said the educator, who taught math, civics, and history at Spur High School for thirty-three years. "I learned to do things *they* liked to do."

To explain algorithms to her math class, she arranged—without the principal's permission—for two cars to transport the students to the town football stadium, where she had them measure the field, using their newly acquired knowledge.

"It meant so much more to them," she said.

Though she never had children of her own, Johnston, a widow, spoke maternally of her former students—"my exes," she called them.

"I insist they all go to college one year, to see what it's like. I had one student who told me he didn't need to go to college because he wanted to be a mechanic. I convinced him to try it; I suggested Texas A&M. Now he's an instructor. He still carries his tools around in his car, though."

In her nineties, Johnston was still attending the school's pep rallies on Friday afternoons; and she continued to drive with confidence, having taught a good number of the area highway patrol officers.

"I guess I'm not too slow and I'm not too fast," she said, revealing, albeit metaphorically, the secret of her longevity. "If anything ever happened, they'd take care of me."

Johnston lived to be 103 years old. ★

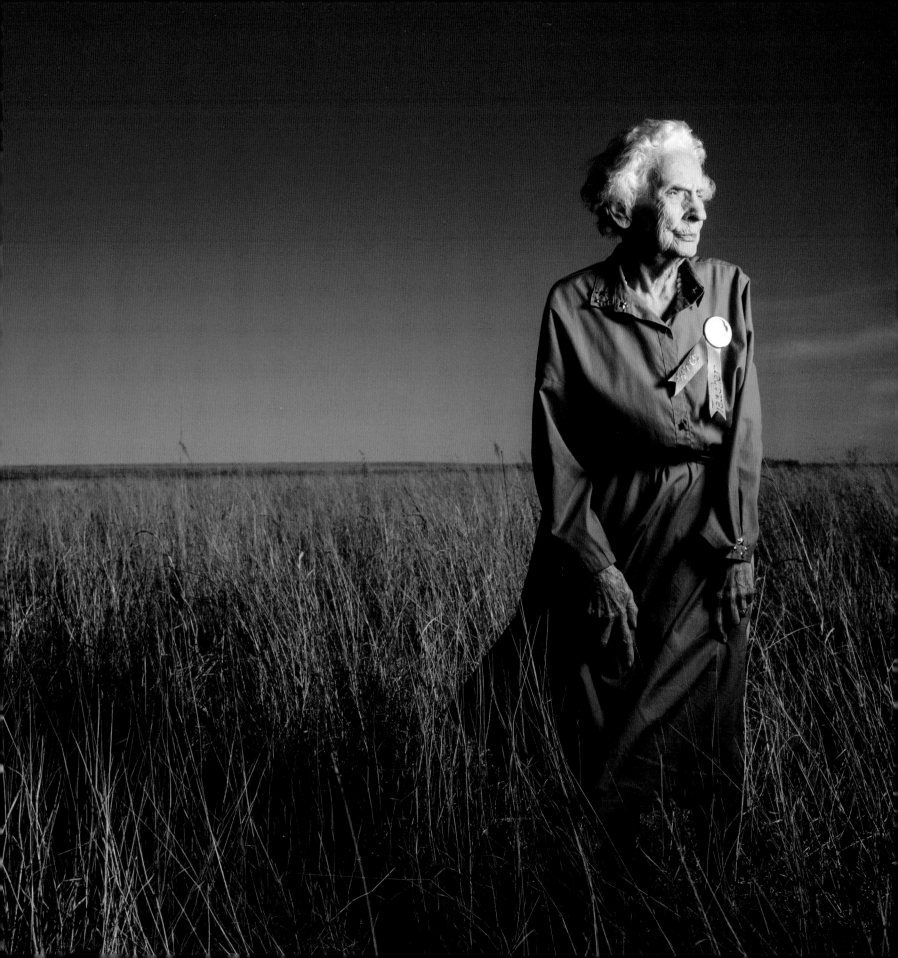

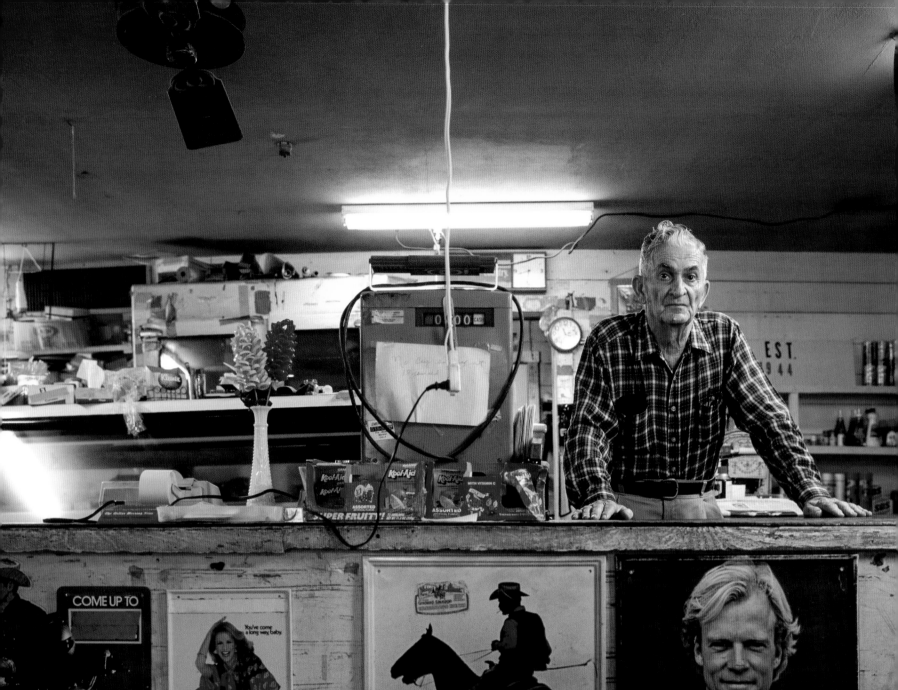

Wilson Pickard

OVILLA

1998

Wilson Pickard (1917–2000) "popped off" and bought Ovilla Grocery on Halloween night, 1944. He'd had experience in the wholesale grocery business and figured he'd like to be his own boss. Pickard and his wife, Juanita, ran the small store together until her death in 1996. He managed it alone until the day before he died.

"I just come down here to have something to do," he said, at eighty-two. "I talk to these old whippersnappers who come in here and set all day. We solve all the problems."

Pickard was born on a farm a couple of miles outside Ovilla, "up on Bear Creek, by the water tower."

"The lady across the road, Minnie Young, delivered me," said Pickard, who was Ovilla's first mayor, in 1963. "By the time the doctor got there, his job was done."

Small-town life may be relatively uneventful, but Ovilla had some excitement when some infamous outlaws roared through the area, around 1930.

"I was around thirteen when Bonnie and Clyde came through town," said Pickard. "I saw Bonnie in the front seat of their car with a submachine gun across her lap."

Later, when the movie *Bonnie & Clyde* was made, the film crew used Pickard's grocery as a location.

Pickard is survived by two sons—Billy, a housepainter in Waxahachie, and Donnie, Ovilla's longtime fire chief—and three grandchildren. ★

Cara Collier

Cara Collier was just a preteen when this photograph was taken for a Nike ad in 1990. The Nike crew used her dance studio in Richardson, Texas, to conduct the casting session, and Cara was chosen as a real-life model.

"I was twelve years old, in middle school, and dance was my life," said Collier. "I did ballet, modern, jazz, and tap."

At sixteen, Collier enrolled at the Booker T. Washington High School for the Performing and Visual Arts in Dallas, where she performed with the dance department, though she went on to graduate from Plano High School. Instead of going to college, Collier began learning web-page design and got caught up in the high-tech industry.

She ran her own web page for a time, featuring local garage bands, then went to work for various start-up companies.

"By eighteen, I had a corporate job," she said. "I was working in web services and the Internet."

Collier later returned to school at Brookhaven College in Dallas, but after only one semester, she moved to Austin to work for MCI. She spent the next few years back in the high-tech industry; then wanderlust got the better of her again.

"I packed up my stuff, left my boyfriend in Austin, and moved to San Francisco," said Collier, who studied education and dance at the University of San Francisco and carried on a long-distance relationship with her boyfriend, a chip designer in Austin.

Collier eventually moved back to the Texas Hill Country, married the microchip engineer, David Corley, and went into the real estate business. She specializes in finding farm- and ranchland that can be converted into vineyards. She and David have a daughter, Caroline, and their third Jack Russell terrier. They live in a green home in Hays County.

"I'm a fifth-generation Texan on my mother's side," said Cara. "Texas is family to me." ★

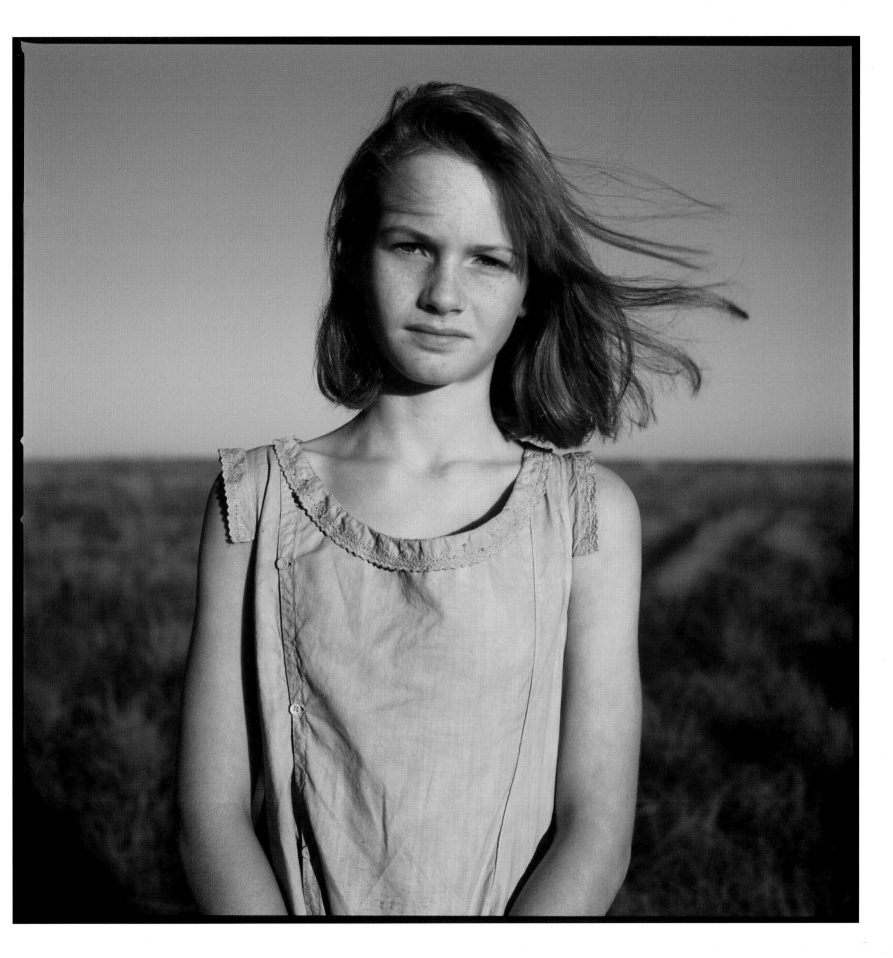

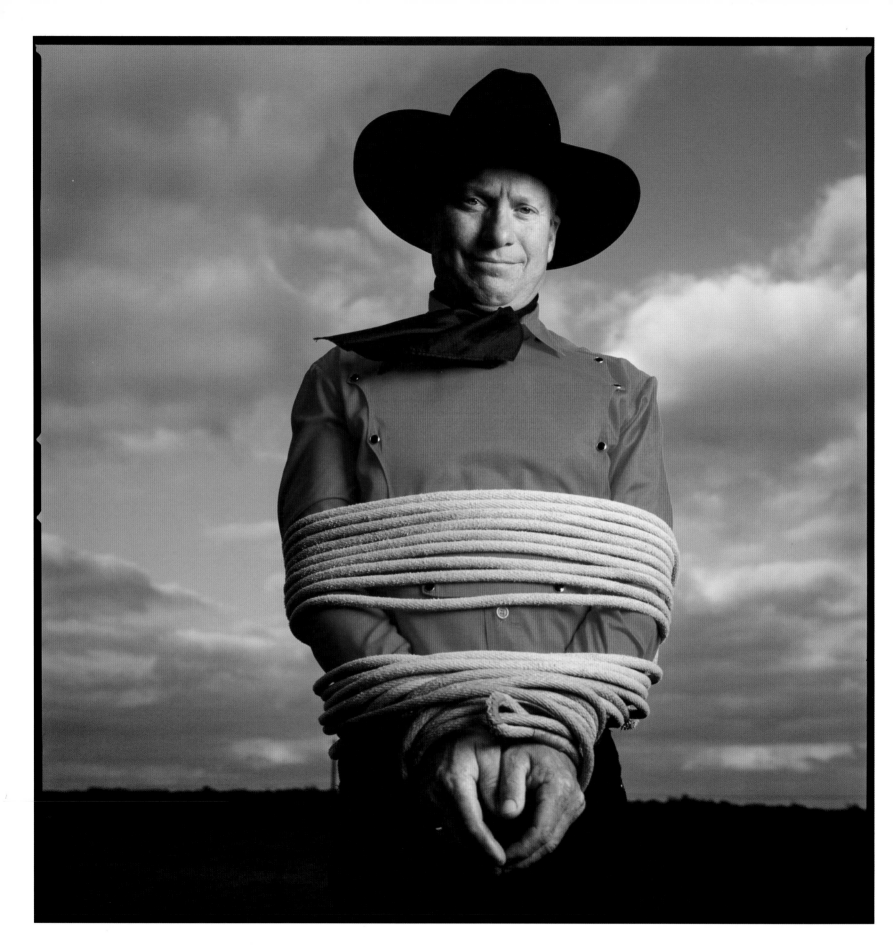

Kevin Fitzpatrick

BANDERA

1998

"Cowboy Kevin" Fitzpatrick can do just about anything with a rope. Besides lassoing horses, bulls, people, and anything else that moves, he can transform a rope into a beautiful, soaring butterfly. His "Ocean Wave" is just that—a dramatic, rolling rope wave, crashing onto shore. His "Rollovers" and "Flataround" are equally sublime. When he attended the Guinness Book of World Records Show in Germany, he tied the reigning European champion with his "Texas Skip," completing seventy-nine in-and-out loop jumps in fifty-six seconds before stepping on his rope on the eightieth jump.

"I'm a cowboy," said Fitzpatrick, the son of an accomplished farrier and rodeo rider. He often stands or does handstands on his horse while performing. "That's all I do, is rope and ride."

Fitzpatrick was raised in Phoenix, Arizona. As a boy, not surprisingly, his favorite toy was an old worn-out rope.

"I dragged that old rope around for years, unaware that a rope would be the dominant factor in my future lifestyle," he said.

Fitzpatrick moved to Bandera, Texas—the "Cowboy Capital of the World"—just after high school in the mid-eighties. He followed his father, Bud, who had moved back to his native state after working for years in California.

"My dad was a rodeo rider in the thirties and forties," said Fitzpatrick, who worked with his father shoeing racehorses when his dad slowed down. "He used to gallop racehorses and ride bucking horses and bulls. He competed in the world finals of bull riding at Madison Square Garden in 1943. Roy Rogers was there."

Fitzpatrick hired on at a series of dude ranches. Then he got his own horse, a two-year-old quarter horse nicknamed "Wet." With visions of Roy Rogers and Gene Autry in his head, he spent his free time with Wet, learning how to ride and rope.

Eventually, Fitzpatrick became so skilled at roping and so in demand as a performer that he quit his regular job in pursuit of his art. He and his younger horse, Chief, a "paint," make a living traveling around to rodeos, conventions, stock shows, schools, and birthday parties. (Recently, Fitzpatrick had to put down his faithful old horse Wet, his partner for thirty-two years.) He and his horses also appear in occasional ads and have traveled as far afield as Geneva, Berlin, London, and Toronto doing promotional work for the Texas Department of Tourism. In 2001 Fitzpatrick performed at the Texas Society's "Black Tie and Boots" party for George W. Bush's inauguration. In 2008 Fitzpatrick was named World Champion Trick Rider at the National Cowboy Symposium in Lubbock.

"I have the most complete life of anybody," said Fitzpatrick, who lives on thirty-seven acres in the Hill Country with his wife, three children, horses, and a menagerie of other animals. "I get the best of every world, and I make people happy." ★

Brent Cunningham

AUSTIN

1989

Brent Cunningham was nine years old, a fourth-grader at Plum Creek Elementary School in Lockhart, Texas, when this photograph was taken at the 1989 Austin–Travis County Livestock Show and Rodeo. He had competed with his young heifer in the Red Brangus division, and walked away with a second-place ribbon.

"It's pretty much what we did when we were growing up, showing heifers and stuff," said Cunningham. "It was a 4-H kind of thing. We'd feed 'em, raise 'em, and train 'em to walk around with halters. We'd show our heifers in Austin, Houston, Fort Worth, and here in Caldwell County."

Cunningham grew up on his family's four-hundred-acre ranch in Lockhart, where he took on adult responsibilities at an early age.

"When your parents are divorced, and you grow up on a ranch, you have to become a jack-of-all-trades," said Cunningham, now owner of A-Tex Boat Docks, a dock building and repair business. "My stepfather was off working all the time, so I was the man of the house. I had to grow up a lot faster than other kids."

By the time he was a teenager, Cunningham had started working outside the ranch as well.

"At age fifteen he had his own welding business, and I was his secretary," said Cunningham's mother, Pat Lock. "He even skipped school to do jobs, and I had to drive him."

Cunningham went to work full-time straight out of Lockhart High School, continuing his welding and wrought-iron fence work, then expanding into the boat-dock business. Since he'd spent a great deal of time at his grandparents' house on Lake Travis—and even more time building and repairing things at the ranch—the work was familiar.

"When I was a kid, I was always building things," said Cunningham. "I've always done my own thing, and paid my own way." A committed entrepreneur, Cunningham hopes to branch out into other businesses, like real estate, and feels there is great opportunity in his home state.

"I feel I'm lucky to be living and working in Texas, specifically Central Texas," Cunningham said.

I recently returned from a trip to New York in early February and am very thankful for our mild winters down here with no blizzards. The people here are easy to get along with and have an easy Southern way about them. On top of everything, I work in the marine construction industry and get to work on homes and shorelines around the water. It's not just that Texas is home, it's just a great all-around place to live. It has all you'd need: beaches, lakes, rivers, mountains, hill country, forests, ranch land, etc. . . . Who would need anything more? ★

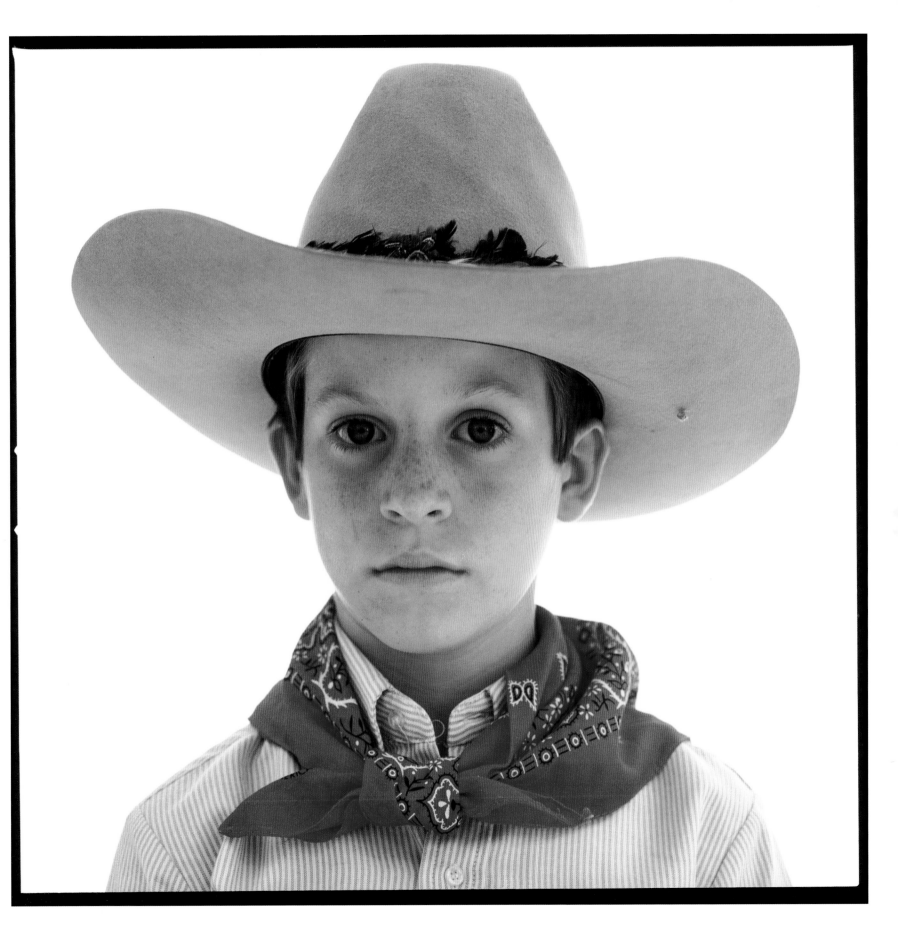

Sam
O'Brien

Sam O'Brien was four years old when his dad, Michael, took this photograph, in 1995. Sam needed an impressive costume for a talent show, and Michael—a native of Memphis, Elvis's hometown—brought the "Hunka-Burnin'-Love" costume back from one of his photography assignments. Sam blew his competitors out of the water.

Sam grew up in Austin and played club soccer throughout his youth, traveling to tournaments around Texas, and sometimes farther afield, for eleven years. His competitive spirit came in handy later at Baylor University, where he took a course called Accelerated Ventures. The class, with only twelve students, was an entrepreneurship incubator in which he and two classmates started a business selling a bottled alkaline water called Whol-E Water. The product's slogan—"Feel Good Do Good"—embodies the water's healthful properties and mission to donate to nonprofits that provide clean water to impoverished nations.

Upon graduation in May 2013, Sam moved back to Austin to pursue his business. ★

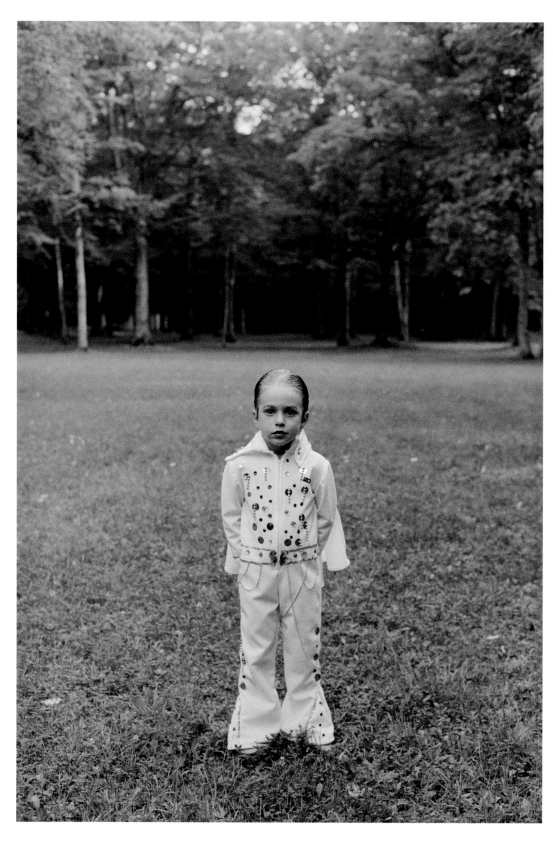

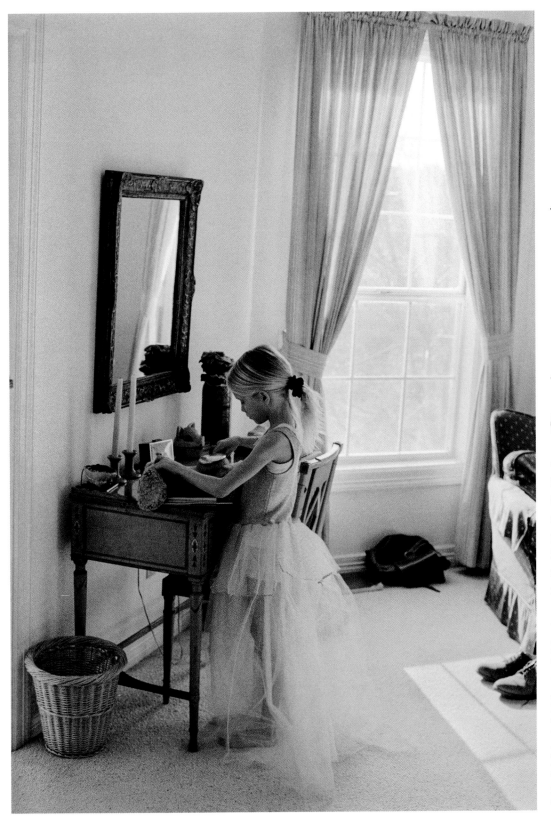

Owen O'Brien

AUSTIN
1995

Owen O'Brien was eight years old in 1995 when Michael took this photograph of her at our Austin home. From the time she was two years old, she had the freedom to choose her own outfits, which resulted in her donning fairy wings, hula skirts, and polka-dot tights on a regular basis. She would spend hours after school putting together whimsical ensembles and transforming herself into the characters that danced through her imagination—mermaids, primate researchers, and forest fairies.

During high school, Owen played on the tennis team, worked as an editor for the school newspaper, and spent her free time hiking the Greenbelt with her friends and her dogs. In 2010 she graduated from the University of Texas. After backpacking through Central America, she worked in Houston for a year as an Advise Texas college advisor to underserved students at Barbara Jordan High School. In 2012 Owen graduated from Tulane with a master's degree in social work. She is now back in Austin, working as a member of the Travis County Mobile Crisis Outreach Team. ★

Boys at
the Creek

Austin Price, Jeff Armbruster, and Jesse O'Brien spent afternoons, weekends, and summers from the ages of eleven to fifteen riding their mountain bikes down to the low-water bridge in the Lost Creek subdivision, an entry point to the Barton Creek Greenbelt in Austin. The boys rode the trails, hiked the canyons, and swam in the creek, where they whiled away hours fishing and swinging on a crude rope swing accessible from the top of a boulder on the creek's bank. When they grew tired, they sprawled out in the sun on huge limestone slabs that formed miniature islands in the water.

The three boys graduated from Westlake High School. They posed again in 2008, at the end of their college sojourns.

Austin, Jeff, and Jesse have now all graduated from college, bought homes of their own, and started their adult lives. Austin, an assistant manager at the Four Seasons Hotel in Kona, Hawaii, married Allison Bruce in 2013. Jeff works in supply chain management at Motion, an Austin-based computer tablet company. And Jesse co-owns and manages Westlake CrossFit and runs his own fitness business. The boys, still close friends, get together every few years for a retake of their "famous" group portrait. ★

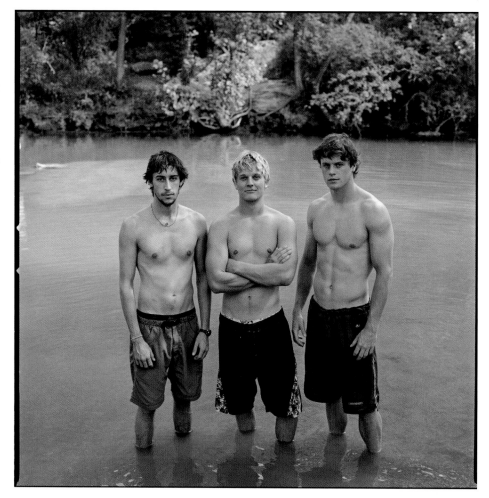

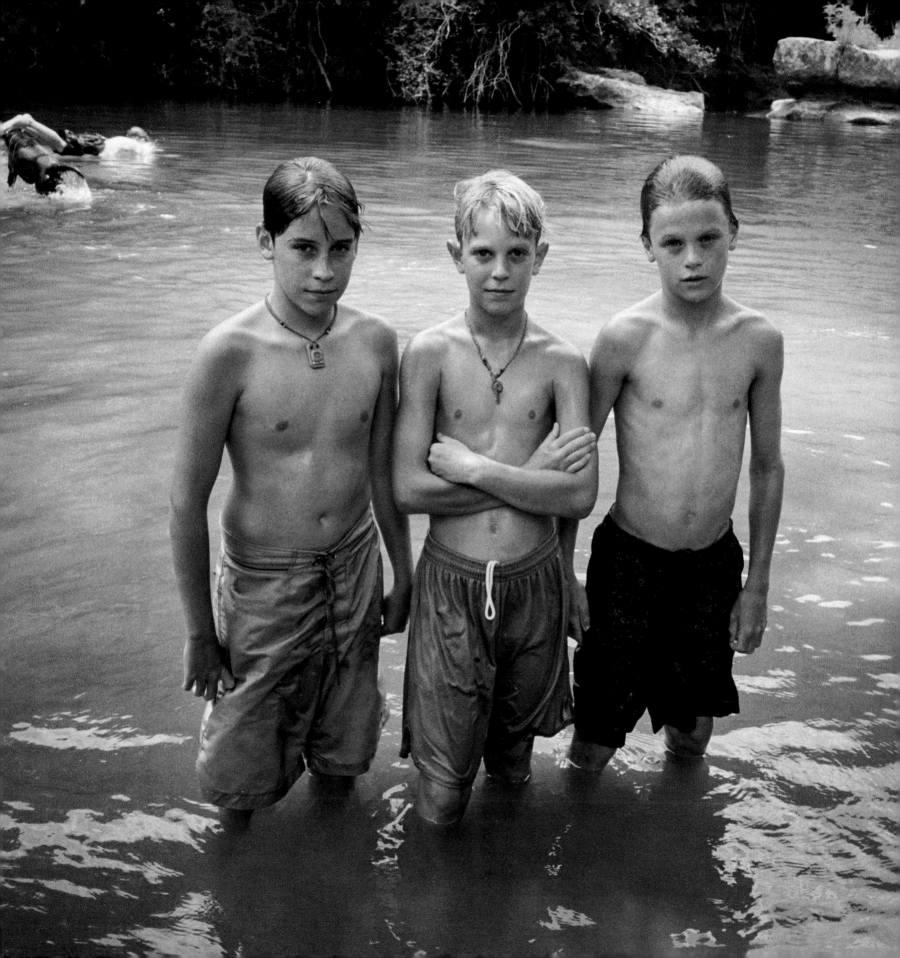

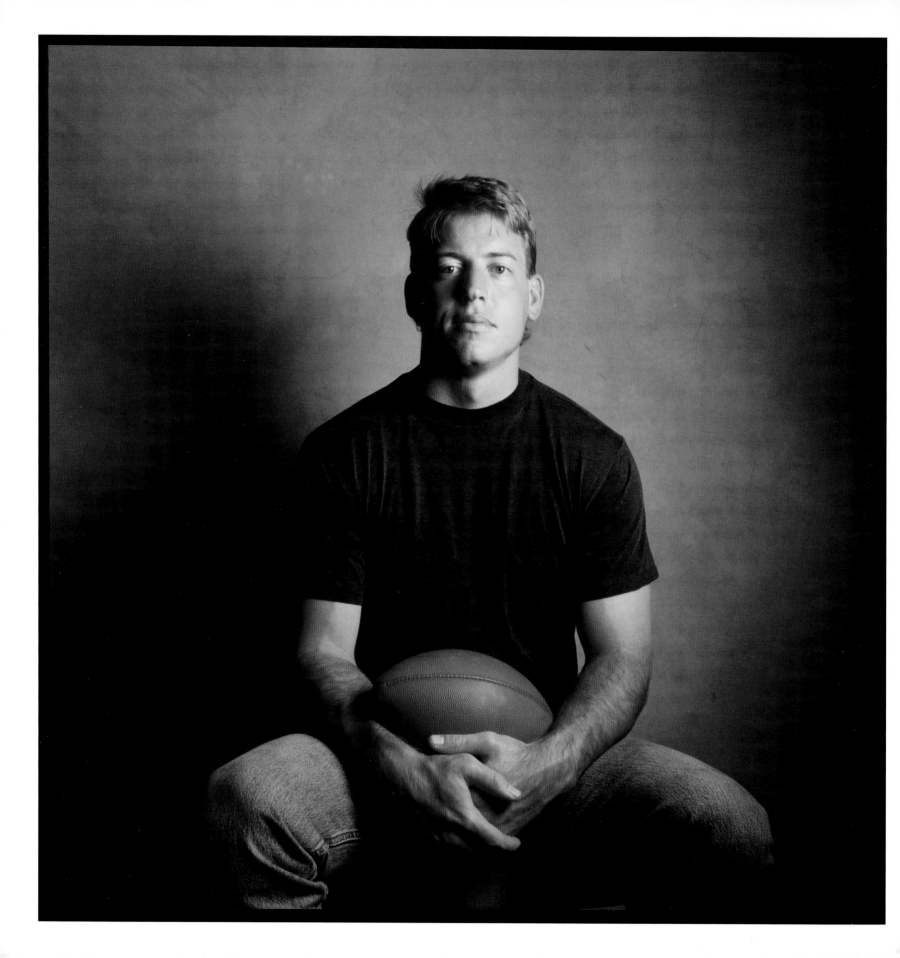

Troy Aikman

DALLAS

1993

Troy Aikman possessed a distinct talent in football: an ability to throw accurate, crisp passes and the savvy to target secondary receivers beneath defensive coverage. The six-foot-four, 220-pound quarterback earned three Super Bowl rings and completed 2,898 career passes.

Born Troy Kenneth Aikman in West Covina, California, in 1966, Aikman grew up in the suburban sprawl of Cerritos, California, but later moved to a 172-acre ranch in Henryetta, Oklahoma. After he adjusted to culture shock, he grew fond of Oklahoma—and country music—and went on to earn all-state honors at Henryetta High. He began his college football career at the University of Oklahoma—somewhat unhappily—but transferred to UCLA, where he was better able to play his game, a pro-style offense designed by coach Terry Donahue. In 1989 Aikman was the Dallas Cowboys' first draft pick; the six-year, $11 million deal was considered excessive by some. But the new quarterback was ultimately able to reverse the team's losing streak, leading the Cowboys to consecutive Super Bowl championship wins in 1992 and '93 and becoming a stellar replacement for the legendary Roger Staubach. He was selected MVP of Super Bowl XXVII in 1993. The Cowboys were victorious again in Super Bowl XXX in 1996. In 2006 Aikman was voted into the Pro Football Hall of Fame.

Aikman has said he got his determination from his father, a hard-driving pipeline construction worker and rancher.

"Part of the reason that I play the way that I play, and don't fear getting hit . . . stems from back when I was younger and seeing how hard [my father] worked and how tough he was," said Aikman, who suffered many injuries during his career. "I always wanted to prove that I was as tough as he was."

But Aikman has another side. The man who was once the highest-paid player in professional football history had a reputation for being shy and reluctant to sell himself. When asked his reaction to being chosen as one of *People* magazine's "50 Most Beautiful People," he quipped, "Well, they must not know very many people."

He has concentrated on using his image to help others. He established a permanently endowed scholarship at UCLA, where he majored in sociology. His Texas-based Troy Aikman Foundation benefits children's charities in the Dallas–Fort Worth area and funds interactive playrooms and education centers called "Aikman's End Zones" at children's hospitals in Texas and Oklahoma. He also wrote a children's book, *Things Change*, with proceeds going to the foundation.

Aikman, who retired from football in the spring of 2000, went to work as a broadcaster for FOX Sports. He has earned three Emmy nominations for his broadcast work and provided live commentary for three Super Bowls: XXXIX, XLII, and XLV.

He lives in Dallas with his two daughters. ★

Cherokee Charmers

The officers of the Waxahachie High School Cherokee Charmers, the school's performing dance squad, posed for *Life* magazine in 1989. From left to right: Susan Duke, Hope Hays, Shelley Fromm (captain), Heather McCutchen, and Michelle Rhodes. The Cherokee Charmers—still in existence, though the crew in the photo has moved on—perform at football games, pep rallies, and other special events. ★

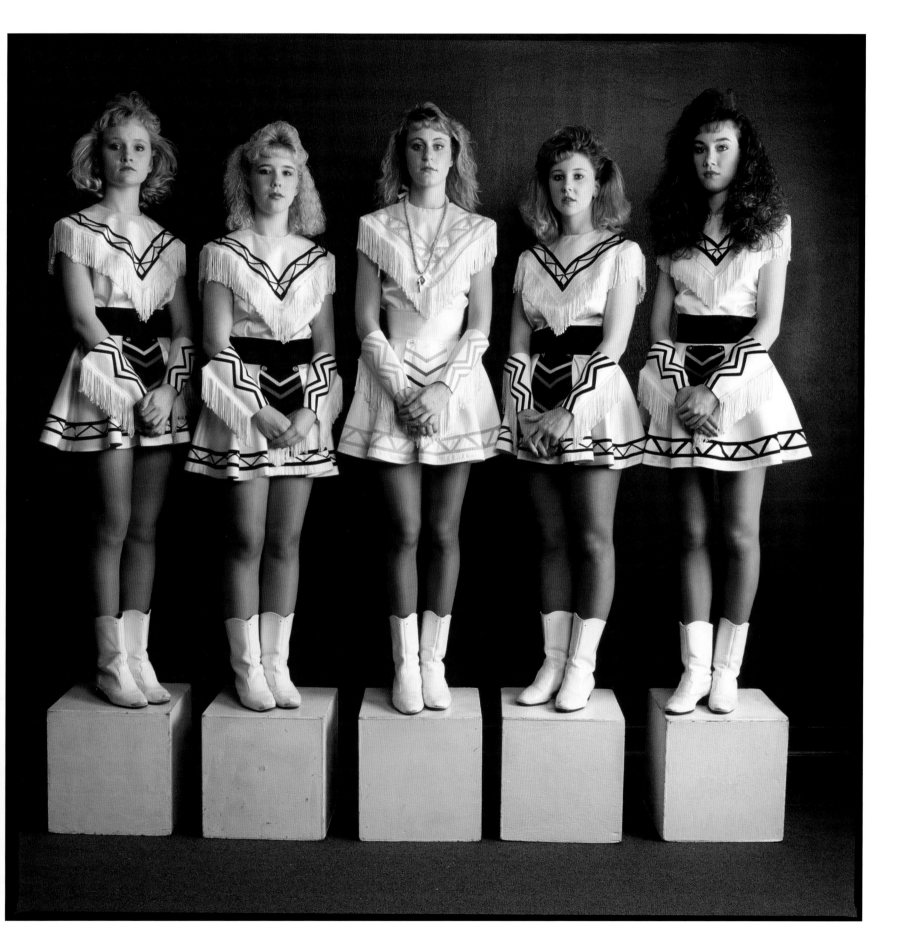

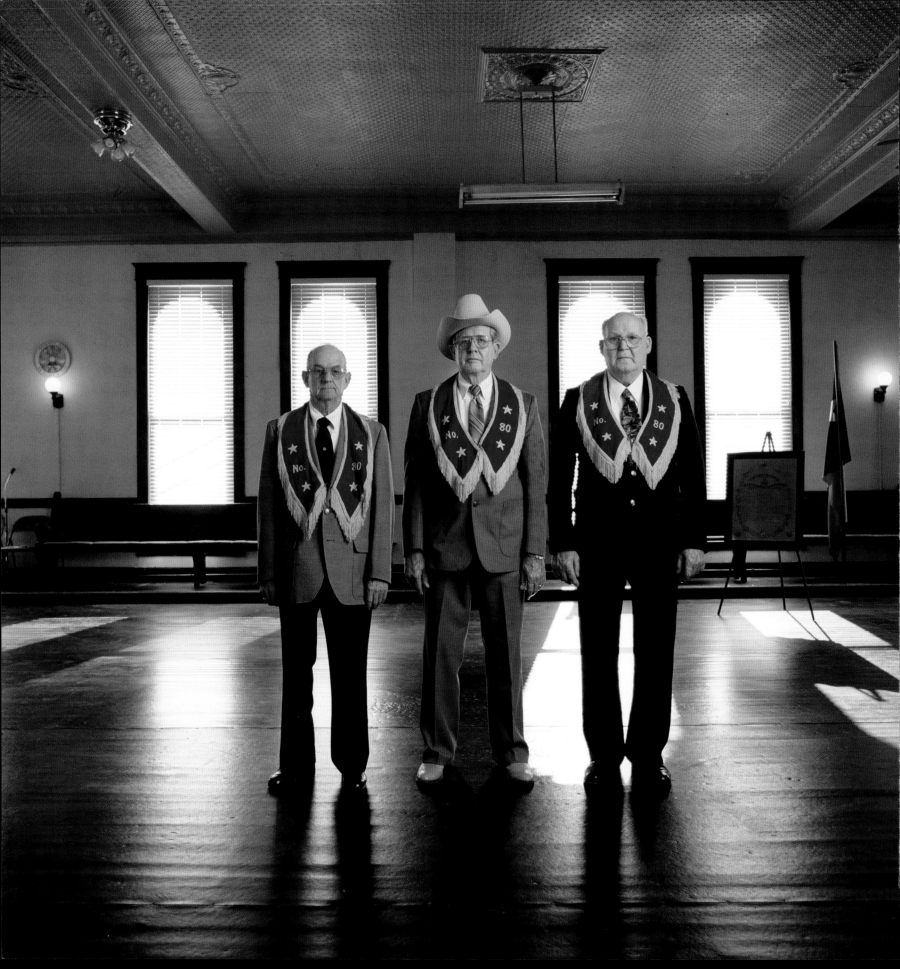

Odd Fellows

WAXAHACHIE
1998

L. W. Banks, Kels Lowry, and R. H. Chiles (left to right) were proud members and trustees of Waxahachie's Lodge No. 80 of the Independent Order of Odd Fellows, a fraternal organization that carries out charitable enterprises. The Waxahachie lodge raises money for such local concerns as the fire department, Toys for Kids, and the Waxahachie Care Center.

Chiles, a retired homebuilder, served as Noble Grand of Lodge No. 80, which was chartered July 6, 1871. Banks, like Chiles, was an Odd Fellow for more than four decades; he had a career in auto parts. And Lowry, a former postal employee, was a member for close to thirty years.

The Odd Fellows have a rich history; in fact, the organization played a key role in Texas statehood. According to legend, the term "Odd Fellows" came about in the late 1700s in England, when the country was a monarchy. Some commoners, when times were bad for their neighbors, formed an unofficial system whereby they would work together to help the unfortunate families back on their feet, whether by rebuilding a barn that had burned or putting in a new crop after a devastating season. Such helpers came to be known as "odd fellows," so named by the general population, who thought they were "an odd bunch of fellows" to behave in such a selfless and seemingly impractical fashion.

The English eventually established the Manchester Unity, an official fraternal organization dedicated to helping their fellow man. In 1819, an Englishman living in Baltimore organized a group of like-minded Englishmen there and petitioned the parent organization for permission to start an independent order in the States. Soon the Independent Order of Odd Fellows spread to other states; in 1838 a lodge was established in Houston—before Texas attained statehood—and the Lone Star Lodge No. 1 became headquarters for the development of the Republic of Texas. Notably, the Odd Fellows became the first fraternity in the States to include both men and women when it adopted the "Beautiful Rebekah Decree" in 1851.

The Odd Fellows, now a huge international nonprofit organization, have supported such causes as the World Eye Bank and the Arthritis Foundation, and they funded a chair at Johns Hopkins Hospital in Baltimore, Maryland, for research on eye disease. The organization also operates the IOOF Education Fund, which provides low-cost student loans; and it sponsors a two-week trip for deserving high-school students to New York City to visit the United Nations. To this day, the mission of the Odd Fellows remains true: to "Visit the Sick, Relieve the Distressed, Bury the Dead, Educate the Orphan, and Protect and Care for the Aged and Widowed." ★

Lady Bird Johnson

L B J R A N C H
S T O N E W A L L
1 9 8 9

Lady Bird Johnson (1912–2007) was a memorable First Lady, both during her stint in the White House and in the years afterward. She made a distinct—and literal—mark on the world. Her beautification projects, including her founding of the National Wildflower Research Center, now the Lady Bird Johnson Wildflower Center in Austin, have had a profound impact, not only aesthetically but environmentally. Thanks to her, tulips and daffodils flourish in springtime in Washington, D.C., and wildflowers embroider Texas roadsides. Her dream to encourage the planting of indigenous species has influenced individuals and environmental organizations around the world.

In a letter for the Wildflower Center, she wrote,

My hope for what lies ahead in the field of landscape design . . . is not a revolution against the use of non-natives, but a resolution to educate ourselves about what has worked for Mother Nature through the ebb and flow of time, and to put that knowledge to work in the planned landscapes that are everywhere a part of our lives. . . . Beauty in nature nourishes us and brings joy to the human spirit, it also is one of the deep needs of people everywhere.

Claudia Alta Taylor got the nickname "Lady Bird" as a little girl when one of her nursemaids pronounced her "as purty as a lady bird." She was born December 22, 1912, in Karnack, Texas, to an affluent family. Her mother, Minnie Pattillo Taylor, died when she was just five, and Lady Bird was raised by her father, Thomas Jefferson Taylor, owner of a general store, with the help of her aunt Ettie and the family servants. She had two older brothers, Tommy and Tony.

She attended the University of Texas back when women were the exception on college campuses. She earned a BA in history in 1933 and a degree in journalism the following year. She met Lyndon Baines Johnson, the future thirty-sixth president, in 1934, when he was a congressional aide. It was a quick courtship, and they were married the same year.

Lady Bird played an important role in her husband's political career. She borrowed from her inheritance to finance his first congressional campaign; and she ran his office when he served in the Navy during World War II. When he suffered a heart attack in 1955, she took care of him at the ranch.

Her challenge as First Lady was formidable: after the assassination of President John F. Kennedy, she followed Jackie Kennedy, who had set a new elegant standard in the White House. But Lady Bird established her own identity, supporting the "war on poverty" and the Head Start Program for preschool children. She began her beautification work in Washington, D.C., with her First Lady's Committee for a More Beautiful Capital.

Lady Bird and Lyndon Johnson had two children: Lynda Bird Johnson Robb and Luci Baines Johnson. Lady Bird also had seven grandchildren and eleven great-grandchildren. For years, Lady Bird kept a place in Austin, though she considered the LBJ Ranch in Stonewall, Texas, "home." She is buried there beside her husband. ★

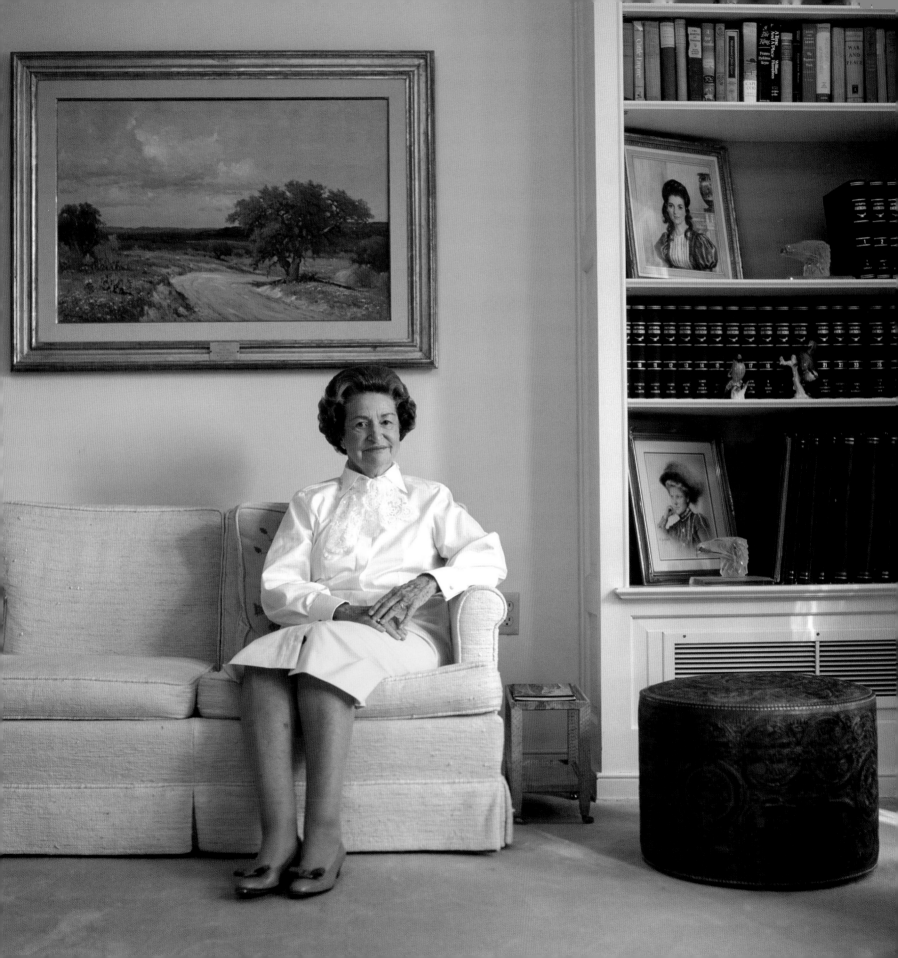

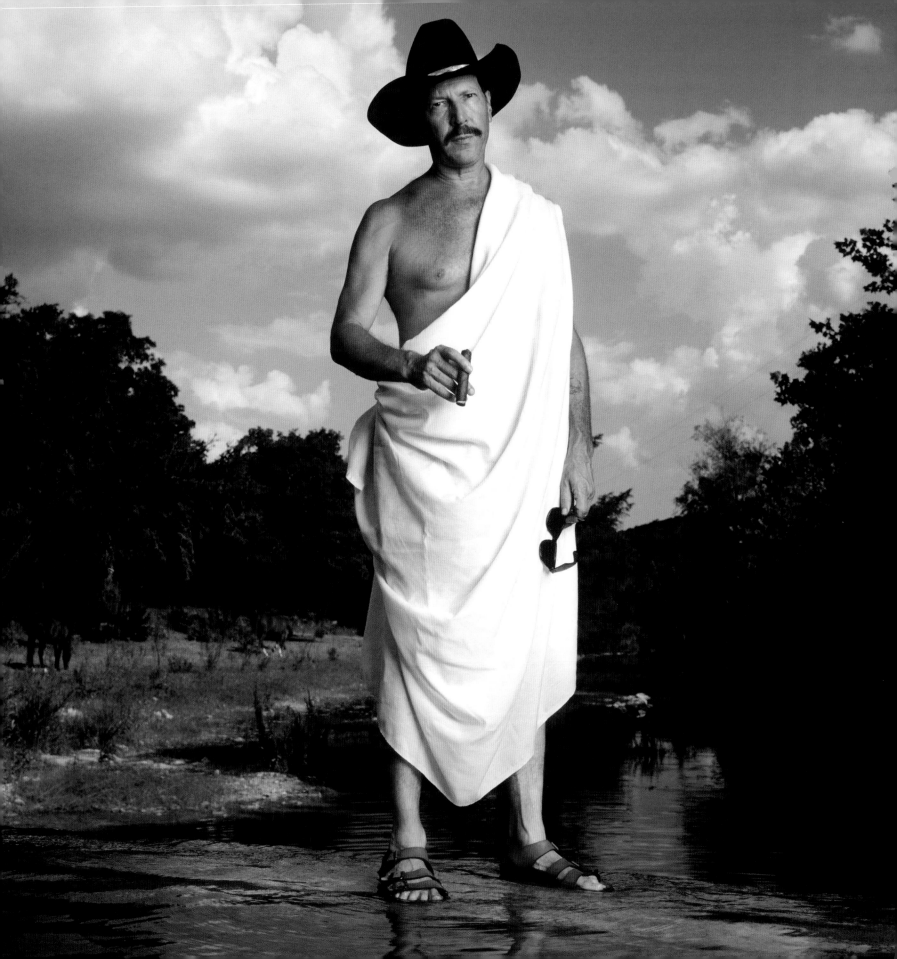

Kinky Friedman

Kinky Friedman has made a career of being an irreverent, iconoclastic, and boisterous anomaly: a Texas Jew. Born Richard Friedman on November 1, 1944, in Chicago, Friedman and his family moved to Houston when he was a year old, then moved again, dividing their time between Austin in winter and Kerrville in summer.

"I was born in Chicago, lived there a year, couldn't find work," said Friedman. "So I moved to Texas, where I haven't worked since."

Friedman—whose nickname came from his unruly, copious head of hair—has had many lives, including counselor at his family's four-hundred-acre ranch camp for children, Austin High graduate, Plan II Honors Program and psychology student at the University of Texas at Austin, Peace Corps volunteer, singer-songwriter and founder of the cult-famous Texas Jewboys band, prolific writer of mystery novels and other books, *Texas Monthly* columnist, animal advocate and founder of Utopia Animal Rescue Ranch, and independent candidate for Texas governor. He also calls himself a "professional friend of presidents," specifically, Bill Clinton and George W. Bush. "I call myself the new Billy Graham," he said. When he ran for governor, his platform included "the dewussification of Texas." Even though he lost, badly, he still calls himself "The Governor of the Heart of Texas."

Friedman uses himself and his friends as characters in his mystery novels, which recount the adventures of a musician-turned-gumshoe, fond of cigars and Jameson's whiskey, who lives on Vandam Street in Lower Manhattan and discusses his cases with his cat. "The cat said nothing" is a frequent rejoinder in his mystery books. He's also published nonfiction books, most notably *Kinky Friedman's Guide to Texas Etiquette: Or How to Get to Heaven or Hell Without Going Through Dallas–Fort Worth*, and nonmystery novels, including *Kill Two Birds & Get Stoned*, about three people trying to destroy a Starbucks.

Friedman is the son of the late S. Thomas Friedman, a former UT psychology professor, and the late Minnie Samet Friedman, a speech therapist who founded Echo Hill Ranch, "a child-centered, noncompetitive ranch camp for boys and girls six to fourteen," more than sixty years ago. It was there that Friedman cut his entertainer's teeth, performing on skit nights and "bunk song" nights. He wrote his first song, "Ol' Ben Lucas," at eleven. While in the Peace Corps in Borneo after college, Friedman continued writing songs, including the satirical "Ballad of Charles Whitman," about the tower sniper at UT. Friedman's stint with the Jewboys—a country band with a social message—took him across the country throughout the seventies, culminating in a tour with Bob Dylan's Rolling Thunder Review. Afterward, Friedman went solo; and in the mid-eighties, he put down his guitar and took up his pen, publishing his first novel, *Greenwich Killing Time*.

When he's not traveling to promote his books, Friedman—famous for his love of cats, chess, and Cuban cigars—lives in the Hill Country on the family ranch, where he spends his time writing and helping save neglected and abandoned animals for his rescue ranch, which he founded in Utopia, Texas, but which has since moved to Medina.

For his work with animals—which began, in his heart, in Chinatown, New York, when he rescued Cuddles, a kitten abandoned in a shoebox—he enlisted the support of many famous and not-so-famous friends, who contributed money, time, land, and love. An excerpt from the eulogy he wrote for Cuddles, who died in 1993, reveals Kinky's more sentimental side: "They say when you die and go to heaven all the dogs and cats you've ever had in your life come running to meet you." ★

Ben Jack Riley & Flossie Lee Riley

ALBANY

2002

B en Jack Riley, who posed with his mother, Flossie Lee Riley, was delivered at home by Doc Harrell in Throckmorton County, Texas, in 1927. As sheriff of neighboring Shackleford County for twenty years, he cut a handsome figure in his signature white Stetson and gun and holster; everyone knew who he was.

"He was the good guy, all right," said Betty Jo, his wife of sixty-seven years.

Born and raised as a rancher, Riley took a break from the cowboy life to run for sheriff in 1972 after his eleven-year-old son, one of five children, died after being kicked in the neck by a horse. Losing a child, he said, "just does something to you," and he felt compelled to make a change. He won the election and ended up keeping the job until 1992.

"To me, it was one of the greatest things I ever did," said Riley, who as a youth worked alongside his brothers for fifty cents a day cutting prickly pear cacti on ranches and burning off the stickers so they could feed the fruit to the cattle.

> You make a lot of friends sheriffin'. I knew most of the 254 sheriffs in the state of Texas. All I had to do to get help was call one of them and say, "This is Ben Jack Riley and I'm the sheriff of Shackleford County and I got a little boy runnin'." And they'd call back in a little while and say, "Ben Jack, we got him. You can come on down and get him."

Riley says his experience as an Air Force MP in Japan after World War II helped prepare him as a lawman. As sheriff, he dealt with eleven murders over twenty years and a number of other crimes. Instead of spending his time "running radar," he "just enjoyed helping people." When a local oilman's home was burglarized, Riley went to work, using his myriad contacts to track down the thieves.

> It was the three Cromwell brothers who did it. They had a brother-in-law who worked cleaning the oilman's office. We found all his stuff in Portland, Oregon—mostly guns and expensive Indian blankets he had on his floors and hanging on his walls. The only thing we didn't get back was a nineteen-inch color TV and maybe a bottle of whiskey that the robbers drank while they were stealin'.

At seventy-six, Riley was still a cowboy. After spending his early life working on various ranches in the area—including a thirty-two-year stint with the Green family, "good people"—he had come full circle and moved back to town.

"You don't get ranchin' out of your blood," he said. "I built some horse corrals in town and I still cowboy a little—help people brand their calves. But now I'm gettin' to where I follow the herd, do the drag," which, he explained, means "driving the cattle from behind, in the dust," while the younger fellows lead the herd.

At eighty-six, Riley admitted to being mostly retired, living peacefully with Betty Jo. Even so, he said, he still "messes with horses" every now and then. ★

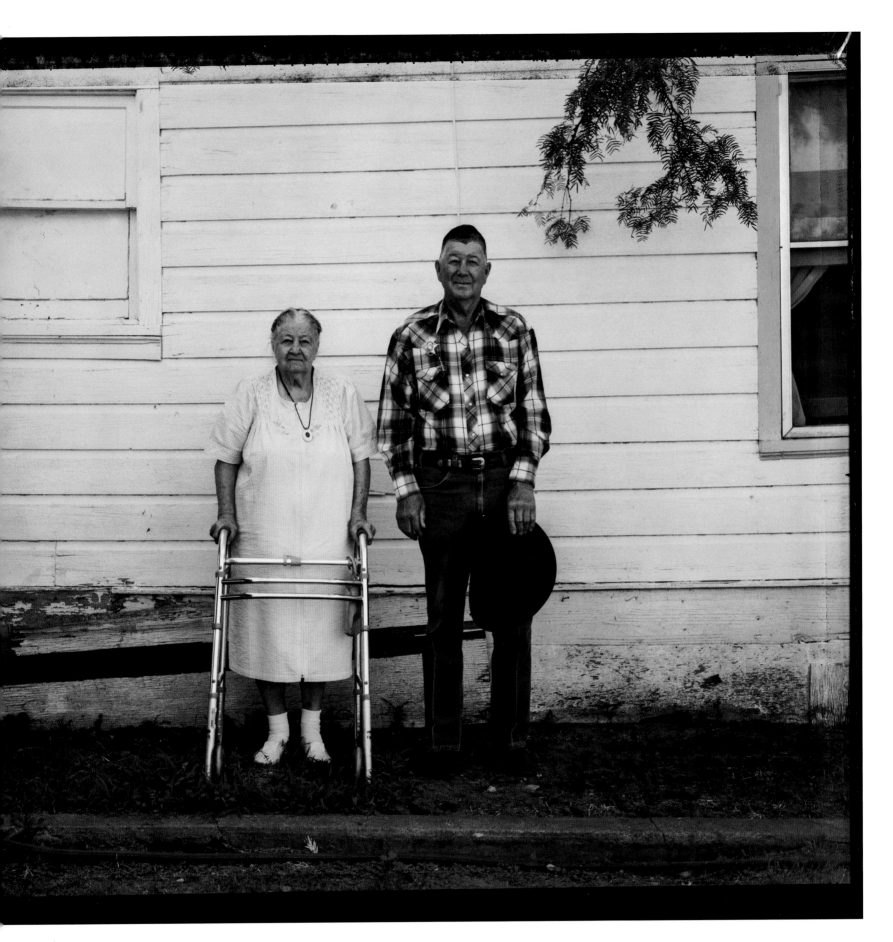

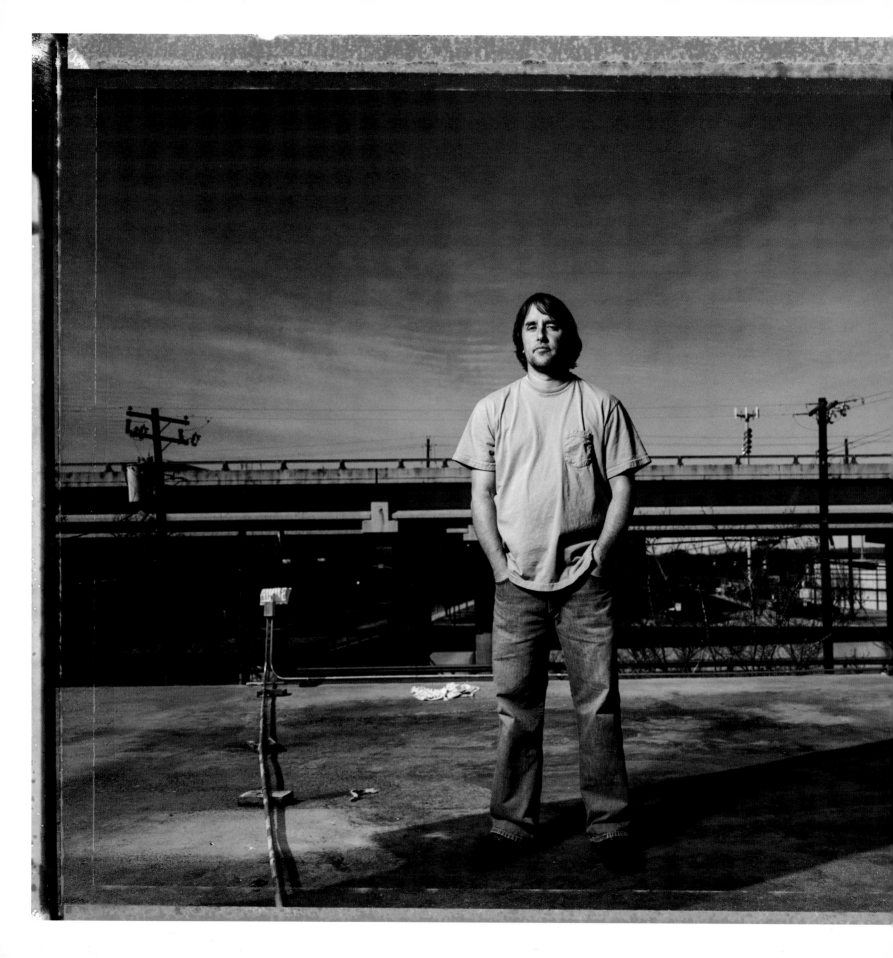

Richard Linklater

AUSTIN
2006

Self-taught writer and film director Richard Linklater has developed a reputation, however accurate, for being a spokesman for certain generations and places. Although a Baby Boomer himself, Linklater is known for capturing the aimless, quasi-intellectual angst of Generation X, the post-Boomer cohort, in such films as *Slacker*.

"Most of us are losers most of the time, if you think about it," said Linklater, whose movies follow a pattern: they often take place in a single day, are "talky," and focus on young people and what Linklater calls "the youth continuum rebellion." They are also often set in Texas. *Bernie*, a portrait of a small town and its charismatic funeral director, is set in Carthage, Texas, and features interviews with real townspeople.

With *Slacker*, Linklater is also partially responsible for enhancing Austin's "weird" reputation.

The plotless film focuses on a day in the life of various "Gen X" Austin misfits who discuss things like political marginalization and social exclusion. Linklater himself plays a garrulous taxi passenger. His other claims to fame include introducing Texan actor Matthew McConaughey to the film world in *Dazed and Confused*—a comedy focusing on various groups of Austin teenagers on the last day of school in the summer of '76—and capitalizing on actor Ethan Hawke's coming of age, and even middle age, in *Before Sunrise*, *Before Sunset*, and *Before Midnight*.

Linklater, a Houston native, dropped out of Sam Houston State University and set off to work on an oil rig in the Gulf of Mexico. While there, he read a lot of literature; back on land, his interest in telling stories through film grew, and he finally saved up enough money working on the rig to buy a Super-8 camera, a projector, and some editing gear. Thus equipped, he moved to Austin.

In the mid-eighties, Linklater enrolled at Austin Community College and studied film. He founded the Austin Film Society and set about learning his craft. By the early nineties, he was in business. He credits the film *Raging Bull* with changing his life and giving him inspiration.

"Each film is like doing a thesis," he said.

Linklater was inducted into the Texas Film Hall of Fame in 2007. ★

Ran
Horn

R an Horn of Van Horn hadn't lopped off his ear, but otherwise the artist was living up to his image as the "Van Gogh of Van Horn." Randell Horn owned Van Gogh in Van Horn, an art gallery and used bookstore where he sold his own Van Gogh imitations and offered art lessons—for a mere five dollars.

"I want to redo all of Vincent's paintings and maybe come up with an original idea," said Horn, who paints all day, eschewing both phone and computer, "then, if there *is* a beyond, have a good laugh with Mr. Van Gogh."

Horn—a former Baptist preacher, prison guard, and mail carrier—was born in "flat, dry, dusty Odessa," where his father worked in the rich Permian Basin oil fields while his mother raised him and his seven sisters. He left Texas and worked as a preacher in frigid Duluth, Minnesota, for several years before moving back. He chose Van Horn, where he could be "Ran Horn of Van Horn" and support his family as an artist—more or less.

"I will mow lawns and sweep parking lots to make sure bills are paid," he said. "I'm trying to be like Vincent, Leo Tolstoy, and Jesus, who identified with the poor. Ephesians 4:28 sums it up quite nicely: '[We] must work, doing something useful with [our] own hands, that [we] may have something to share with those in need.'"

Horn is pictured just off Main Street in Van Horn with his Chihuahua, Lilly, named after Lillian Gish, the silent-film star. ★

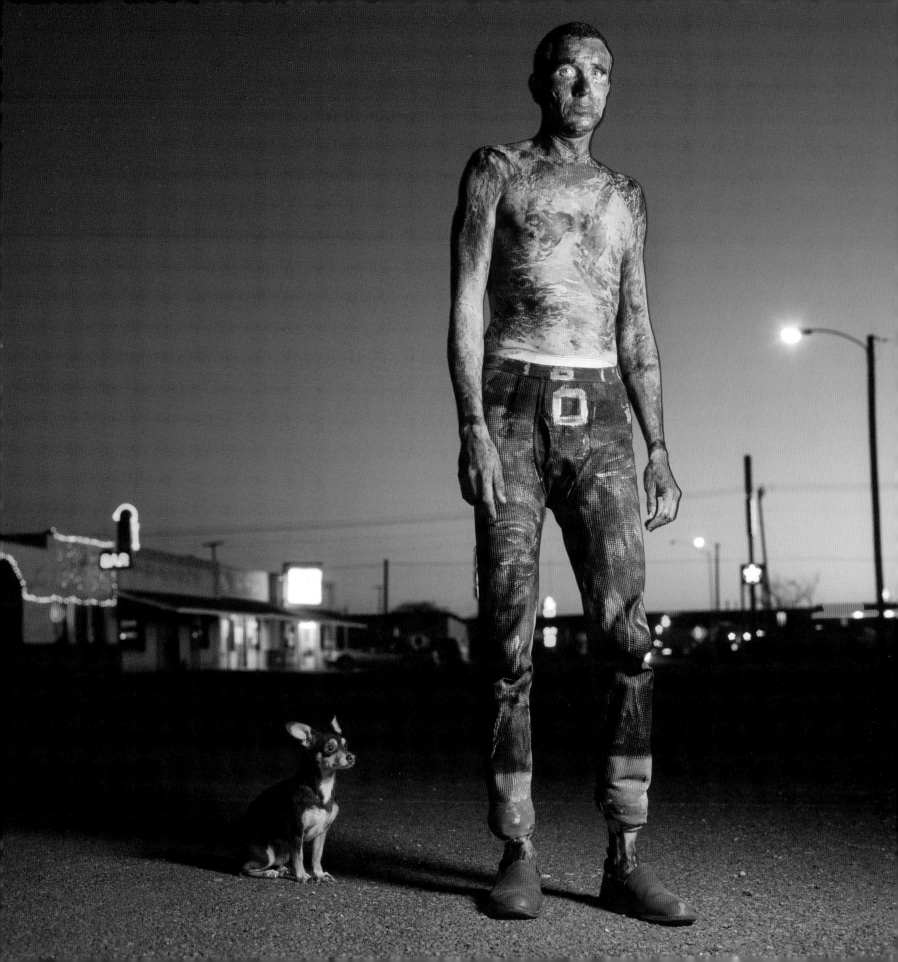

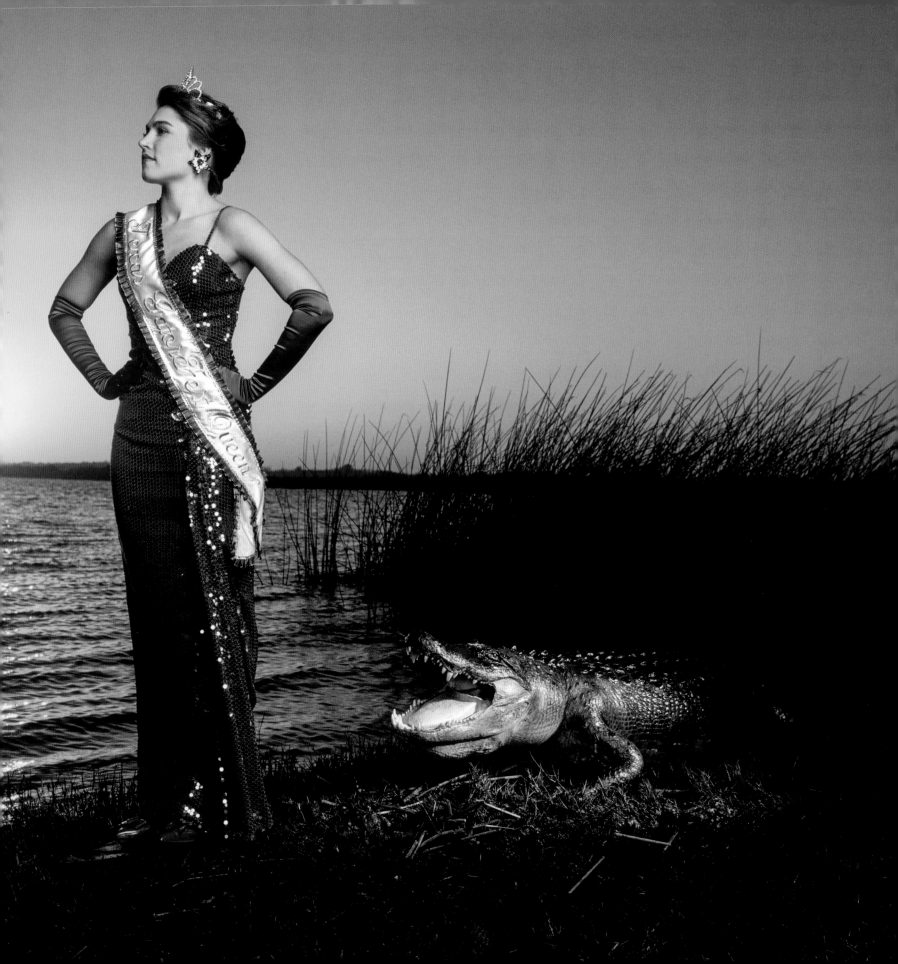

Shannon Perry

ANAHUAC
1989

Shannon Perry, of Anahuac, Texas, was crowned Gatorfest Queen—the first ever—in 1989. The contest is devoted to finding a "complete young lady" who embodies the spirit of the small town and the annual festival.

Gatorfest, held in September the weekend after Labor Day, was established in '89 as an Anahuac Chamber of Commerce fundraiser to celebrate the reopening of the alligator harvesting season in Texas—after the reptiles were removed from the endangered species list. The festival is an action-packed weekend featuring contests for the largest alligator hides, live music and entertainment, street dancing, and the crowning of the Gatorfest Queen—as well as the younger Gatorfest Princess and the even younger Little Gatorfest King and Queen. There's an educational tent hosting a live baby alligator and experts expounding on alligator minutiae. And there's plenty of good food, including, of course, alligator entrees of every variety: alligator-on-a-stick, grilled alligator steak, alligator etouffee, and alligator gumbo.

After Perry moved on, her pint-sized niece Erynne followed in her aunt's footsteps: in 2002, at the age of three, she won first runner-up for Little Gatorfest Queen.

Meanwhile, Perry buckled down to real life: after competing in the Miss Texas Pageant in 1993, she went on to attend Sam Houston and Lamar Universities and then moved to Houston, where she worked happily for a large insurance company.

"It's really rewarding to me," she said of her job. "But people still remember me as the Gator Queen. I'll always be remembered as the very first one." ★

Beyoncé Knowles

HOUSTON

2000

Beyoncé Knowles was photographed for the May 2000 issue of *Texas Monthly*. This was an outtake. The picture that was published was of Destiny's Child, the Houston-based R & B vocal group, which at the time included Farrah Franklin, Kelly Rowland, Michelle Williams, and Knowles. The original members—among them lead singer Knowles and Rowland—began singing together when they were children. They had their first number-one single with "No, No, No" when their average age was sweet sixteen; the song went platinum and put the group on the musical map.

Though she didn't invent the term, Knowles catapulted "bootylicious" into the pop lexicon when the group's "Bootylicious" single from their number-one *Survivor* album—along with the video of the song, featuring a cameo by Stevie Nicks—was released. "It's about having confidence and feeling good about your mojo and whatever you have," said Knowles, who says she came up with the song after listening to a Nicks CD on an airplane. The term was also used to describe an especially attractive member of the opposite sex or a particularly delicious food item.

Destiny's Child also had a serious, philanthropic side. The group established the Survivor Foundation, which donated a good deal of money to AIDS Foundation Houston (AFH), and the singers became public advocates of HIV/AIDS education and social services. In addition, the group donated three hundred of their signature dolls to AFH's Camp Hope, a camp for children living with HIV/AIDS.

Destiny's Child has since disbanded, and Knowles, better known simply as Beyoncé, has been a solo performer for many years. She wowed millions of viewers with her spectacular Super Bowl XLVII Halftime Show, which included a Destiny's Child reunion; and she won her seventeenth Grammy, for Best Traditional R & B Performance, for "Love on Top." She remains an iconic artist, actress, philanthropist, and businesswoman. She is married to the rap star Jay-Z, aka Shawn Carter, and they are the proud parents of daughter Blue Ivy Carter, their first child, born in 2012. ★

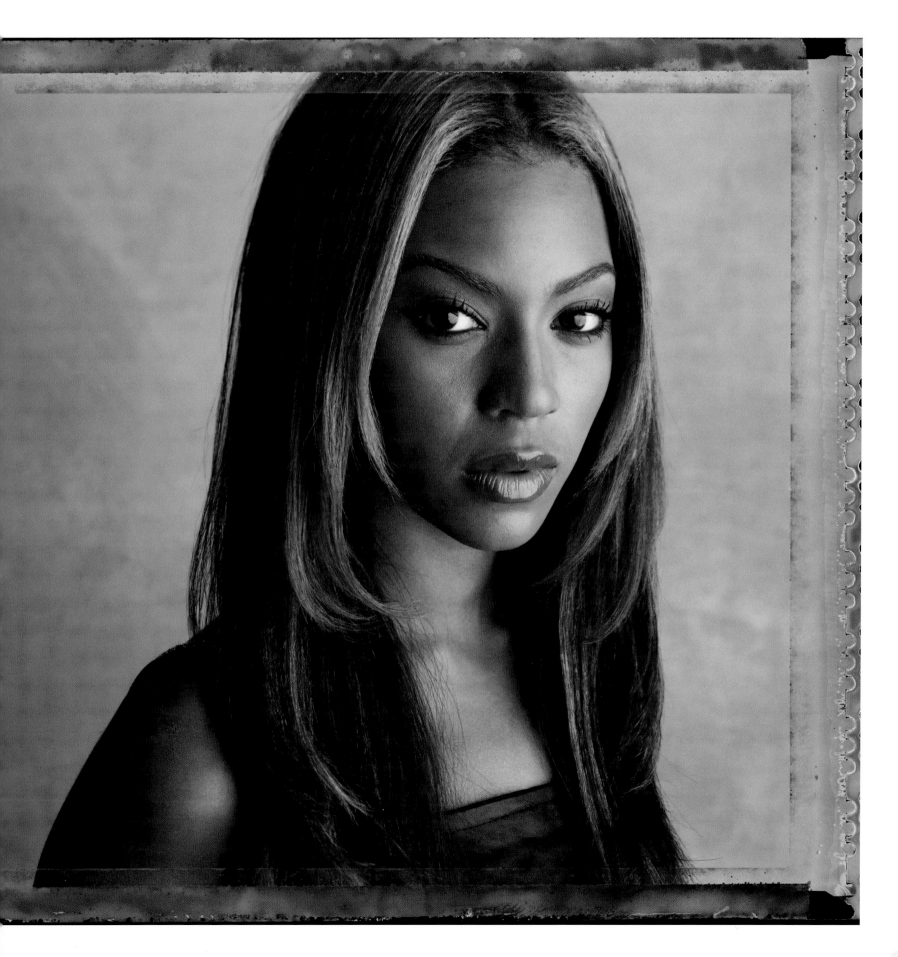

Los Lonely Boys

AUSTIN

2014

History is repeating itself with Los Lonely Boys, three brothers from San Angelo, Texas, who got their musical start playing with their father, Ringo Garza Sr., of the Falcones, a sibling band active during the '70s and '80s. A generation later, Los Lonely Boys has gained a loyal following playing a versatile and dynamic mix of rock, conjunto, Tejano, blues, and Tex-Mex—what they call "Texican." "We always use the phrase Texican style, or Texican rock 'n' roll, to introduce the rest of the world to what we are and where we are from," said Jojo Garza. "It's because we are very proud to be Texans, but we are Mexican American."

The boys began playing and singing with their father after Ringo Garza Sr. left the Falcones and went solo. The family moved to Nashville in the 1990s, and the boys continued to back their dad until they decided to peel off and become their own entity. The three brothers—guitarist Henry, bassist Jojo, and drummer Ringo Jr.—eventually moved back to Texas and released their double-platinum album *Los Lonely Boys* in 2004. They recorded the LP at Willie Nelson's Pedernales studio near Austin, with Willie himself on hand as mentor. The album's lead single, "Heaven," became a hit and won the band a Grammy in 2005 for Best Pop Performance. More recently, Los Lonely Boys won Best Rock Band at the 2010 Austin Music Awards.

Los Lonely Boys has weathered some difficulties over the years: Jojo developed lesions on his vocal chords while the band was on tour in 2010, and Henry fell off the stage during a gig in 2013 and seriously injured his back. After both incidents, the band had to take a break—not easy for a group that spends the bulk of its time touring. A testament to their popularity on the road, some 350,000 fans flocked to their 200 shows during the band's 2009–2010 tour.

Although the band travels much of the time, the members remain passionate about their Texas roots and about championing local causes. Los Lonely Boys recorded the single "Solid Ground," written with the poet Nancy Ghoston, about the Family Justice Center, which provides services to victims of domestic violence. The song won the Austin-based CTK Foundation's Heart and Soul grant in 2009.

"Music is something special to us here in Texas," said Jojo. "We learn to appreciate the roots. . . . Many very famous people have come from Texas, musically, as well as actors and actresses. It's like a breeding ground for awesomeness. Our love for Texas is apparent in everything we do. From how we play music, to how we comb our hair, to how we dress, to what we eat, how we respect folks."

Jojo says that while there are many special places in Texas—"the best-lookin' state across the whole globe"—the band loves one part the most: "Basically we have it all here. . . . But for Los Lonely Boys, we love West Texas! This is where you can see the fields and crossroads as well as some Hill Country. It's a dry heat out this way, and if you aren't accustomed to it, you just don't know how to appreciate it." ★

George Strait

PEARSALL
1991

More than four decades ago, George Strait was on the verge of abandoning his dream of a music career and signing on instead with a company that designed cattle pens. But Norma, his wife, intervened: she encouraged him to turn down the job and give music another try. After a few false starts, Strait got his break in 1981 when he recorded a hit single, "Unwound," which led, finally, to a record deal with MCA.

Strait sings country music the way it's supposed to be sung—with conviction, vulnerability, and poignant artistry. His clear, powerful voice delves into pain and heartache with such compelling vocal phrasing and resonant lyricism that mainstream pop radio stations have changed their tune. As one of radio's most played artists, his influence has increased radio play of other more traditional, less pop-influenced country music songs.

Strait, born on May 18, 1952, in Poteet, Texas, the "Strawberry Capital of the World," is considered the class act of country music. Handsome, courteous, and refined, he has earned a reputation as a gentleman and country artist of the highest order. The singer, whose inspirations include country legends Bob Wills and Merle Haggard, has sold over sixty million records, with nearly three dozen albums going platinum or multiplatinum. At one time, he had the most number-one singles of any artist in history, including Elvis. He has earned countless music and entertainment awards, and in 2006 he was inducted into the Country Music Hall of Fame.

Strait grew up near Poteet on his family's two-thousand-acre cattle ranch in Pearsall, Texas, near the Frio River; the ranch has been in the family for a century. He studied agriculture briefly at Southwest Texas State University, and then eloped with his high school sweetheart, Norma Voss, the woman to whom he is still married. Shortly thereafter, he joined the Army, planning to resume his education—and the ranching life—when he returned. It was during his stint in Hawaii, where he was stationed, that he began his music career: he bought a cheap guitar and a Hank Williams songbook and auditioned for lead singer in an Army-sponsored band. Rambling Country, which was formed by Strait's base commander to entertain the troops, immediately began to garner attention.

When he returned to Texas, Strait—a genuine cowboy who learned to ride horses and rope cows before he handled a guitar—reenrolled at Southwest Texas State on the GI Bill, eventually earning his agriculture degree. He also joined a band, Ace in the Hole, which developed a passionate local following. To supplement his music income, he worked as a ranch manager. It was on that ranch near San Marcos that his life changed forever: he heard his song, "Unwound," playing on the radio.

★

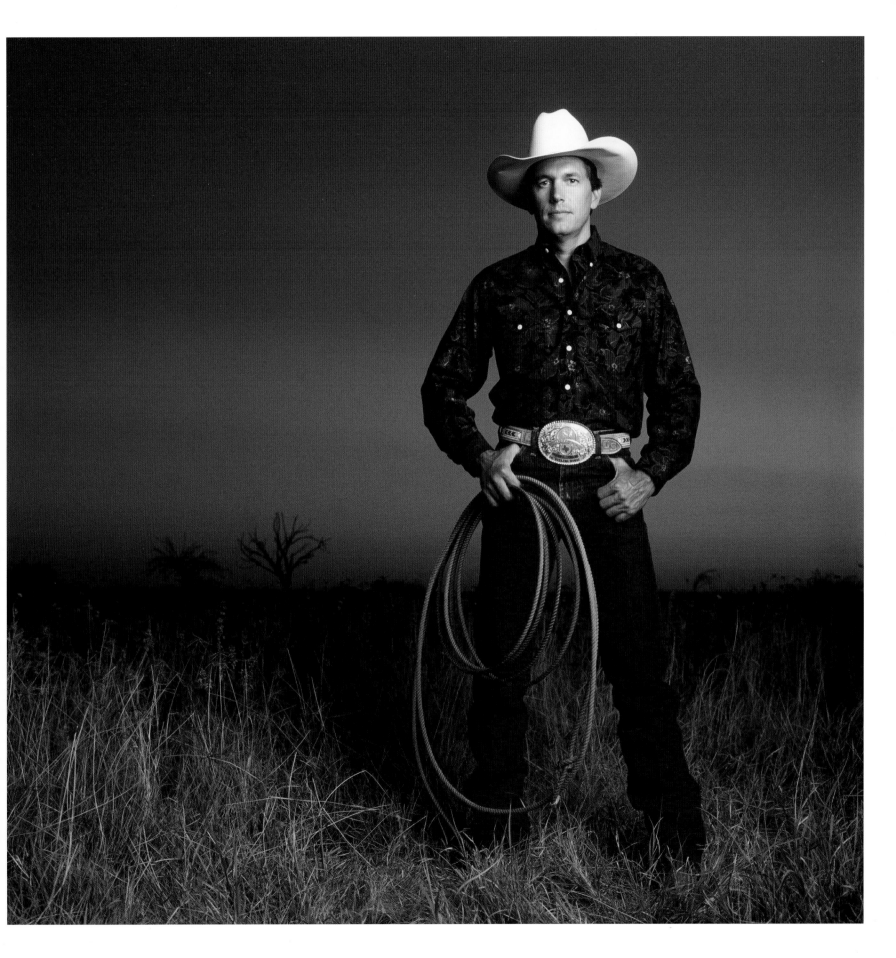

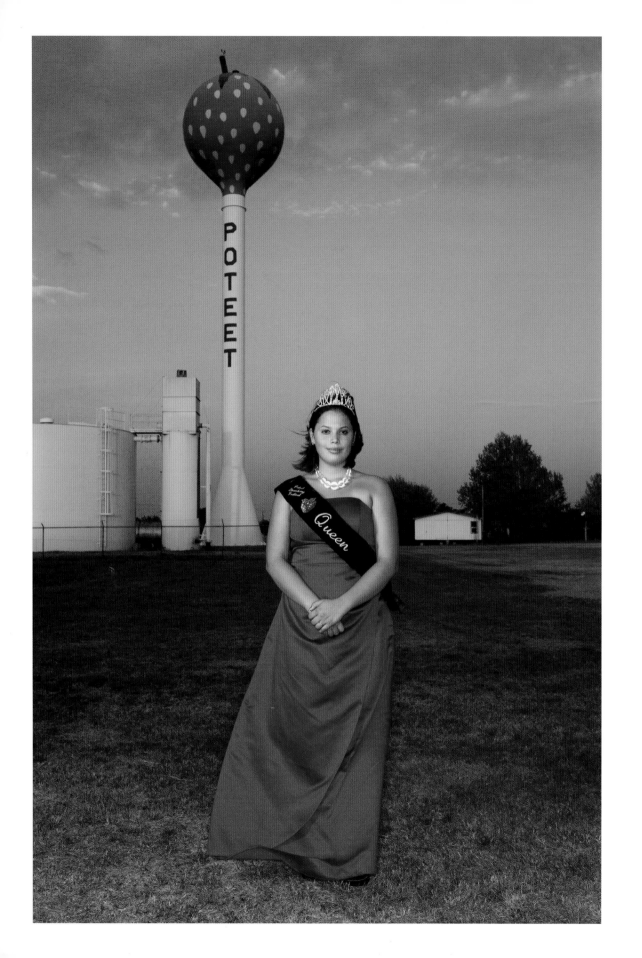

Nikkiah Guerra

Nikkiah Guerra was just seventeen when she reigned as Strawberry Queen in Poteet, Texas. Poteet, distinguished by a seven-foot-tall, 1,600-pound concrete strawberry, is known as the "Strawberry Capital of America." Its Strawberry Festival is one of the largest and oldest agricultural festivals in Texas, an annual event held in April that attracts over one hundred thousand visitors. The weekend features live music and other entertainment, food, dancing, crafts, and rodeo events. Local growers—with a reputation for producing some of the finest, sweetest berries in the country—have participated since 1948.

Since her days as Strawberry Queen, Guerra has started on her life path, an intense journey of helping others, particularly children. Guerra is a Licensed Vocational Nurse working in home health, where she cares for seriously ill children who have had tracheotomies or who are on feeding tubes and ventilators.

"It is a blessing every day that I can make a difference in these children's lives," said Guerra. "I love it!"

Guerra is also attending community college, where she is on track to earn her Registered Nurse credentials. Once she finishes school and becomes a full-fledged nurse, she wants to work in the Neonatal Intensive Care Unit, caring for premature babies. She said the experience of being Strawberry Queen helped set the stage for a fulfilling future.

"Being Strawberry Queen was a small-town dream come true," Guerra said. "I received a scholarship that paid for some of my nursing school—not all, but a nice chunk. As queen I gained confidence in myself and acquired more self-awareness. I wanted to become a positive role model for others."

Guerra was born in San Antonio, and she and her two older brothers were raised by a single mother in Poteet, a town of just over 3,200. She spent a year living in Dallas during her junior year of high school—and she has done a little traveling—but she said she is always glad to come home to Poteet.

> I love the feeling of home. I love Texas and everything this state stands for. I am from here and have roots here. I love driving home from work and seeing beautiful trees, cows, and dirt in my everyday path. I am country to the bone. I like the unusual weather here and also that Texas has a little piece of every kind of geography.

Guerra and her husband, Ricky, are holding off on having a family while she moves forward in her career. "There's an abundance of folks who are starving physically and spiritually. I need to do my part to help the ones here," Guerra said. "I want to work with preemies because I could see miracles unfold every moment. All the odds are against a preemie living, but by grace they survive."

She said there is "nothing like knowing this life is temporary and I have to make today count." ★

Obie Satterwhite

LULING

1998

Obie Satterwhite (1916–1999) is sorely missed in his hometown. Known as the "Number One Sports Fan of Luling," Satterwhite rarely missed a football or baseball game at Luling High School. At football games, he could be found in the end zone, waiting to cheer for his team's touchdown, or out on the field, performing with the cheerleaders. At baseball games, it was a tradition for Satterwhite—a catcher in his youth— to throw out the first ball. And he was a fixture at pep rallies.

"They looked for Mr. Obie to cheer," said Satterwhite's daughter, Ada Johnson. "He was known for it."

Before he retired, Satterwhite worked at Davis Food Market, where he did the butchering and barbecuing and became famous for his homemade sausage. Later, he worked at H-E-B.

"He sang or whistled while he worked," said Johnson, who directed "Brother Satterwhite" in the choir at Friendship Baptist Church, where she played organ and piano. "He even sang in his sleep. My daddy was one of those rare people who truly loved everybody. He always said, 'God loves everyone and I love 'em, too.'" ★

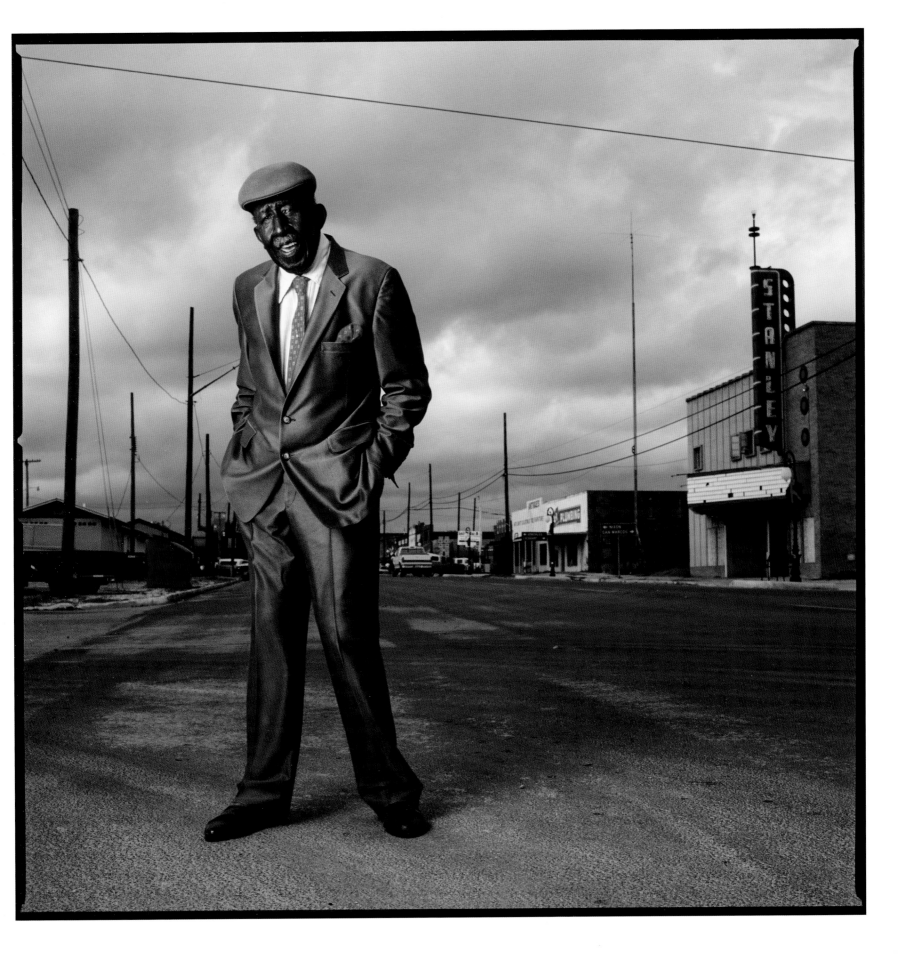

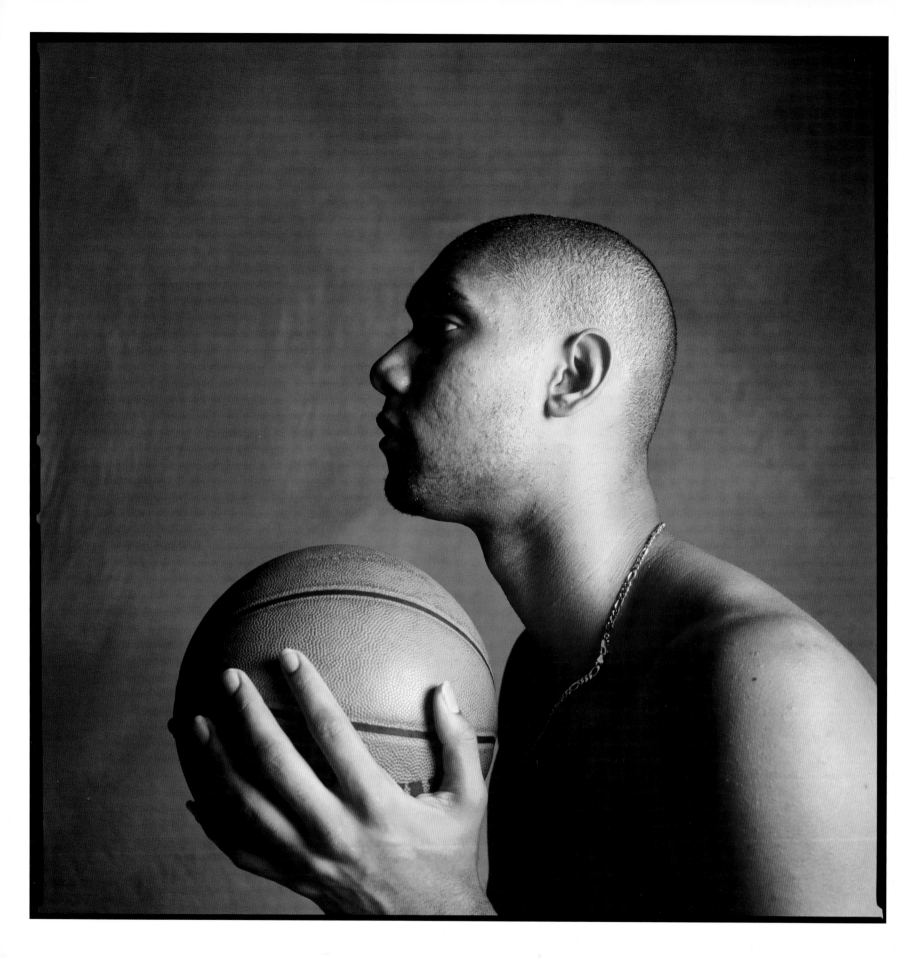

Tim Duncan

SAN ANTONIO

1999

Tim Duncan is an imposing human being: he stands seven feet tall and weighs 260 pounds. Yet the Saint Croix, Virgin Islands, native—who in 1999 led the San Antonio Spurs to their first NBA title and was named MVP in the finals—admits to being afraid of heights and sharks.

Unlike many professional basketball players, Duncan is a college graduate, having attended the prestigious Wake Forest University. It is not surprising that he earned his degree in psychology, considering he's known for his impassive "game face" and for being, in one sportswriter's words, "the coolest player on the planet." Yet he started his basketball career relatively late, swimming competitively until he switched sports in the ninth grade.

Duncan has remained loyal to Texas and the Spurs, even in the face of an extraordinary offer from the Orlando Magic after his spectacular '99 season. He likes his Texas life and feels especially comfortable with the Spurs, for whom he played power forward for years next to David Robinson's center. The two were dubbed the most effective "Twin Towers" in NBA history.

Besides that, San Antonio depends on him. In 2001 he won the NBA Home Team Community Service Award. Duncan gives away twenty-five Spurs tickets to each home game, donates computers to local schools, and reads to schoolchildren. To honor his mother, who died of breast cancer when he was fourteen, Duncan hosts the Bowling for Dollar$ Charity Bowl-a-Thon, which benefits various cancer-related charities and is one of many initiatives sponsored by the Tim Duncan Foundation. The organization funds nonprofits in the areas of education, health awareness, and research, as well as youth sports and recreation.

Duncan, known for wearing his practice shorts backwards, has been a four-time NBA champion, a two-time MVP, and an Olympic medalist. ★

Bill
Cauble

Bill Cauble—cowboy, chef, artist—was born in 1938 in the prehospital days of Albany, Texas, at the home of his grandmother, Jimmie Bizzell. At the age of one, he moved with his family out to Cook Ranch—just two ranches over from where he works now, at the legendary Lambshead Ranch. His father worked for the oil company Roeser & Pendleton on Cook Field, one of the biggest oil fields in Texas at the time.

The family raised their own milk cows, hogs, and chickens, and Cauble and his three younger brothers learned to take care of themselves and their home at an early age.

"Like all boys, we ran wild in the country," said Cauble, who published *Barbecue, Biscuits, and Beans*, a unique cookbook featuring authentic chuck wagon cooking, with fellow cowboy Clifford Teinert. "With four boys, my mother taught me early how to cook. We washed dishes, made our beds, and cleaned our rooms every day before we left for school. I raised three daughters and not a one of them would do that."

Cauble attended Nancy Smith Elementary School and Albany High, then headed out to far West Texas and New Mexico, where he worked the oil fields. After another oil field stint back in Albany, Cauble—who had always loved to draw—spent the next several years pursuing a career as an artist, working with a different kind of oil; he worked for an art dealer in Fort Worth, producing some 1,700 landscapes. His most lucrative years as an artist followed, when he was commissioned by big oil companies to make large-canvas paintings of oil rigs. Cauble worked in oil-rich areas like Dallas, Midland, Odessa, and Brackenridge, Texas, as well as Tulsa and Oklahoma City. His paintings graced the walls of the oil companies' corporate offices. He also spent some time mastering the art of bronze sculpture, an expensive process that entails sculpting a figure in wax or clay, then taking it to a foundry to cast it in bronze.

"I work at something until I can do it, then I pick something else," said Cauble, who continued to alternate between art and oil field work. "I'm always looking for something to do."

Cauble met his second wife, Doris, when he was working in Pittsburgh, Tennessee, as a partner in some drilling rigs. But when the bottom fell out of the business in the mid-eighties, Cauble returned home to Albany, where he hired on with Watt Matthews at Lambshead Ranch. He's been there ever since, working the ranch and making a new name for himself—this time as a premier chuck wagon cook and preservationist of authentic chuck wagons, equipment, and methods. His catering company, Western Wagons, cooks for gatherings across Texas and at the National Cowboy and Western Heritage Museum in Oklahoma City.

"When people ask me where I'm from, I say '*West* Texas,'" said Cauble, a fifth-generation Texan. "It's my part of the country. It's a hard land, but it's home." ★

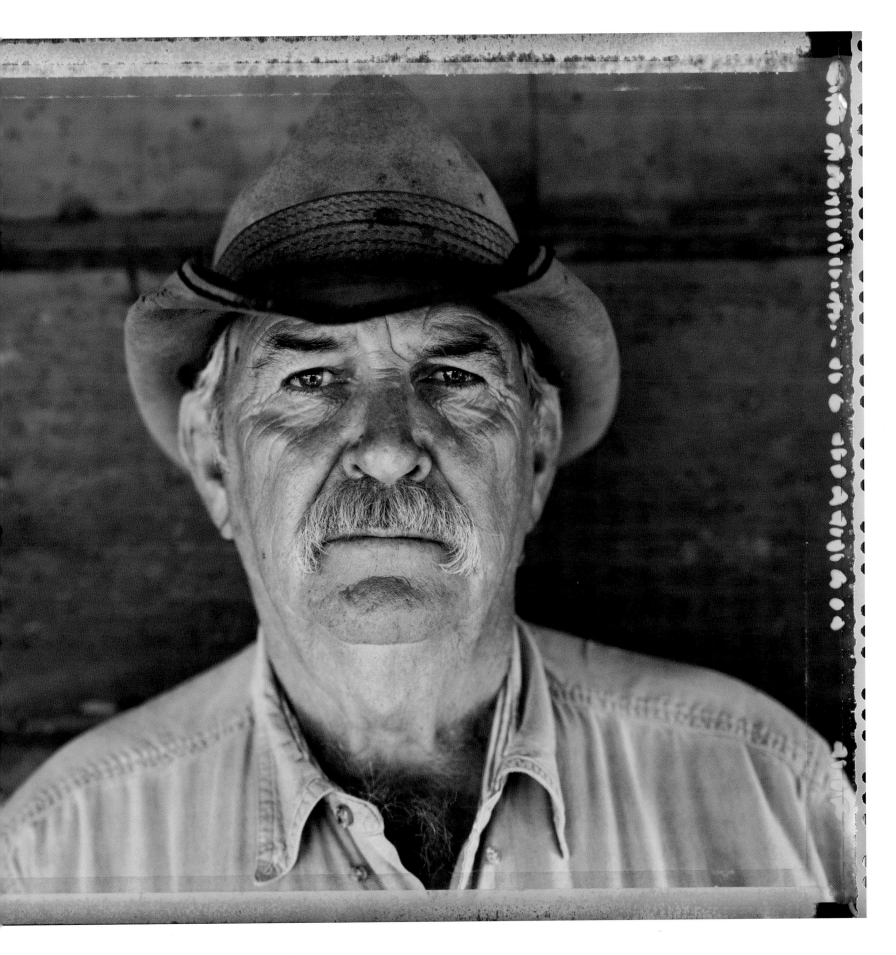

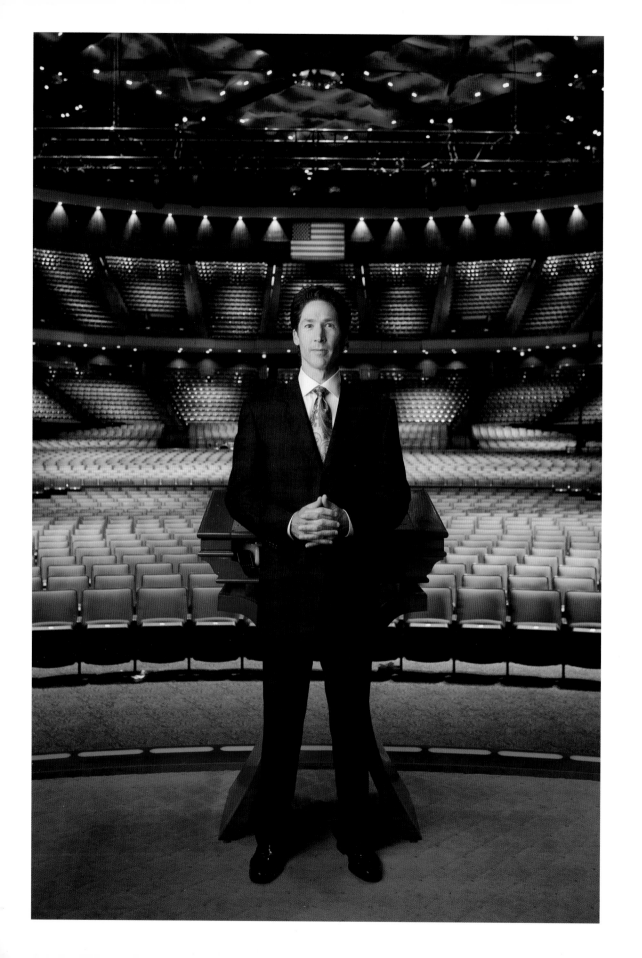

Joel Osteen

Joel Osteen was a reluctant preacher. He preferred working behind the scenes for his father's ministry at Lakewood Church in Houston, producing the television ministry. But when his father fell ill, he called Joel into his room and asked him to give the sermon that Sunday. Joel, who had studied at Oral Roberts University but had never been to divinity school, balked. He had never preached a sermon in his life, and he didn't see himself at the podium. His father, John, insisted. Joel finally agreed to be a one-time pinch hitter.

As if through divine intervention—and to Joel's astonishment—the sermon flowed out of him. Whether or not John Osteen was prescient, his son had an unmistakable, though unacknowledged, gift. He planned to slip under the radar again when his father recovered.

But John Osteen died of a heart attack. Joel had no choice, then, but to take over the ministry. His mother and siblings—he is the fourth of five children—recognized his talent and "elected" him senior pastor. After seventeen years of running his dad's TV ministry, Osteen took to the podium permanently in 1999. In 2005 the church had grown so much under his charismatic guidance that Osteen renovated the former Compaq Center, once home to the Houston Rockets basketball team, and moved Lakewood to the new facility. Now Lakewood is the fastest-growing church in America. Each Sunday Osteen preaches to close to forty thousand attendees. His television ministry reaches some twenty million Americans each month and is broadcast in almost one hundred nations around the world. His first book, *Your Best Life Now*, sold more than four million copies. Its theme: happiness is a *choice*.

Osteen's message is simple but compelling: each human being has a divine purpose and destiny. God is a good god who loves us and wants us to be successful. All we need is faith in Him through Jesus Christ. Osteen's goal is to break down denominational barriers, and indeed, people from all kinds of religious backgrounds flock to his services—whether in person or via TV and the Internet. Though few can argue with his message of hope and encouragement, Osteen has been accused of espousing the Christian "prosperity" gospel, wherein followers are promised material rewards for their faith. Osteen begs to differ:

> I get grouped into the prosperity gospel and I never think it's fair. . . . I think prosperity, and I've said it one thousand times, it's being healthy, it's having great children, it's having peace of mind. Money is part of it; and yes, I believe God wants us to excel and be blessed so we can be a bigger blessing to others.

Joel Osteen the man is the very embodiment of positive psychology and hence a pastor of his time. He radiates well-being and resilience. His pretty wife, Victoria, often joins him on stage.

"I've always been very happy," said Osteen, father of two.

> I've always been easygoing and I've always been very encouraging, it's just my personality. For thirty-six years, before I was a pastor, I was the same way. This is just who I am. I try to look on all the great things God's done, and not focus on the negative. It's a perspective. ★

John Bray

John Bray was born and raised on a farm in Haskell County, in northwest Texas. As a boy, his chores included chopping cotton in the fields and "heading maize"—pulling the heads off the stalks and throwing them in a horse-drawn wagon. During World War II, he volunteered for the Navy and was stationed in the Philippines, where he managed the naval post office base. He also spent some time stateside, along the West Coast; but Texas always claimed his heart.

In 1946 Bray returned home and went to work at the First National Bank of Albany, Texas, just fifty-five miles from where he grew up. He spent a happy career there. Even when he was "past retirement age," he was still a fixture at the bank, where his duties included helping with loans and IRAs, "just odds and ends that help the other officers and tellers."

"I just hope I've made some contribution to society," said Bray, who assisted many folks in procuring crucial loans through the years. "At least I know I've helped some people."

Bray, a lanky gentleman who says—with a chuckle—that he stands "five foot, sixteen and a half inches," considers himself fortunate in his birthright.

"I'm proud to be a Texan," said Bray, a longtime widower. "Born and raised." ★

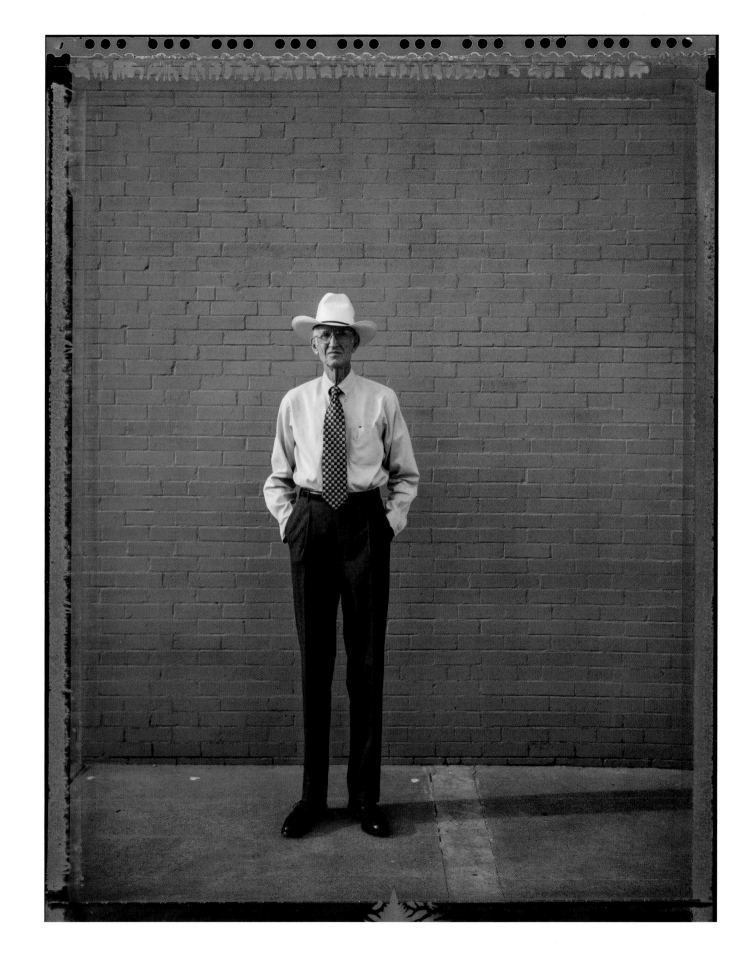

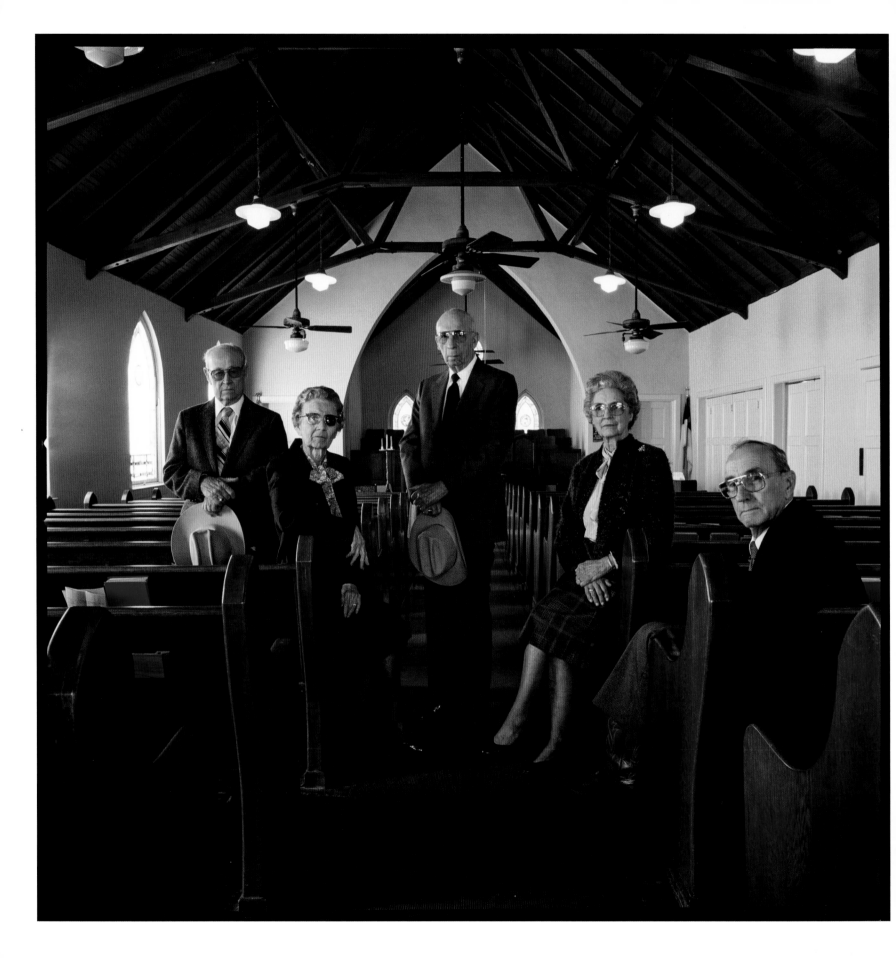

Bethel
Methodist
Church Group

BETHEL

1988

P arishioners at Bethel Methodist Church in the small community of Bethel, Texas, southwest of Waxahachie, posed for a portrait. From left to right: Oscar Curry, Yula Murdock, Jack Taylor, Lois Curry, and Stanley Murdock.

The church was founded in 1853 under a brush arbor at High Springs, site of an underground spring that bubbled to the surface, unearthing a trove of Native American artifacts. Parishioners met in a log schoolhouse at Greathouse until 1860, when services were moved to a schoolhouse at Bethel on Baker's Branch. The first meetinghouse, built south of the cemetery in 1872, was destroyed in a storm in 1892. The present sanctuary replaced the second meetinghouse, located north of the cemetery, in 1924. The tabernacle, built in 1907, served for camp meetings and God's acre sales. A parsonage, erected in the early 1900s on E. M. Brack's land at Boz, was moved to the present site in 1952.

Bethel Methodist Church was the site of the first God's, or Lord's, acre sale in Texas. Churches held such sales—for which parishioners, most of whom were farmers and ranchers, pledged the bounty of one of their acres of land to God—to raise money for the pastor's salary, operating costs, and cemetery upkeep. God's acre sales, still held in rural farming communities, are generally held the third Saturday of October, just after harvest. Bethel Methodist's cemetery, which dates from the earliest years of the church, is populated with the graves of wagon train pioneers, many of whom succumbed to cholera on their journey. ★

Julie & Jeffrey Choate

BETHEL
1988

Julie and Jeffrey Choate were photographed at church in Bethel, Texas, in 1988. As an adult, Julie worked as a prison guard in Venus, Texas. Jeffrey, who stands six foot two, worked in a machinist's shop in Whitney, Texas. ★

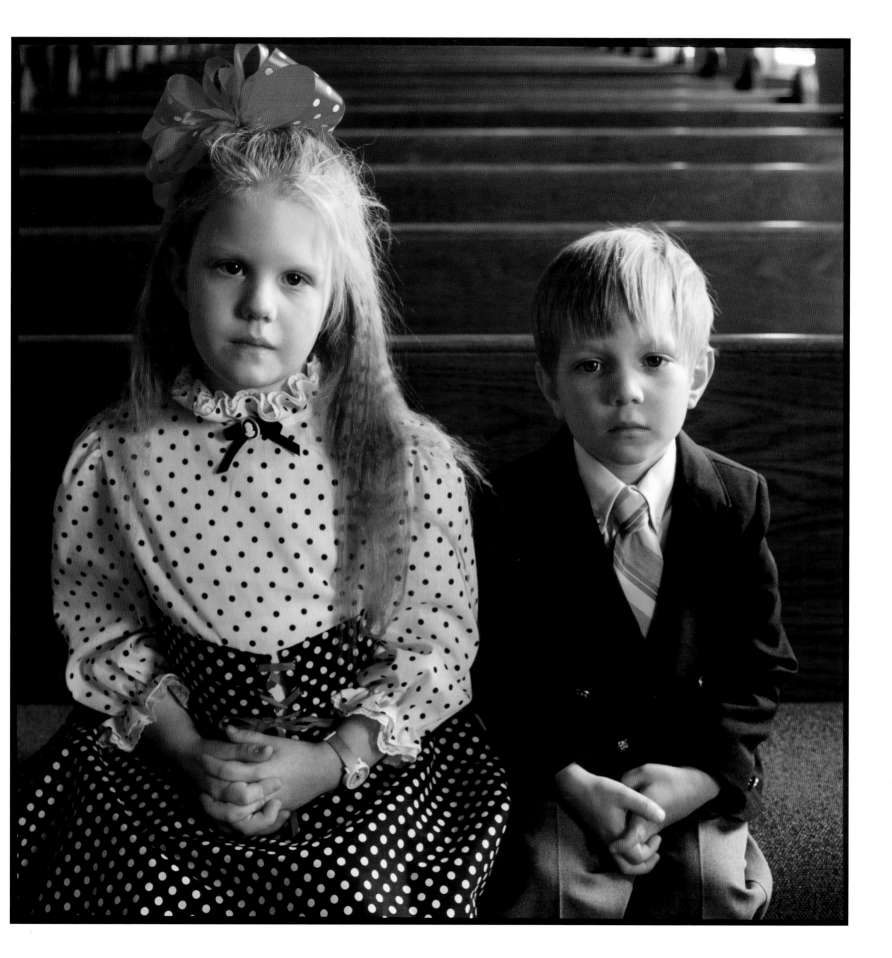

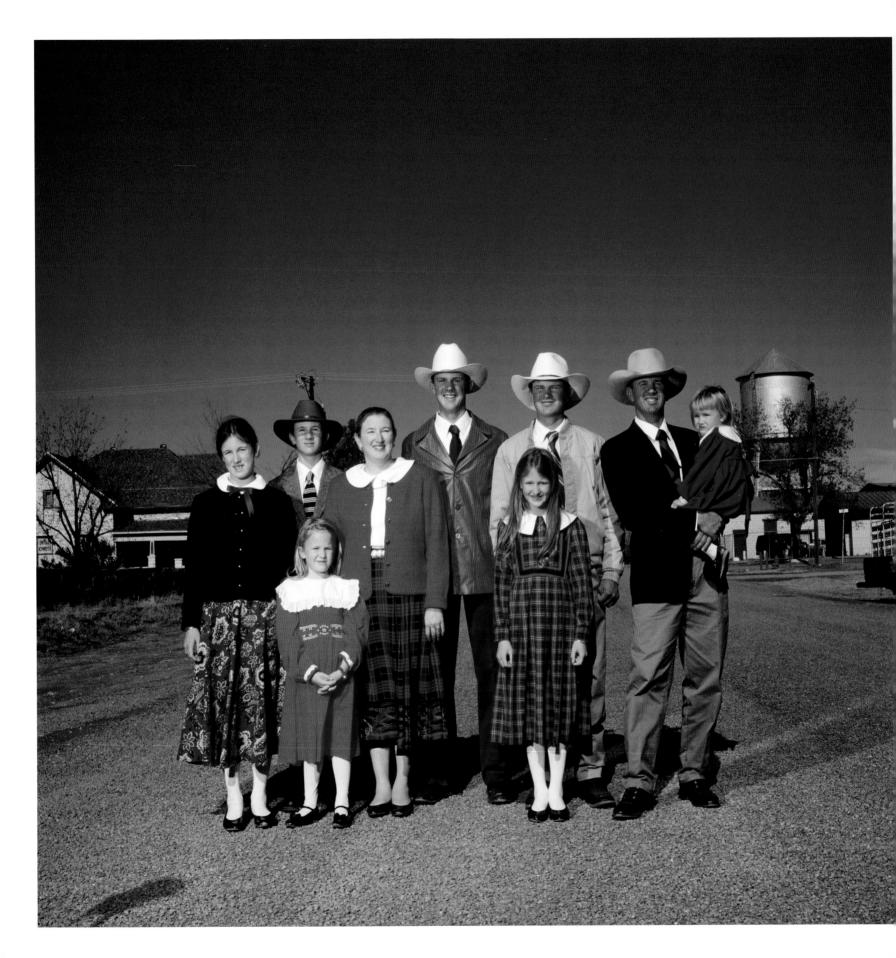

The Largent Family

VAN HORN

1998

The Largent family of Fort Davis, Texas, lived as pure a life as possible at the turn of this high-tech century. Television, video games, the Internet, and fast cars were foreign to their social lexicon.

They lived, in the words of mom Emily Largent, a "fairy tale."

"We live on the land and off the land as much as we can," said the rancher's wife, who hails originally from Louisville, Kentucky. She visited Fort Davis years ago, then stayed on to teach in the town's one-room schoolhouse. "I wouldn't trade it for the world."

Emily and husband Roy and their seven children—Roy Rust, Ivan, Tate, Caroline, Emily Anne, Maria, and Hannah—lived on a four-thousand-acre ranch ten miles west of Fort Davis and two hours north of Big Bend National Park, at the base of Blue Mountain. Like their relatives and neighbors—fellow ranching families—the Largents homeschooled their children and otherwise raised them as young ranchers-to-be, teaching them more in one year about the land, and themselves, than city kids learn in a lifetime.

"We're thankful," said Emily, who holds a master's degree in special education. "We don't have to de-program them. We're trying to teach our children life skills, give them a broader picture."

The Largents lived in a spacious, adobe-walled, century-old ranch house that had been in Roy's family for years. They raised miniature Hereford cattle and, to a lesser extent, cashmere goats. They also owned "a few head" of Shetland sheep and some horses, dogs, and cats. They kept milk cows for themselves, butchered their own beef, got fresh eggs from their cousins nearby, canned gallons of vegetables every year, baked their own bread, and participated in a food co-op for the staples they couldn't produce themselves. Self-sufficiency was a necessity, as their ranch was forty miles from a proper grocery.

Their daily routine began at dawn with barn chores, a big breakfast, and homeschooling; and continued with a hearty lunch followed by more chores—domestic tasks for the girls, ranch work for the boys—a light dinner, and early bedtime. The girls also learned their share of ranch chores so they could help out in busy times and fill in for the boys when they were gone on ranch business.

Although Emily and Roy said they would support their children's life choices, they believed most of their offspring would ultimately choose the ranching life.

"I think they've got the land in their blood," said Emily. "They're happy here. And as it says in Proverbs: 'A merry heart doeth good like a medicine.'" ★

Annie Mae Hayes

Annie Mae Hayes (1924–2002) was manager and dispatcher for City Taxi in Waxahachie, Texas, for twenty-four years. But to friends and family, she was a great deal more.

"We worked together for years," said Bertha Johnson, another dispatcher at City Taxi.

Every time I think of her, I start to cry. She'd go out of her way to help anybody. When someone didn't have a place to stay, she always opened her door. Even though she had nothing, she'd say, "You can come in and sleep on the floor." She'd give you her last dime and do without herself.

Theodore Hayes, her only son, said his mother—who worked in her younger years as a nurse's aide at the veterans' hospital in Dallas—was a positive force.

"She could find something good in any kind of adversity, and she always had something good to say," he said. "She didn't meet any strangers. She was pretty as a button and had a heart as big as Texas."

Hayes's boss, Robert Baber, owner of City Taxi, mourned her loss.

Annie Mae was known throughout Ellis County. She was a very religious person. She wasn't a crusader, but she was very outspoken in her way about lots of issues around Waxahachie, like school desegregation. It went very well here because of people like Annie Mae, because people *listened* when she talked. People of all kinds, mothers and fathers, would stop by the cab stand. And if they didn't catch her here, they'd catch her at church. Her way was not one of force; she was one who believed in the soft answer, the quiet spirit, and silence in the time of an uprising. It always brought forth the right kind of fruit. She would say, "Always be in a position where you can turn the other cheek." That was Annie.

"She was here until she just couldn't go anymore," said Baber. "We miss her greatly every day. Annie *was* City Taxi."

City Taxi opened in 1932, and Baber's late half-brother, E. D. "Pete" Overstreet, made the original sign, which still hangs outside the door.

"The old sign was hanging by a piece of wire just like it was when it was hung in 1933," said Baber. "I remember when Pete made it: he got a piece of light sheet metal, cut, and painted it. He made all the little signs that hang inside the shop, too."

The place once contained a restaurant as well, and was called Willie D. Johnson Restaurant and Cab Stand. ★

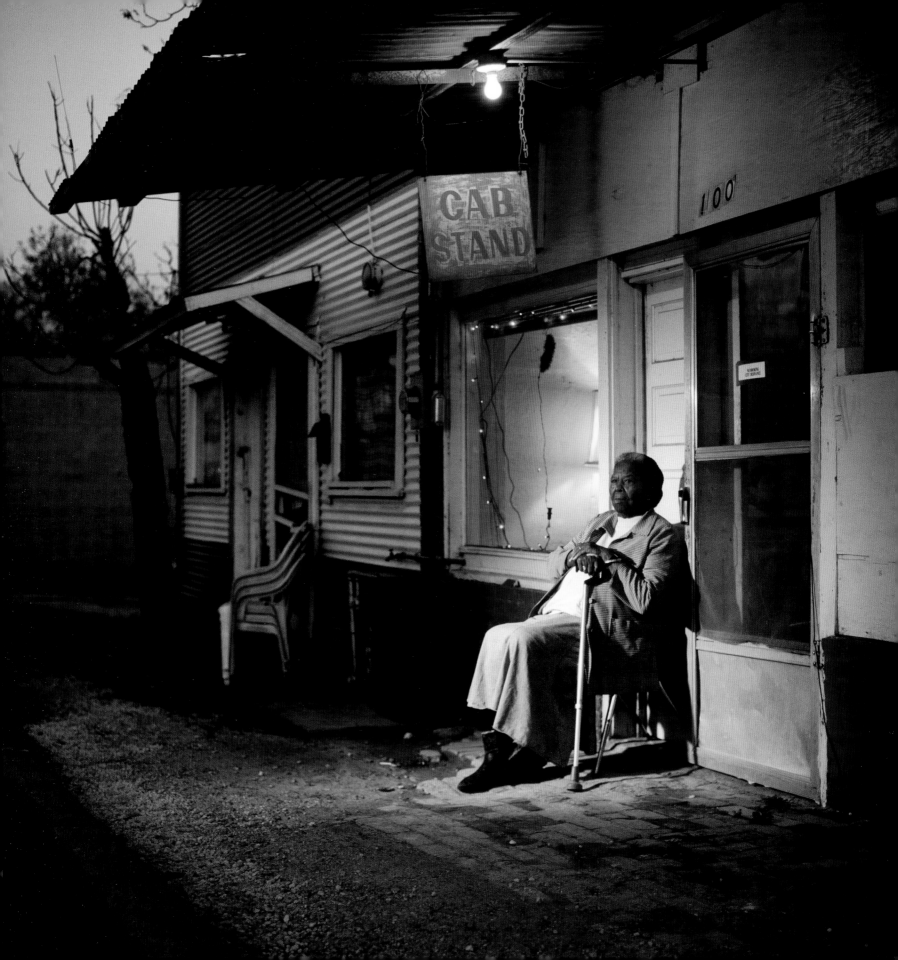

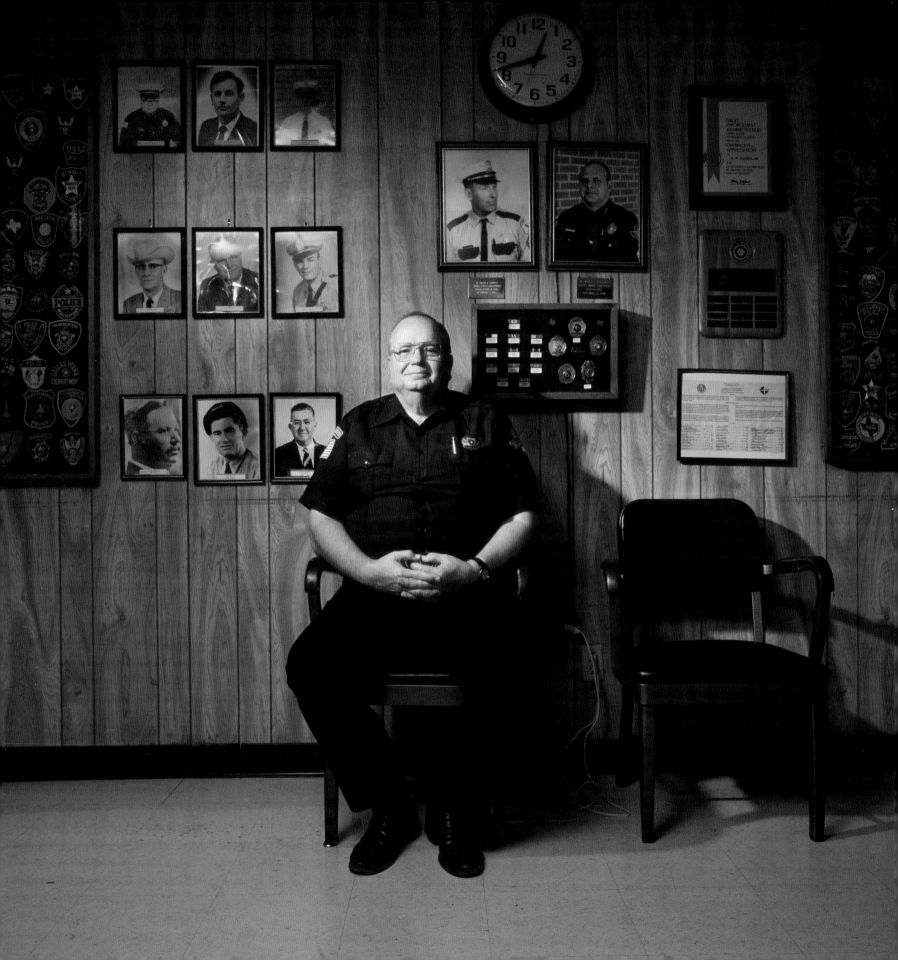

Dave Harris

D ave Harris (1938–2007) was the police chief of Athens, Texas, for thirty-three years. He came up through the ranks, starting as a patrol officer and working his way through sergeant, lieutenant, and assistant chief. When he retired, he had been with the force for some forty years.

"I'm a fifth-generation peace officer," said Harris, whose grandfather, Dan L. McDuffie, was a Texas Ranger killed in the line of duty, and whose father, Dave Harris Sr., was deputy sheriff, chief of police, and justice of the peace in New Boston, Texas, county seat of Bowie County. "You know, I believe policing is a calling."

Harris's two oldest sons are deputy sheriffs for Henderson County; and a nephew is an assistant chief in the border patrol in Washington, DC. Harris was born and raised in New Boston, where his parents' home, originally built in 1895, served as ersatz police headquarters until a proper police station was built. His mother, Nina, worked as police dispatcher—for no pay—and she helped out as needed at the courthouse, in the clerk's office and during elections.

Harris said his most exciting adventure as police chief was the apprehension of the serial killer Carl Robert Taylor. Taylor and his gang had shot a police officer in California, and Taylor was believed headed toward Athens, where his mother lived.

"We caught him in bed asleep at his mother's place," said Harris. "He was exhausted from running from the California officers. Between him and his daddy-in-law, they had killed twenty-one people. I believe they based an *Adam-12* TV series episode on them."

Though Harris claimed he "never really did anything spectacular," he felt it was important to carry on the family tradition.

"My folks created a legacy—of honest, hard-working law enforcement," he said. "All I tried to do in my forty years was not mess up what they had laid out for us. Through all my years, I just tried to keep a lid on it. We tried to make Athens a good, safe place to live, to make it better."

In his retirement, Harris did consulting work for the city of Athens, and spent more time with friends and family.

"I got a good wife and a good dog," said Harris, who doted on Jessie Mac, his boxer, whom he raised on a baby's bottle. "She does not know she's a dog." Of his wife, Glenda, retired as bookkeeper for Brookshire's Grocery, he also spoke fondly: "Glenda raised the kids while I had fun policing."

Harris retired from the Athens Police Department on October 18, 2002. He died at sixty-eight of complications from prostate cancer. ★

Boob Kelton

Boob Kelton doesn't care for big cities—or small towns, for that matter. But since he lives in the middle of nowhere—Upton County, in the vast expanse of West Texas—he has to brave civilization every once in a while just to buy supplies.

"I get out of there as quickly as possible," said Kelton, who added that living on a remote ranch situated between the small towns of McCamey and Rankin is just right for him. "I like the wide open spaces. You don't ever feel lonely with a bunch of cattle. I'm not much at visitin', and cattle don't talk back."

Eugene "Boob" Kelton was born in 1932. When his mother went into labor at the family ranch several miles outside tiny Crane, Texas, they had to drive all the way to Odessa for the nearest hospital. He got the lifelong nickname "Boob" from his father, who was fond of the popular Rube Goldberg cartoon strip, *Boob McNutt*.

Kelton was raised on his parents' ranch—the McElroy Ranch—and has been a rancher all his life. His only foray into another life was when he attended the University of Texas at Austin and served a stint in the Army afterward during the Korean War. But he was never sent overseas and spent his military time stateside, at Fort Bliss in El Paso and then at the missile range in White Sands, New Mexico, working in the guided missile program. When he completed his service, he returned to his wife, Peggy, whom he had married

beforehand, and they lived on ranches in Colorado and outside Marathon, Texas, before settling for good in Upton County.

"We raised three daughters here," said Kelton, brother of the late writer Elmer Kelton, author of, among other books, *The Time It Never Rained*. "They're all still in the livestock business, one way or another." He said his daughters married farmers and ranchers and have carried on the family tradition in West Texas.

Kelton and Peggy, his wife of more than sixty years, raise chickens and Charolais cattle now, though in younger days they also raised sheep and Spanish goats. But things have changed: the severe drought of the fifties, the current drought, and the fracking boom have transformed not only the landscape but also the economy of the region. Ranch hands are scarce or nonexistent, and the cities and towns cater to the oil and gas business. The land can no longer support the same variety of farm animals, and ranchers have had to resort to hanging feed sacks on the cattle because they can no longer graze. Many ranchers have given up altogether, "trading ranching for oil," in Kelton's words.

"There aren't any cowboys left; they've all gone to work in the oil fields," said Kelton, who works his ranch alone, zipping around on a dune buggy. "I started having trouble with my hip, so I couldn't ride a horse anymore. I built my own dune buggy, and I do all my own repairs. But it doesn't replace a horse."

Besides their chickens and cattle, the Keltons have a pet goat, two cats, and a blue heeler who's earned pet status. Occasionally, they have to adopt and bottle-feed an abandoned calf. They live a tranquil life, but a life that may be disappearing.

"I like to sit and watch the deer—two bucks chasing a doe—I just enjoy it," said Kelton. "I see things you'll never see in town. It's good, workin' man's country. There are very few days when you can't get out and work." ★

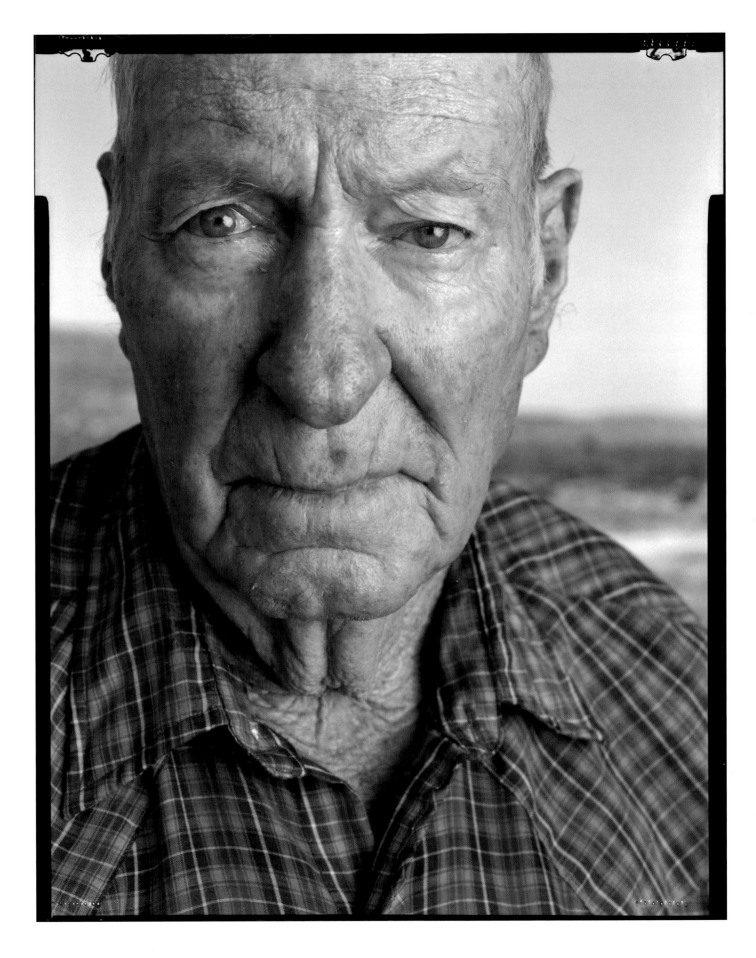

William Wayne Justice

TYLER

1982

William Wayne Justice (1920–2009), son of an eminent trial lawyer who fought the Klan, had an innate destiny for the high road. In the face of prejudice and good-ol'-boy politics, he made monumental reforms for human rights in Texas. His controversial rulings were instrumental in desegregating public schools, reforming the prison system, and educating undocumented immigrants.

In *United States v. Texas* (1970), Justice—then a U.S. District Court judge for the Eastern District of Texas—ordered the Texas Education Agency to assume responsibility for desegregating Texas public schools. It was one of the most sweeping desegregation orders in legal history and was the first of several provocative reform rulings that dramatically changed Texas public institutions. His ruling in *Ruiz v. Estelle* (1972), the longest-running prisoners' lawsuit in U.S. history, mandated that the state reduce overcrowding, improve prisoner rehabilitation and recreation programs, create a genuine medical treatment system, and refrain from practices deemed detrimental to prisoners' safety.

"I was aware that I was an object of hatred in many people's eyes, but my wife was the one who really suffered," said Judge Justice, who married his wife, Sue, in 1947. "She was always highly regarded both as a person and a personality; but after I started making those kinds of decisions, it was like turning on a water tap: she was ostracized as the wife of a bad judge." Local beauticians refused to fix her hair, and the couple was shunned socially. Still, the judge held firm.

"I never did have the feeling that I was alone," said Judge Justice, who worked for many years in both Athens and Tyler, Texas, before moving to Austin, where he served as a senior U.S. District Court judge. "I had a feeling that the poor people, the blacks, and Mexican Americans approved."

His favorite case, though, was the lesser-known *Plyler v. Doe* (1982). The Texas legislature had passed an act allowing school boards to charge tuition for the children of undocumented immigrants, and the Tyler School Board adopted the resolution.

> The school board was essentially telling these poor workers they couldn't send their children to school. It was prejudice, purely. I held that these children could go to public school without the payment of tuition. The Supreme Court affirmed my decision 5–4. Probably a million or more children have been able to get an education since then. That's the case I'm proudest of.

Justice, who graduated from the University of Texas Law School in Austin, earned many awards in his career, including the NAACP Texas Heroes Award in 1997 and the Texas Civil Liberties Union Outstanding Federal Trial Judge Award in 1986. In 1982 he was deemed Outstanding Federal Trial Judge by the Association of Trial Attorneys of America. In 2001 the American Bar Association gave him the Thurgood Marshall Award, its highest civil rights commendation.

Columnist Molly Ivins wrote that Judge Justice lived up to his name, saying he "brought the United States Constitution to Texas." Justice is the subject of a biography, *William Wayne Justice: A Judicial Biography*, by Frank R. Kemerer. ★

George W. Bush

AUSTIN

1999

George W. Bush, as forty-third president of the United States, maintained a strong presence in Texas with the "Southwest Wing," his sixteen-hundred-acre ranch in Crawford. The ranch, the former "Texas White House," includes a creek, canyons, waterfalls, and meadows where deer and cows graze. The Bushes renovated an existing farmhouse and built a new home there; and Bush relaxes by fishing in a man-made lake that he's stocked with bass. He conducted some official business there, including CIA briefings, and used the Crawford High School gym to announce Colin Powell as his secretary of state designee.

"When I'm not in Washington," he has said, "there's a pretty good chance you'll find me on our place in Crawford, Texas."

Bush, an Ivy Leaguer from an affluent family, is unquestionably his famous father's son. But in spite of his blue-blood background, this Bush—who inherited a redeeming dose of his mother's warmth—comes across as an accessible, down-to-earth Texan. As the forty-sixth governor of Texas—the first governor of the state to serve consecutive four-year terms—he lived in the requisite palace in Austin but behaved like a family man. He kept dogs and cats in the Governor's Mansion (and in the White House) and sent his twin daughters, Barbara and Jenna, to Austin High, a public school. Bush's wife, the former Laura Welch, is a genuine individual who worked as a teacher and librarian before the two met.

When he ran for president, Bush billed himself as a "compassionate conservative"—a calculated political label designed to appeal to both parties. He garnered points for speaking Spanish to his Hispanic constituents and earned popular respect for admitting that he had partied so much in the past that it forced a critical reckoning. As president, Bush was sincere but unapologetic, was not afraid to show emotion, and took responsibility—for the economy, for foreign policy, and for the terrorist threat.

Bush was born in New Haven, Connecticut, and grew up in Midland and Houston, Texas, where his father, the former president, worked in the oil business. Like the elder Bush, he attended Philips Andover Academy in Massachusetts, then Yale University, graduating with a bachelor's degree in 1968. He served as an F-102 pilot for the Texas Air National Guard, attaining the rank of lieutenant, but was never called to Vietnam. He earned his MBA from Harvard Business School in 1975. Before his stint as governor, he worked in the oil business, launching Bush Exploration, an independent oil and gas company; ran unsuccessfully for the U.S. House of Representatives; worked on his father's successful presidential campaign; and became managing partner of the Texas Rangers baseball team in Dallas.

Since leaving office, Bush, an amateur painter, has kept busy: he spends time with war veterans, hosting "wounded warrior" bike rides across Texas; works to fight disease in Africa through his public policy institute; and strives to encourage economic growth at home and promote democracy abroad. His newest passions include the opening of the George W. Bush Presidential Library and Museum on twenty-three acres on the Southern Methodist University campus in Dallas. The facility offers an interactive experience that allows visitors to evaluate his presidency. Most important, he spends time with his first grandchild, Mila, born to daughter Jenna and her husband Harry Hager. ★

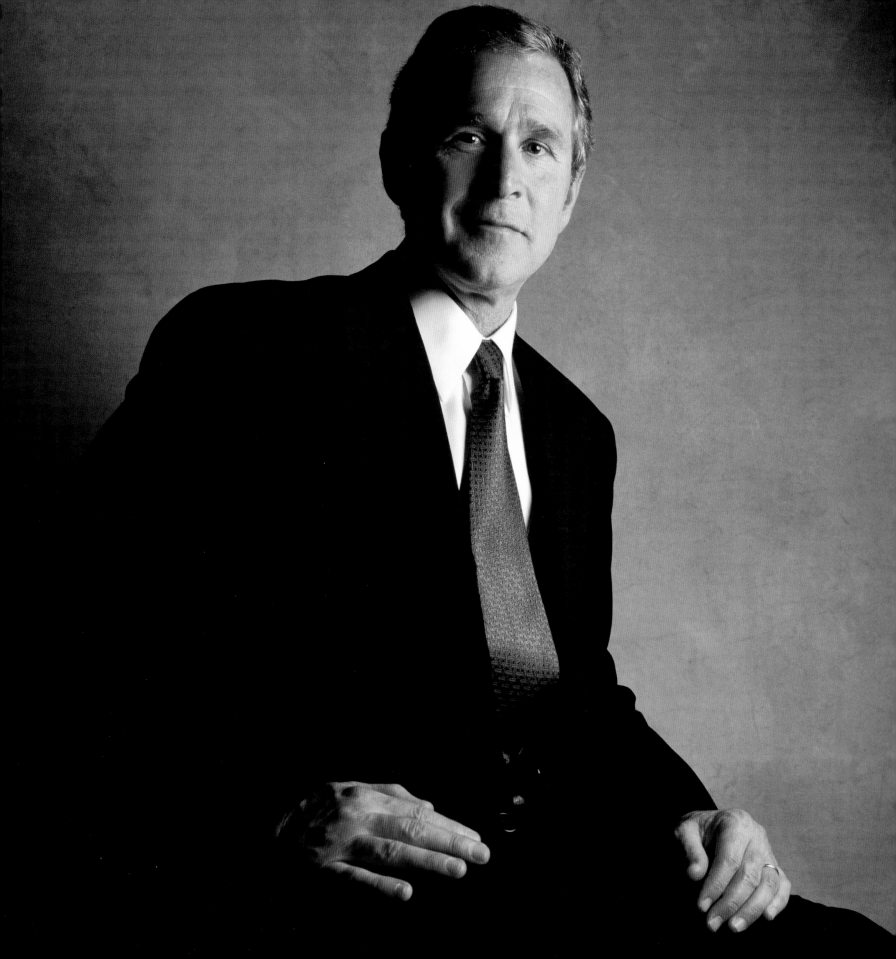

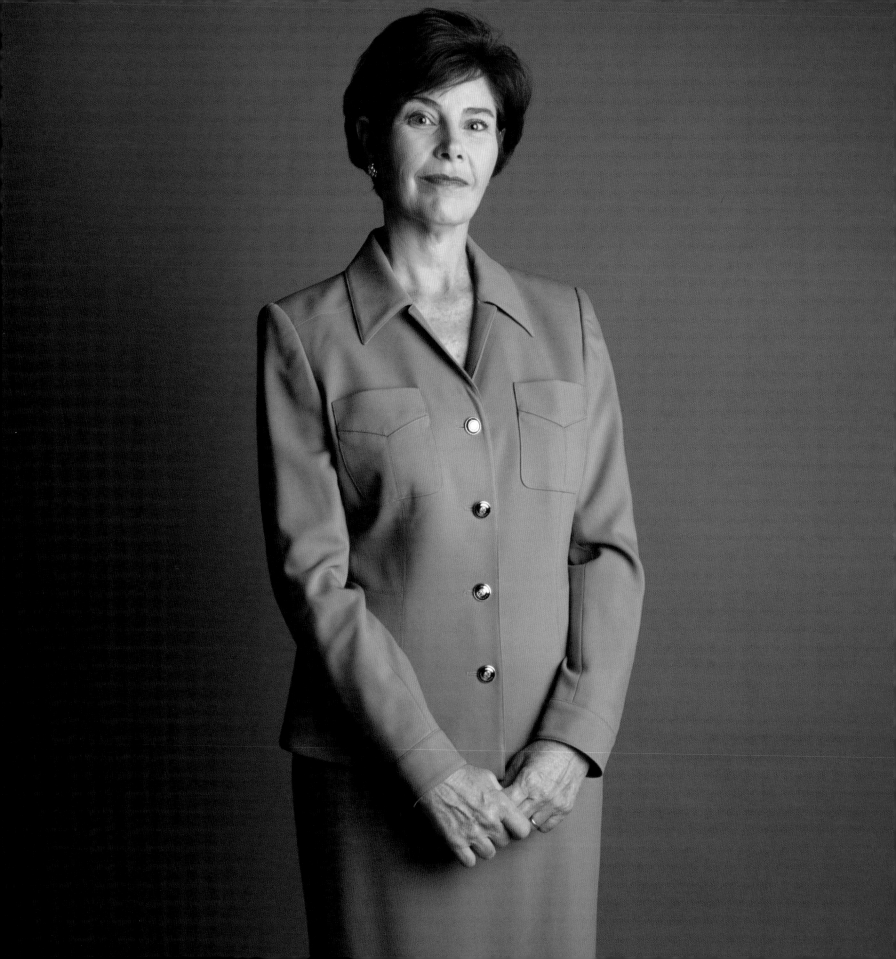

Laura
Welch Bush

AUSTIN

2000

When she was a little girl, Laura Welch Bush, a native of Midland, Texas, dreamed not of being a governor's or a president's wife but of becoming a teacher. Before she even started elementary school, the former First Lady would line up her dolls in a pretend classroom and instruct them.

Mrs. Bush fulfilled her goal—earning an education degree from SMU in 1968 and working as an elementary school teacher in Dallas and Houston—and went far beyond. In 1973 she received her master of library science degree at the University of Texas at Austin, putting it to use first as a librarian at the Houston Public Library, and later as a school librarian at Dawson Elementary in Austin, the job she held when she met her future husband. As the wife of the forty-third president of the United States, she was an educator at large, pushing her national initiative called Ready to Read, Ready to Learn, which encouraged regular reading with an adult for preschool children. On September 8, 2001, Mrs. Bush launched the first National Book Festival in Washington, D.C. Previously, she had helped establish the renowned Texas Book Festival in Austin. As First Lady, she was also active in promoting women's health issues, particularly breast cancer awareness.

By all accounts, Laura Bush—though not avidly political—has been an asset to her husband's career. She is regarded as sincere and soft-spoken but strong. When her husband's formidable grandmother asked her, a newlywed, what she *did*, Mrs. Bush shot back that she read and she smoked. (She quit smoking years ago.) There were no more questions. Laura Bush was instrumental in getting "Bushie," as she calls him, to quit drinking. And she became the first First Lady in history to record a full presidential radio address—speaking out against the oppression of women and children by the Taliban in Afghanistan.

Although the couple purchased a home in Dallas after President Bush left office, they still maintain a strong connection to their ranch in Crawford. Mrs. Bush, who is fond of gardening and taking long walks with her husband, considers their Texas home the most romantic spot on earth, and prefers Texas to anyplace else.

"There's a certain wide openness about the space and the landscape, but also about the people," she has said. "A Texan is a really independent person with a lot of spirit." ★

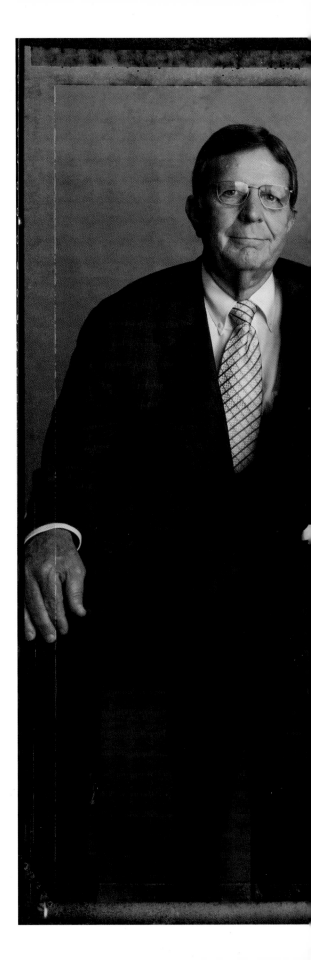

LBJ
Colleagues

AUSTIN

2000

S ome of LBJ's Texan "inner circle," photo-
graphed in 2000 for *Texas Monthly* mag-
azine. From left to right: Larry Temple,
special counsel to the president, 1967–1969;
A. W. Moursund, longtime business partner; Walt
W. Rostow (deceased), chairman of the Policy
Planning Council for the State Department, 1961–
1966, and National Security Advisor, 1966–1969;
and Ernest Goldstein (deceased), special assistant
to the president, 1967–1969. ★

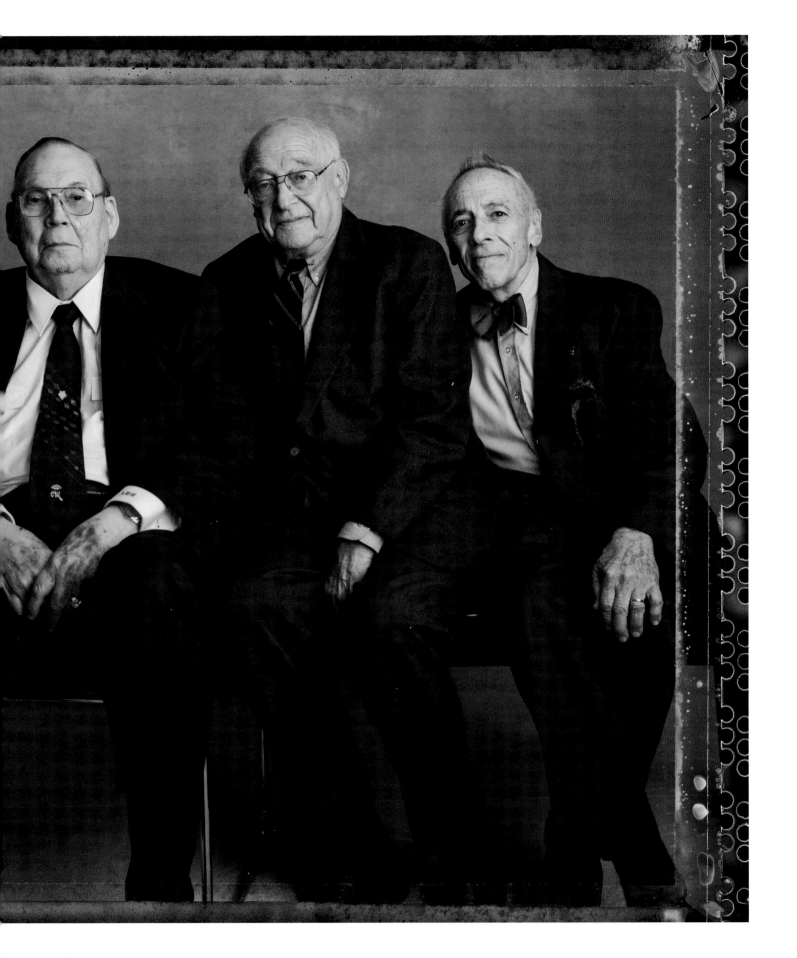

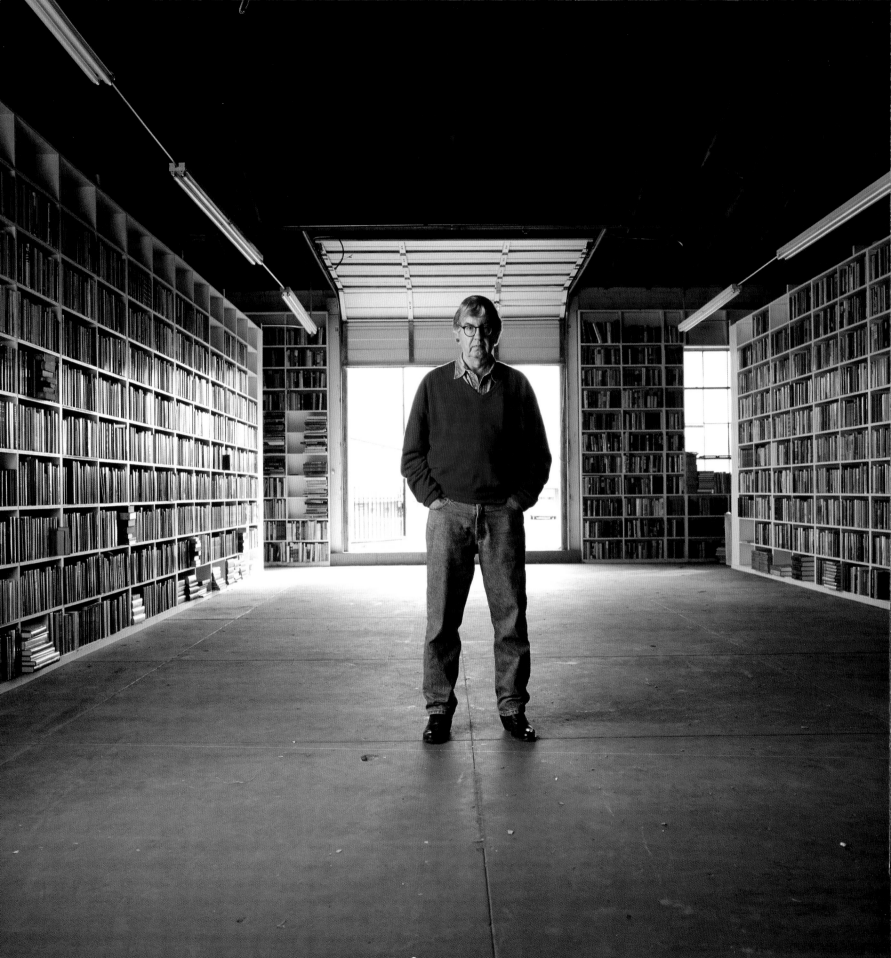

Larry McMurtry

L arry McMurtry died on the operating table in 1991. After having a heart attack, he underwent quadruple bypass surgery, and doctors brought his body back to life. But McMurtry, who fell into a debilitating depression a few months later, believes his personality suffered a permanent rupture; and though he began functioning—and writing—again, he has never been quite the same. In the mid-nineties, after living in big cities most of his life, he returned to his hometown of Archer City, Texas, population 1,800, and focused on his first love: book collecting.

McMurtry, one of America's best-known writers of western fiction—author of more than thirty-nine screenplays, three memoirs, two essay collections, and twenty-nine novels, including *The Last Picture Show*, *Terms of Endearment*, and the Pulitzer Prize–winning *Lonesome Dove*—has never liked horses. But he's a rancher nonetheless—of books. He has transformed Archer City into the home of the largest collection of used and antique books in the country. His enormous bookstore, Booked Up, is housed in four buildings—one of them the former Ford dealership—scattered around Archer City's town square. It is the largest business in the once nearly bookless town—inspiration for *The Last Picture Show*—that sits at the intersection of Highways 25 and 79 in the rolling plains of North Texas.

"I think of my bookshop as a book ranch—a large one," said McMurtry, who was born in Wichita Falls and grew up in nearby Archer City with his grandparents, ranchers and first-generation pioneers. "Instead of herding cattle, I herd books."

Booked Up has a small staff, mostly concentrated in the main building; the other three buildings are often left unstaffed and open to customers, who are expected to use the honor system and lug their prospective purchases to the cashier across the way. Booked Up is set up for browsing, and book enthusiasts have to catch on to McMurtry's quixotic system: a store flyer notes that the books are arranged "Erratically/Impressionistically/Whimsically/Open to Interpretation." Works of fiction are located in two buildings, split by the year 1925; history books are spread across three stores; and art catalogs are housed separately from art and photography books.

McMurtry opened the original Booked Up in Washington, D.C., in 1971. Although he once owned another store, in Tucson, Arizona, he preferred customers to make the trek to Archer City. His dream is to create another Hay-on-Wye, the small Welsh village that has become a mecca for book lovers around the globe. And with the death of urban bookstores in America, his future as a bookseller seems bright. In the meantime, he has found a late-in-life literary companion: in April 2011, he married Faye Kesey, widow of author Ken Kesey, his old colleague from the graduate writing program at Stanford. ★

Franci
Crane

HOUSTON

2004

F ranci Crane was one of Houston's most feared attorneys, according to the Houston press. She was photographed for a *National Geographic* story on Houston's wealthy elite living in tony zip code 70019. Crane referred to herself as a "gladiator" during the years she practiced law. Her husband, Jim Crane, owner of the Houston Astros, was the first to agree.

A graduate of the University of Texas Law School, Crane worked as a litigator for the Houston law firm Susman Godfrey for more than two decades. The firm handles high-stakes commercial litigation, representing both plaintiffs and defendants. Crane worked on prominent cases and was cocounsel for Exxon in the aftermath of the 1989 *Exxon Valdez* oil spill. She helped the corporate giant win a $480 million settlement from its insurers.

In more recent years, Crane has served as a philanthropist, community volunteer, and champion of the arts. In 2007 UT chose her as its Distinguished Alumnus for Community Service. She and her husband are key supporters of the Museum of Fine Arts Houston, where she has served on various committees.

When she turned sixty in 2010, the B-52s pop-rock group performed at her birthday party at the couple's Nantucket summer home. ★

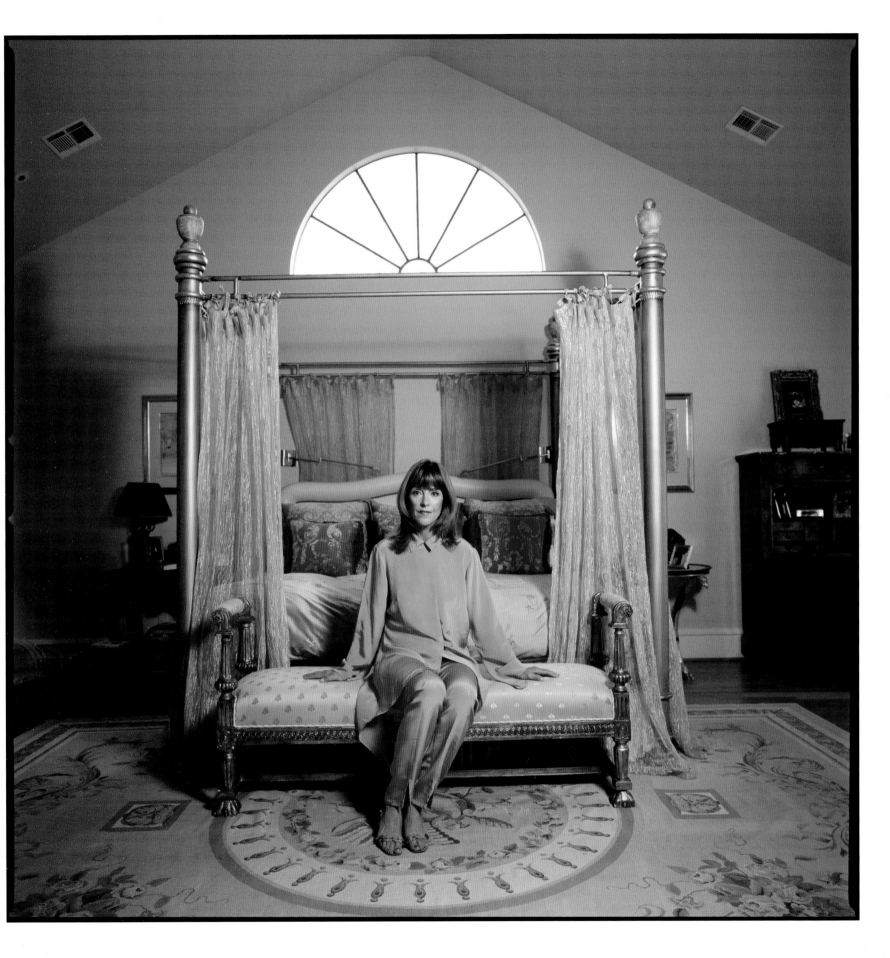

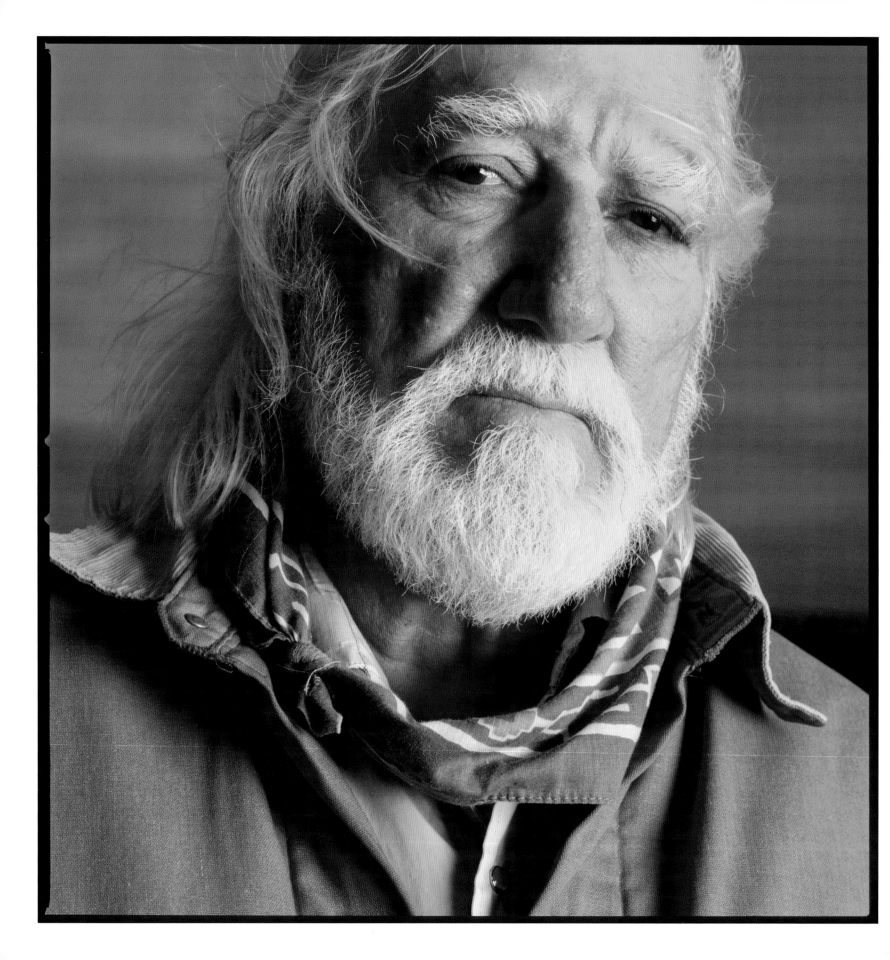

Bob
Holloway

Bob Holloway (1926–2000), the son of a Keller, Texas, dairy farmer, continued the tradition—the old-fashioned way—on his own 340-acre ranch eleven miles north of Decatur: for thirty-seven years, he milked as many as 150 cows a day. He used machines for the milking, but he didn't go so far as to get a computer to keep track of things. And he brought in bulls for breeding—nature's way—instead of using the far more prevalent method of artificial insemination.

Holloway eventually sold the dairy operation so he could kick back. When he wasn't traveling around border country or out west, he read history (he held a history and government degree from Southwestern University), wrote poetry, traded cattle, and rode horses.

"I kinda hole up here like a cowboy in a dugout," said the six-foot-three Holloway, who also served as a Wise County judge in the mid-eighties. His daughter, Rosalinda, described him as a "larger-than-life character who gave my life character." ★

ZZ Top

Most people know them only by their collective name, but ZZ Top consists of three very distinct individuals: bassist Dusty Hill (left), guitarist Billy F. Gibbons (right), and drummer Frank Beard (seated), pictured here at the Old Humble Barbershop in Humble, Texas. The band keeps its business headquarters in Austin, although all three principals live in Houston.

ZZ Top became a household name after its "Worldwide Texas Tour" in 1976. The band's Texas-shaped stage, adorned with a real live buffalo, a longhorn steer, buzzards, and rattlesnakes, made a vivid—and permanent—impression on those who attended the concerts. Since then, the band has continued its tradition of "Takin' Texas to the People," with mythic concerts across the United States and in international venues as far afield as Japan, Russia, Latvia, and South Africa. The band's trademark hillbilly beards, sunglasses, Harleys, hot rods, key chains, and droll, synchronized stage antics—not to mention the shapely dancing girls on stage—cemented the band's quirky, Delta-blues-based image. And ZZ Top's famous songs "Legs," "Sharp Dressed Man," and "Gimme All Your Lovin'" imprinted the band's persona on at least two generations.

"That little ol' band from Texas," as the band is affectionately called, has been honored as "Official Texas Heroes" by the Texas House of Representatives and been nominated by *Saturday Night Live* as a write-in candidate for president. ZZ Top even performed at President George W. Bush's inaugural celebration, in a show billed as "The Best Little Ball in DC."

The band was inducted into the Rock and Roll Hall of Fame in 2004. ZZ Top's other claim to fame: it offered its services to NASA as the lounge band for the first passenger flight to the moon. Incidentally, neither Gibbons nor Hill has had a close encounter with scissors since 1979. ★

Stephen Blair

AUSTIN

2007

Stephen Blair graces the cover of Michael O'Brien's 2011 book, *Hard Ground*, a collection of black-and-white portraits of the homeless in Austin accompanied by the poetry of Tom Waits. Blair was fifty-three years old when the photo was taken in 2007.

"I'm a homeless guy—broke," he said. "I don't have any ID. I have all the paperwork to get a birth certificate.

"I had a good job—cooking as a chef. But I got to work one hour late one day and my boss gave my job to another guy. I live anywhere now—that is, anywhere I feel safe. I've been homeless for sixteen years. Where I stay at, it's just a place to lie down at night.

"I have a mother, a brother, and a sister. I can't tell you anything about my brother and sister—they got high society—and my sister don't want to talk to me. I pray for her every day. I talk to my mother every once in a while. She lives in Fort Worth, but I haven't seen her in twenty years. I go to a pay telephone every other day at five p.m. If the phone doesn't ring in five minutes, I know Mother is not going to call. But she calls most of the time. I ask her if she wants me to come home and take care of her, but she says she is okay. My mother has a loving heart."

Blair still holds forth—flying a sign—either at the intersection of Mopac and Lake Austin Boulevard or in front of the flagship Whole Foods at Lamar and Fifth Street. ★

Monroe
Schubert

LA GRANGE
1998

For more than four decades, Monroe Schubert was the "Barbecue Chef" of La Grange, Texas. Monday through Saturday, dawn to dusk, he tended the sweltering pits at Prause Meat Market, cooking enough brisket and sausage to feed one hundred people at a time. When he finished cooking, he scrubbed everything down.

"Monroe grew up tough," said Gary Prause, whose great-grandfather Arnold Prause opened the market in 1913. "But he'll give you the shirt off his back."

Schubert was raised in nearby O'Quinn, Texas, where he walked to a one-room schoolhouse every weekday, weather be damned. After his family moved up Farm to Market Road 609 to La Grange, Schubert got a job at the feed store, where he ground feed, filled a big truck, and delivered it to all dairy farmers in the area. A few years later, he signed on with the Prauses. He worked with them until his retirement in 2013.

"You're not going to find someone like Monroe," said Mark Prause, Gary's first cousin and another fourth-generation proprietor. "He was one of the first ones here, and one of the last to leave." ★

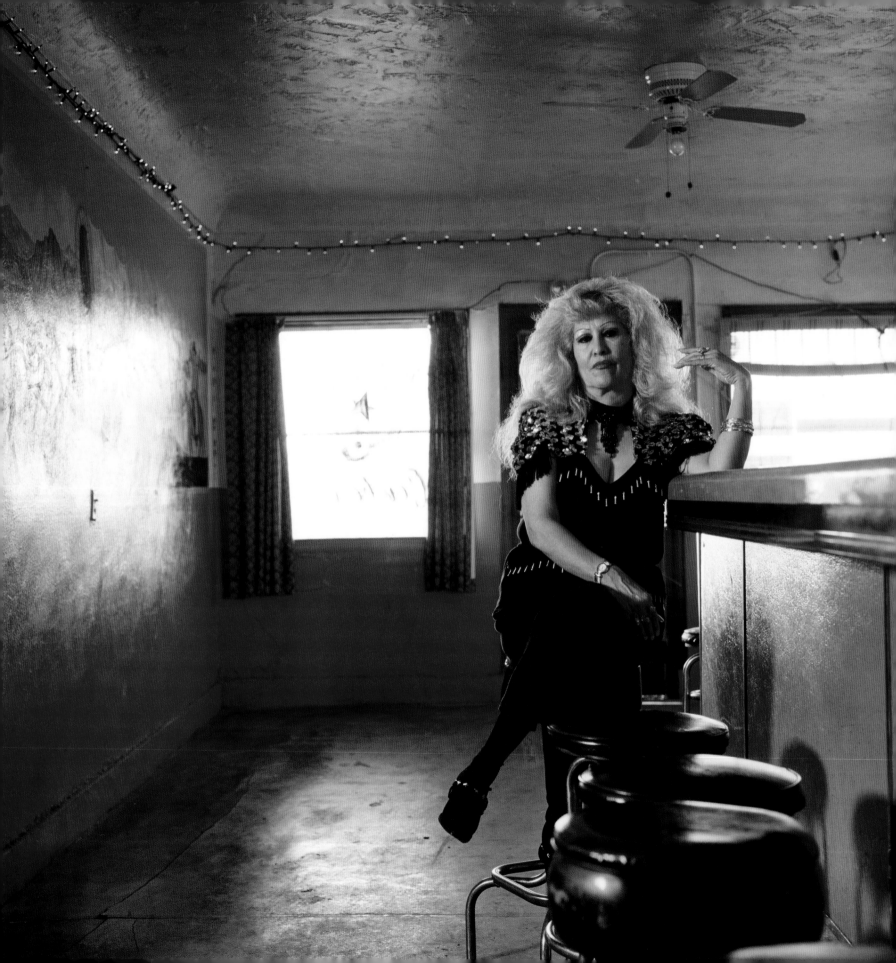

Ruby Sanchez McGill

Ruby McGill got tired of being a waitress. So she bought the joint. McGill has owned Ruby's Bar in Van Horn for more than two decades. Her husband, Don McGill, runs the couple's liquor store next door.

"I like to be around people," said McGill, "and I'm the boss."

When McGill's photograph appeared in *Texas Monthly* magazine—in a story about small-town Texas characters—she became kind of famous.

"Everybody who came down the highway stopped and had me sign their book," said McGill, who was born and raised in Van Horn and graduated from Van Horn High. "I've gotten nine marriage proposals from the penitentiary."

McGill spent a decade living in Phoenix, but was happy to move back home.

"It's a good town," she said of Van Horn. "Everybody knows everybody. I was in Phoenix ten years and didn't know anybody."

Ruby's Bar, formerly JR's Bar and the Mint Bar, has been a watering hole since the 1930s. McGill first rented the place—renaming it after her hero, J. R. Ewing on the TV series *Dallas*—then saved the money to buy it. Ruby's Bar sells beer and wine and features a pool table, dartboard, jukebox, and lots of Dallas Cowboys memorabilia.

"I'm a Dallas freak," she said.

McGill opened a nightclub, Ruby and Don's Lounge, better known as "The Club," on July 4, 2002. It features live music on Friday and Saturday nights.

"All the other bars in town closed," said McGill. "But I still have my little bar." ★

Harry & Jay Knowles

AUSTIN
1997

When Harry Knowles earned a trip to the regional spelling bee in Stephenville, Texas, and the competitors had been whittled down to just Harry and another high-school freshman, Harry misspelled the word "harmonica," blowing his chances for State.

"I don't know what happened to my brain," said Knowles, who later missed only one question on the ACT college entrance exam. "The word was too easy. But it's my fondest mistake, a moment that reveals a simple flaw that can be endearing."

Knowles, a college dropout who created Ain't It Cool News in 1996 at the age of twenty-four after an accident confined him to bed for six months, feels the same way about his famous film-fan website. AICN is full of misspellings, grammatical errors, Knowles's refreshingly politically incorrect opinions, and tall tales about secret advance screenings and Hollywood film junkets. But he knows his stuff: he grew up helping his hippie parents in the film-memorabilia trade.

"I type faster than I think," said Knowles, whose book, *Ain't It Cool*, was published by Warner Books in 2002. "It's all breathless enthusiasm, train of consciousness. After I see a film, I can't wait to get it out of me. I believe perfection intimidates, and faults endear you to people."

After seeing Sam Raimi's long-awaited *Spider-Man*, Knowles wrote a record 3,400-word review; and the site—with a server that can accommodate three million hits—was so deluged that it shut down.

"I generate more text than any reporter in history," said Knowles, a powerful—and controversial—figure in Hollywood. "Other writers don't have the stamina—or typing skills!"

To this day, Knowles remembers his Seymour High typing teacher, Ms. Conners, "a big, bouffant beehive blond typing witch" who came up behind him one day and snipped off his "rat tail" that he kept tucked discreetly under his collar. But he learned to type. He even went so far as to join the typing club—and every other club, from drama to Spanish—to stay away from home. After his parents divorced, he and his little sister moved with their alcoholic mother to a ranch in northwest Texas, and their home life was beyond gruesome. When he finished high school, he fled back to Austin.

"I'm very old-fashioned," said Knowles, who married Patricia Cho Jones in 2007 and moved her into the cluttered, nine-hundred-square-foot house in north Austin that he shares with father Jay, his personal assistant. "I don't think it's necessary to leave your family to become your own person. Fame is an empty cup."

At any given time in his office, Knowles, whose writing stretches can last as long as fourteen hours, might be simultaneously screening a film, doing an interview on speakerphone, typing a review, and spending time with his wife.

"I'm a multi-hyphenate," he said. "I'm very much about AICN."

Since he grabs little sleep some days, he crashes for occasional eighteen-hour blackouts. When the laundry builds up, Jay heads to the laundromat and conducts "laundry orgies," marshaling nine washers and three commercial-size dryers. Father and son organize their whole existence around the movies.

"I call myself a film *advocate*," said Knowles, who organizes the annual Butt-Numb-A-Thon and Fantastic Fest film festivals, both at Alamo Drafthouse in Austin. "'Film critic' is a term of bitterness. To a film critic, movies are guilty until proven innocent. I think a film's great until proven otherwise. I haven't walked out of a movie in nine years. There's usually *something* there." ★

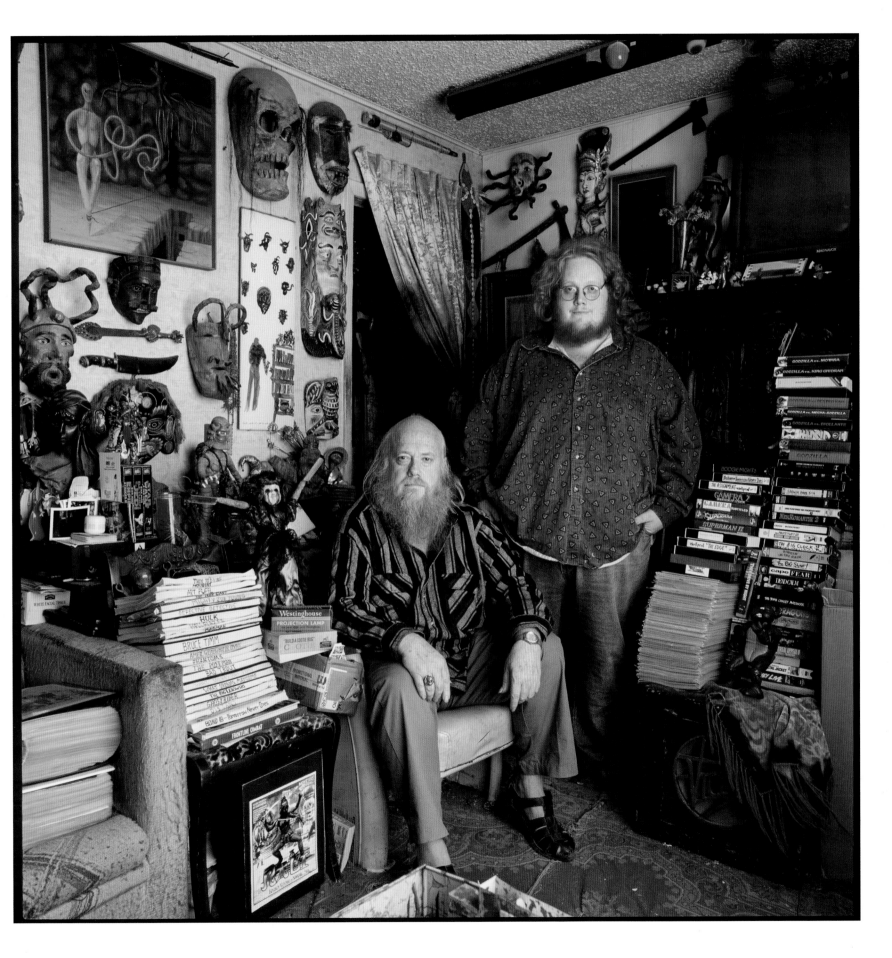

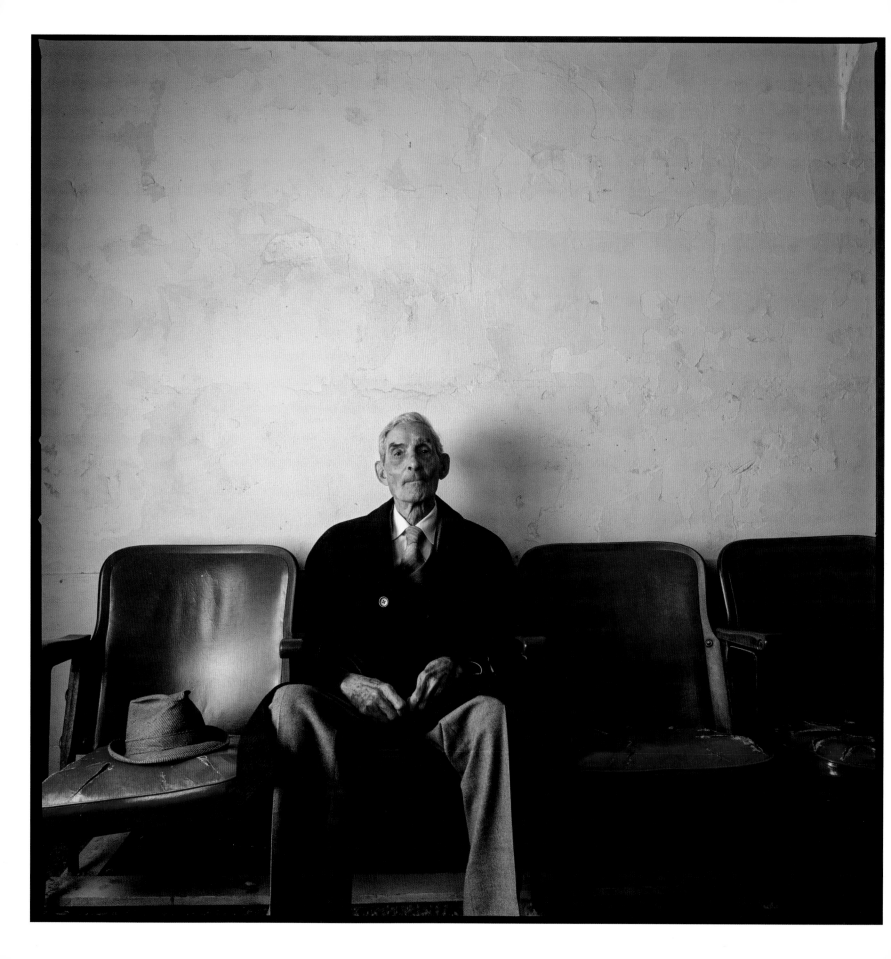

Monta Green

T his 1988 photograph of Monta R. Green waiting to have his hair cut at the old Tennery Barber Shop in Waxahachie, Texas, was taken for a *Life* magazine assignment. *Life* was doing a story on an area outside Waxahachie that was targeted as a possible site for a nuclear supercollider. The idea behind the story was to capture the simplicity of life in small-town Waxahachie—before construction of the prospective high-tech monstrosity and the concomitant transformation obliterated its character. The supercollider was never built.

Green, a Tennery's regular, owned Green Furniture Store on Main Street. His wife, Nell, was a schoolteacher. Barber Andrew Tennery, a lifetime Ellis County resident, had been a farmer and a presser at Haggar Slacks before he became a barber. He first worked at West Side Barber Shop and later went into business for himself, opening his own place on Franklin Street. ★

Junior
Brown

Anyone who has seen Junior Brown perform can tell you he's a radical dude. He takes the stage wearing a crisp suit and tie, cowboy hat and boots, and wielding a strange stringed instrument that looks like a prop in a lowtech alien flick. He's accompanied by his band and his wife—"the lovely Miss Tanya Rae"—who, in her equally crisp skirt-and-jacket suit, looks like an IBMer. Then Brown, playing this "guit-steel" anomaly, opens his mouth with a reverberating country baritone that penetrates to the pit of your gut. His droll lyrics, meanwhile—on the order of "I got to get up every mornin' just to say goodnight to you," about a late-night girlfriend—complete the tongue-in-cheek picture, which is as compelling as it is incongruous.

Junior Brown was born in 1952 and raised in the woods around Kirksville, Indiana; Chesapeake Bay and Annapolis, Maryland; and the piñonstudded hills of Santa Fe, New Mexico. He wasn't happy with just a regular guitar; it didn't meet his musical needs. So he invented his own instrument.

"I was playing both the steel and guitar, switching back and forth a lot while I sang, and it was kind of awkward," said Brown. "But then I had this dream where they kind of melted together. When I woke up, I thought, 'You know, that thing would work!'"

Brown took his dream to guitar maker Michael Stevens, and the guit-steel—a single guitar body with both the steel guitar and six-string necks—was born.

The rest is . . . well, Junior Brown history. There is no one like him, and, though most modern country radio stations still won't play his songs, Brown has forged his own path—all the way from small clubs like Austin's famed Continental Club to the Grand Ole Opry and some of the hippest venues in Manhattan and Europe. He's been nominated for three Grammys; and his album *Mixed Bag* prompted reviewers to label him one of the greatest guitar players alive. He has produced ten albums to date.

"A lot of people tell me they don't like country music," said Brown, who played the piano before he could talk, then unearthed an old guitar in his grandparents' attic. "But they like what *I'm* doing."

What he's doing is a peculiar but driving blend of country and rock 'n' roll that has prompted major magazines like *Musician* to dub him a genius. *Life* magazine honored him as the only contemporary musician included in their "All-Time Country Band." And his song "My Wife Thinks You're Dead" won Video of the Year at the 1996 Country Music Association Awards.

Brown considers his music "traditional honkytonk, with some ideas thrown in," music that resonates in the Lone Star State, particularly in the music capital.

"Texas has always been the place to welcome my music with open arms, when occasionally, in the past, other states have dried up," said Brown, who has worked in Austin for more than three decades. "I've always been able to find an audience in Texas. That, in itself, has spiritual meaning." ★

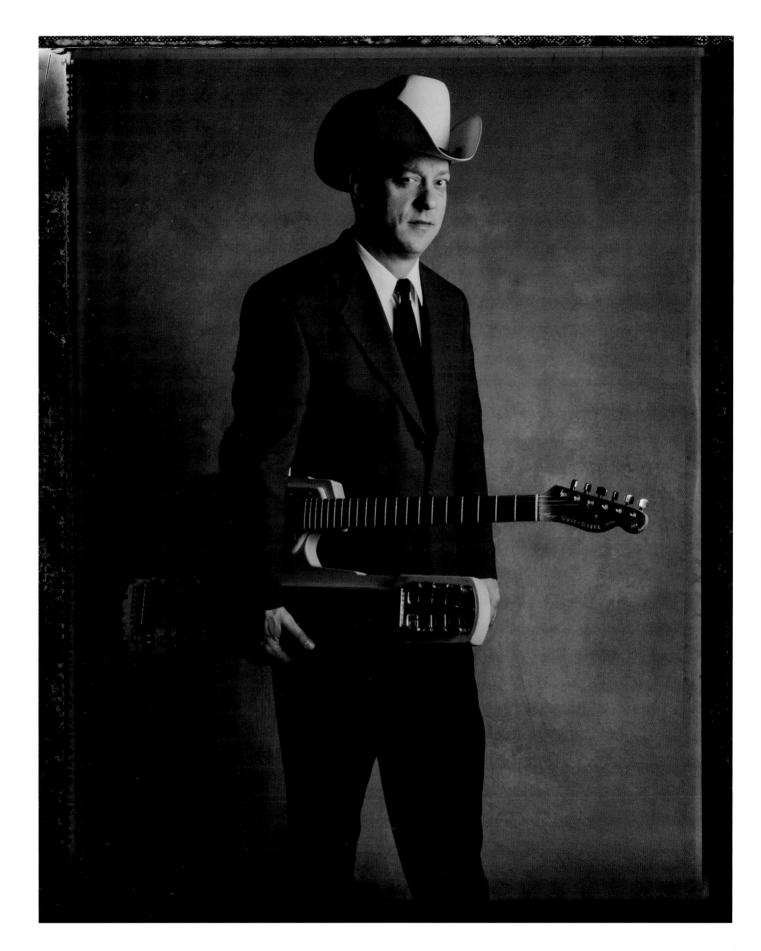

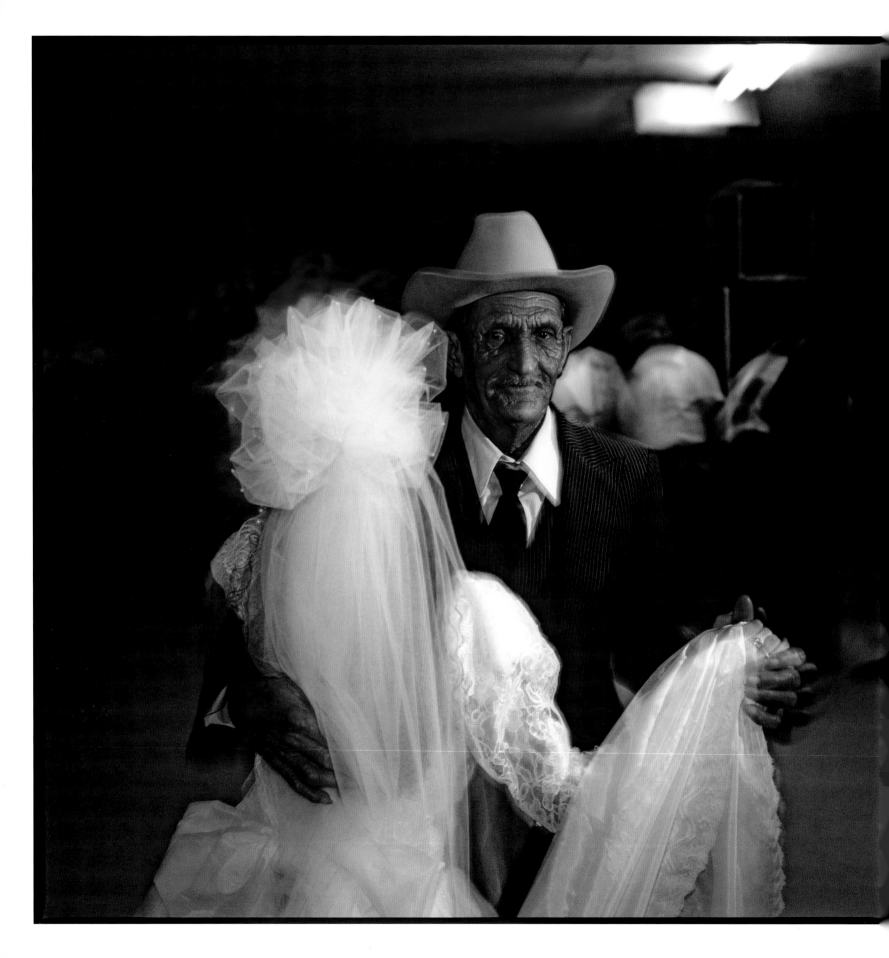

Rosemary Murillo & Douglas Elizondo

Rosemary Murillo celebrated her wedding in June of 1989 at the Flamingo Ballroom in Austin, Texas, where she danced with family friend Douglas Elizondo.

"I can remember it like it was yesterday," said Murillo, mother of three children and a customer service representative at J. C. Penney in Austin. "I really didn't know how to dance, but he led. He was my father's best friend, and I've known him for a long time. It was great. My mother made my dress—of taffeta and lace—and my sister Gracie made the wedding cake."

Elizondo, now confined to a wheelchair, earned his living working road construction.

"He was full of life, like my dad," said Murillo. "My dad was a painter, and they liked to work together fixing up houses. He was very helpful to others."

Gracie Murillo said Elizondo sold their parents the ranch in Creedmoor that became their home.

"My dad always counted on him," she said. "They were together all the time. On weekends, they used to kill hogs out in the country." ★

Johnny Degollado

AUSTIN
1989

Johnny Degollado wasn't like the other boys in his East Austin neighborhood. When they asked him to go fishing, he joined them, but he didn't take a fishing pole. Instead, he shouldered his accordion and practiced on the bank of the creek while his friends fished. Known as "The Montopolis Kid" after the neighborhood in which he grew up—and in which he still lives, just two blocks from his childhood home—Degollado is the king of conjunto Tejano music in Central Texas. He is the only musician in these parts who has played conjunto music continuously for sixty years. His band, Johnny Degollado y Su Conjunto, has never reshuffled or broken up.

"I'm really happy with the way everything has turned out," said Degollado, who has written hundreds of songs and recorded even more—on eight-track tapes, vinyl records, cassettes, and CDs. "For sixty years, I have entertained the people of Central Texas. What I want is for kids to do what I did and keep conjunto music going."

Degollado was an early disciple of the revered but unrecorded master accordionist Camilo Cantu. When Degollado was eight years old, his parents started taking him along to dances at La Polkita, a dance hall on the outskirts of Austin where Cantu, known as "El Azote de Austin" ("The Scourge of Austin") held forth.

"I was watching him all the time, and I loved the way he played," said Degollado, whose father, a carpenter, bought him his first accordion at age ten for forty dollars. "Cantu taught me all he knew. He didn't want conjunto music to die without passing it on. Everyone used to say, 'Camilo Cantu passed the torch on to Johnny Degollado.'"

Degollado's band has five members, including himself, instead of the traditional four: Vicente Alonzo, who has been with him since adolescence, on bajo sexto (a low-voiced, twelve-string guitar); drummer Lupe Murillo; bass player J. J. Varrera; and saxophonist Jesse Botello. The sax was Degollado's idea, and it creates a unique "Austin-style" conjunto sound.

Degollado, married to his third wife—Antonia, his first girlfriend—and father of eight children, has slowed down some in recent years and performs mainly on weekends. During the week, he eats breakfast out at Joe's Bakery, a Tejano musician hangout on East Seventh Street, then heads home and works in his accordion repair shop behind his modest home. Since he is the only person in the area who can tune and repair accordions, he is much in demand. For the past dozen years, he has also organized a popular conjunto music festival, bringing in the best musicians from the region.

In the meantime, he still has his first accordion, a beautiful 1930s-era Hohner that he has restored to its former grandeur; it occupies a place of honor in a glass case in his tiny office. But once in a while, on special occasions, Degollado dusts it off and takes it onstage. ★

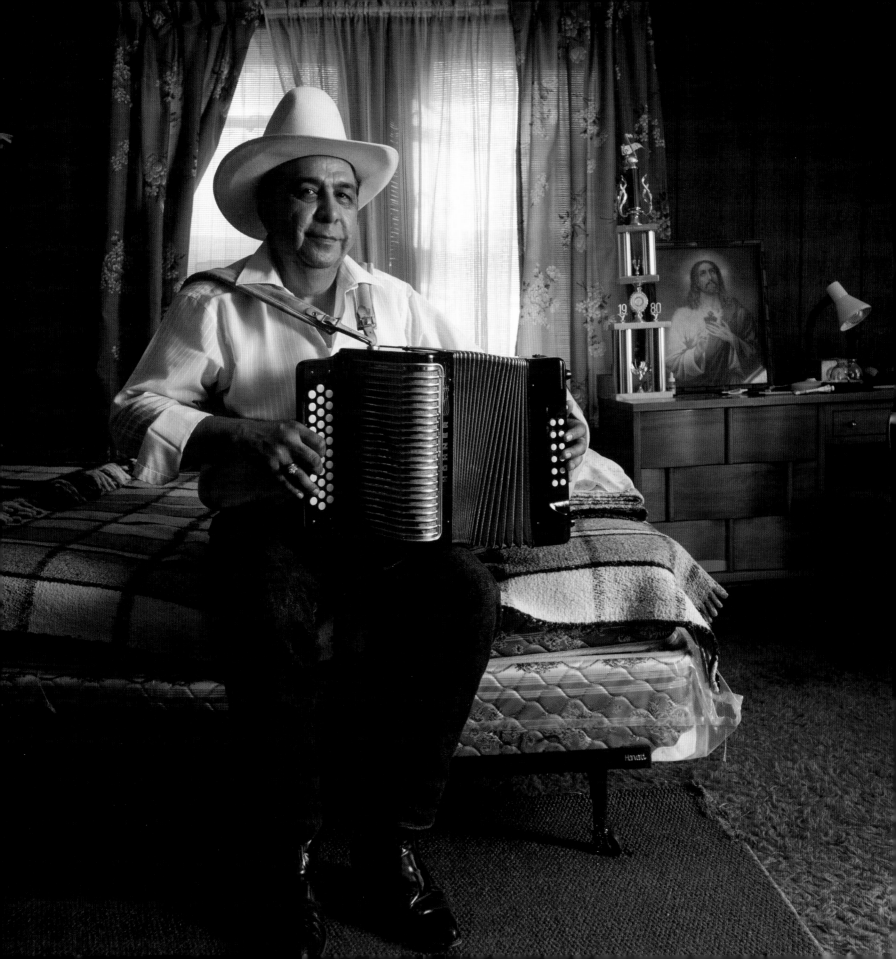

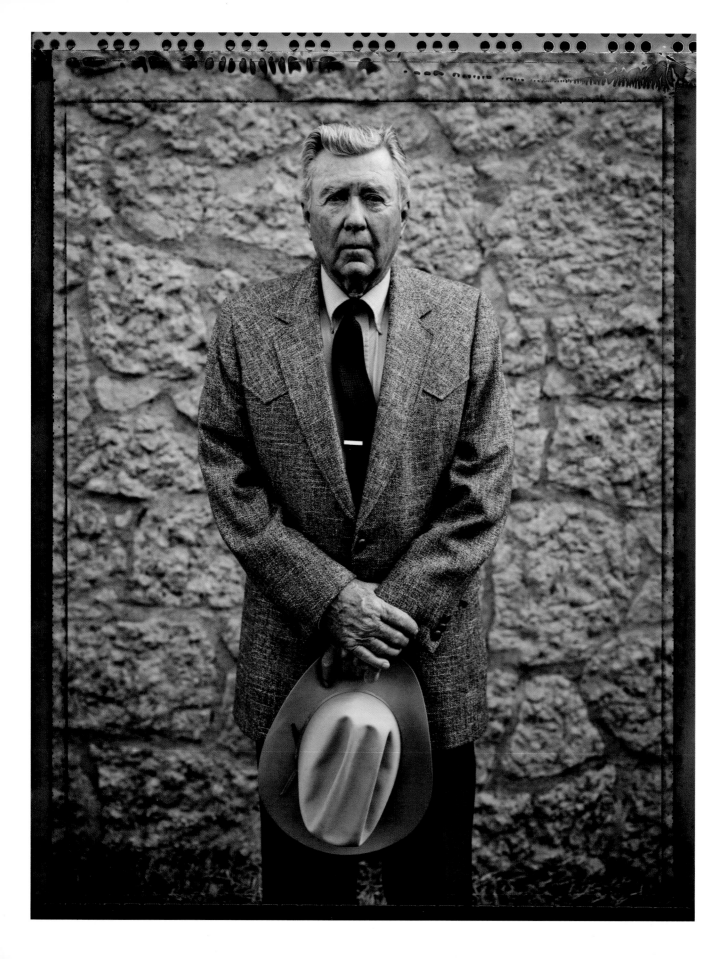

John A. Matthews

John Matthews has ranching deep in his bones, and even when he's not working, his favorite pastime is not going into town for amusement, but loading his .22 and calling his dogs for a stroll around the pastures.

"My grandparents came out here in the 1850s," he said. "This place—West Texas—sort of vaccinates you. It's a way of life; it gets into your blood."

Matthews was born in Dallas in 1919 but raised on a ranch outside Albany—the same 2,200-acre ranch, YL, to which he returned in 1988 after the death of his mother. In the preceding years, he bought, managed, and sold other ranches in Texas, Montana, Colorado, and Australia.

"Working with animals, being in the country, watching things grow, improving your herd . . . I love ranching for the satisfaction of doing it," said Matthews, a former Air Force pilot who was assigned, for a time, to a photographic mapping squadron in Africa during World War II. "I have seen a lot of places, but I haven't seen another place where I'd want to move."

Matthews—a graduate of Cornell University in animal husbandry—grew up milking cows, mending fences, riding horses, rounding up and branding cattle, and "doctoring screwworms." He spent his afternoons after school fooling around his ranch with his dogs, much as he does now.

"I'm still doing the same things," said Matthews, who also owns a 9,000-acre ranch twenty-five miles away on the Clear Fork River. "We just don't have to doctor screwworms."

He explained that screwworms—carnivorous fly larvae from eggs laid in open wounds of cattle and other warm-blooded animals, including humans—were eradicated from the area forty-odd years ago when the government, in conjunction with the livestock industry, developed and released sterile male screwworm flies in a controlled agricultural program. Since the female screwworm fly mates only once, the flies were eventually wiped out, and ranchers were free of an overwhelming burden.

Most of Matthews's family is equally committed to the ranching life. His second wife, Sharon, "fools with horses," in his words, racing and showing purebred and half-bred Arabians and managing a breeding and training facility. She and her daughter Holly also operate a mercantile store in Albany specializing in hunting and western gear. Her son, Randy, is associated with a consulting firm in Dallas and loves the outdoors. Matthews's three sons, Joe, Matt, and Kade, are ranchers, like their father, with spreads of their own. Only his daughter, Jill, broke the family mold: she's a contemporary artist in Austin, Texas, and Santa Fe, New Mexico, although she owns a ranch in Colorado, which she leases to former Matthews employees. ★

Lynn Wyatt

HOUSTON

2004

Tae kwon do is not the only arena in which Lynn Wyatt has a first-degree black belt. In 2000 the Houston philanthropist earned the moniker "Socialite of the Century" from *Texas Monthly* magazine—a superlative no one can dispute.

Wyatt, born in 1935, became known for the lavish parties and fundraisers at her Houston mansion. She counts among her friends heads of state, politicians, writers, captains of industry, actors, rock stars, and sports legends. And she has hosted them all in her neighborhood of River Oaks, which *Texas Monthly* describes as the "pine-shaded, mansion-filled dreamscape of folly and ambition" and the "geographic and mythical heart of Houston." For years, Wyatt's reign in zip code 70019 was supreme. And though younger, newer money has moved into River Oaks' elevated social world, Wyatt remains an icon. She has devoted herself to such causes as homelessness—riding in the Star of Hope Mission for the Homeless van to dispense food herself—and the arts, and credits her upbringing for making her aware of our human imperative to contribute.

"My parents always taught me to give back to the community and to give to people who are less fortunate than I am," she said in her Texas drawl. "It was just inbred."

A third-generation Texan, Wyatt—mother of four sons and grandmother of two children—is the granddaughter and grandniece of the founders of the Sakowitz department store chain. The brothers, Tobias and Simon Sakowitz, were the sons of Ukrainian immigrants. Wyatt's ancestors first immigrated to New York in 1888; later the family moved to Texas to work in the Galveston cotton mills. They bought land nearby in Dickinson, where a Jewish community was burgeoning.

Wyatt is married to Oscar Wyatt, a crop-duster-turned-wildcatter who became a billionaire oilman. Her guest lists at the "Wyatt Hyatt," as her house was known during the oil-boom seventies and early eighties, included such celebrities as Mick Jagger, Elton John, Truman Capote, Princess Grace, Joan Collins, King Hussein and Queen Noor of Jordan, and Bill Blass.

A taut blonde whose youthful looks belie her age, Wyatt is famous for her impeccable taste, open mind, raspy voice, contagious laugh, and devotion to her family and friends. In 2007 her husband was indicted in the United Nations Oil-for-Food scandal and served nine months in prison, after which he suffered a debilitating stroke. She stuck by him, positive and unflappable.

"My motto is laugh a lot, love a lot, and live life as an adventure," she said. "I am happy exactly where I am." ★

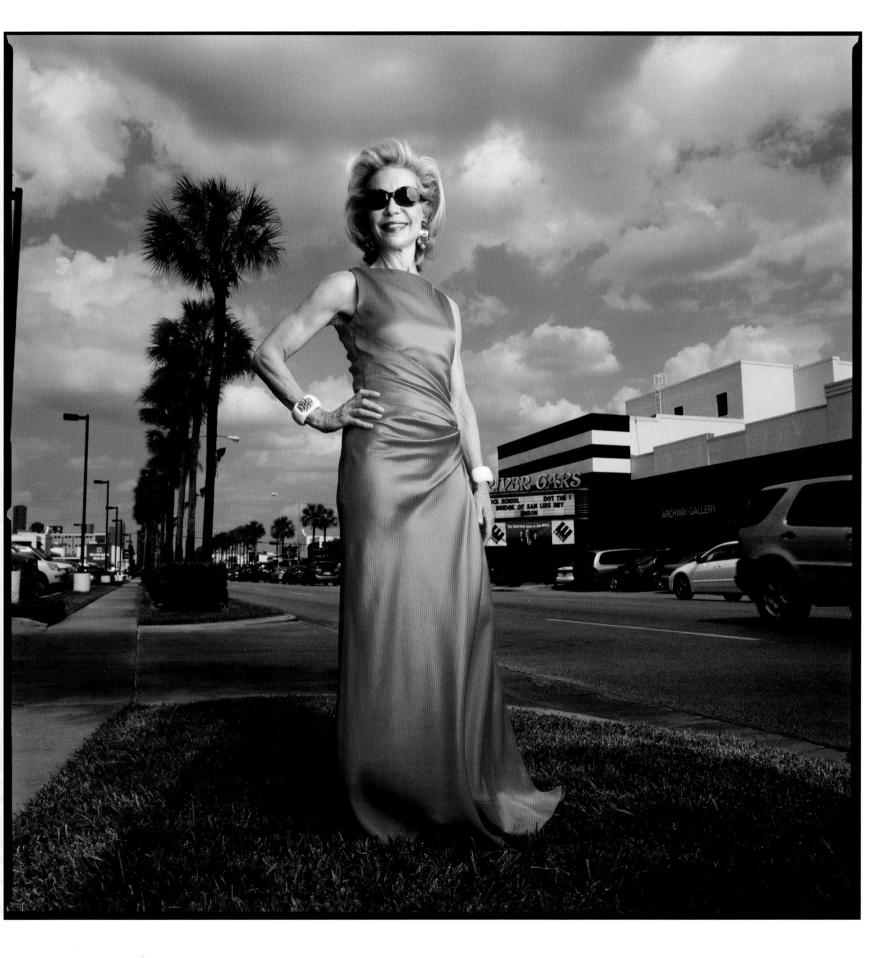

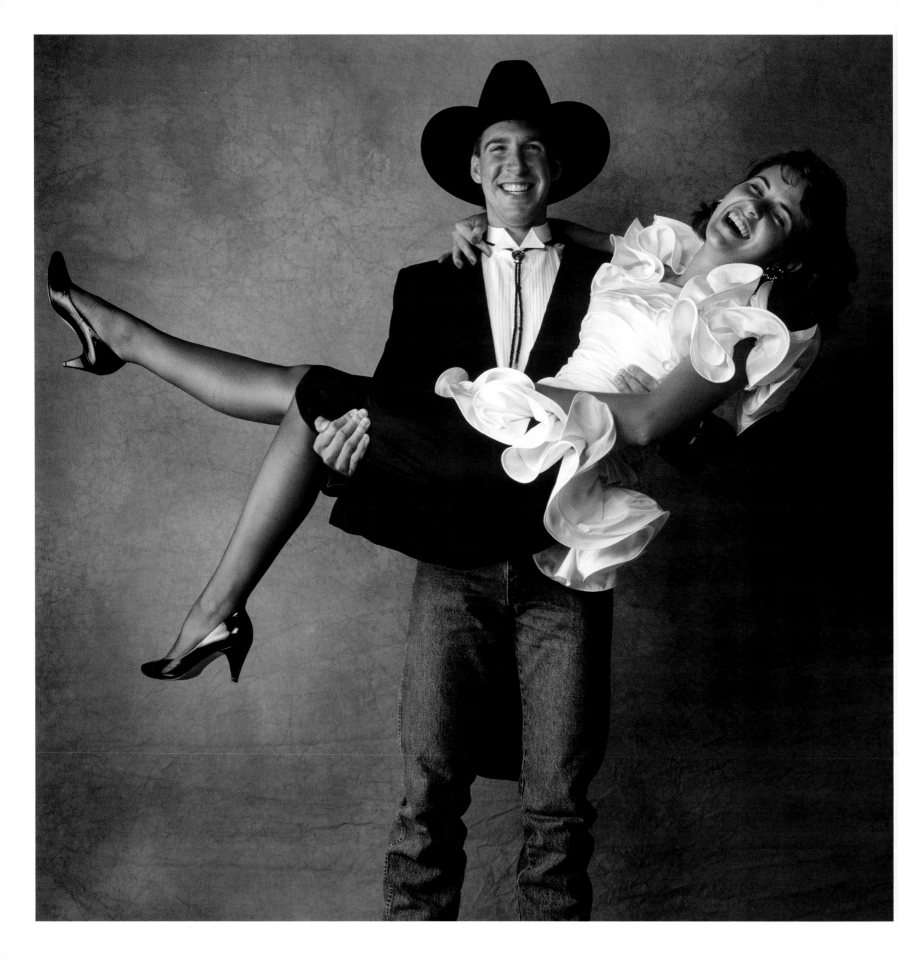

Sloan Teeple &
Tracey Hanslik

AUSTIN

1989

Sloan Teeple and Tracey Hanslik appeared on the cover of *National Geographic* magazine in June 1990 in a story about Austin, Texas, after being photographed at the Austin High School prom in 1989. Teeple and Hanslik were "sort of" girlfriend and boyfriend; their families were close, as they shared a hunting lease, and the couple spent much of their time together as part of a close-knit group of friends.

"Tracey was my dancing partner," Teeple said.

Coincidentally, both wound up in the medical profession, though they married other partners. Teeple became a urologist and Hanslik a nurse practitioner.

Hanslik moved to Houston to pursue her career and to join her brother and sister. Her sister introduced Hanslik to her future husband, Eric, a mechanical engineer whose parents lived right across the street. Hanslik earned her nursing degree from Baylor University and, after working as a nurse in Dallas, went back to school at the University of Texas at Arlington to get her master's. She works with liver patients.

"I love what I do," said Hanslik, whose job as a nurse practitioner allows her to see patients, prescribe drugs, and otherwise work more independently than she could as a nurse. "My parents knew I'd be in medicine since I was five. I was always very concerned with people's well-being. I was a candy striper at the hospital by age ten."

Hanslik said a course at Austin High that introduced students to medicine and a hospital setting at Brackenridge inspired her to pursue nursing.

"We had a really good teacher, Judy Rose, who was a nurse," said Hanslik. "She was a really big influence. She came to my wedding."

Initially, Teeple planned to become a veterinarian. But he was turned down by Texas A&M Veterinary School the first time he applied, and friends convinced him he would make a good doctor. After working in a hospital, he agreed. He graduated from the University of Texas at Austin and was accepted into medical school at UTMB in Galveston. In the meantime, before he changed his mind, he had applied again to the vet school at Texas A&M and was accepted. But by then, his path was set. He did his urology residency in Shreveport at Louisiana State University.

Teeple met his wife, Susan, indirectly as a result of the *National Geographic* cover. A resident of Houston, she was about to enter college at UT Austin. Her father, a longtime subscriber to *National Geographic*, handed her the magazine with Teeple and Hanslik on the cover and said, "Here, read this. It's all about Austin, and you're about to move there." She saw Teeple's picture and said, "He's cute!" Once at UT, Teeple saw her at a fraternity party and found out who she was. Later, at a football party in Dallas, she recognized him from the magazine cover and they finally met. They've been together ever since.

In 2012 the couple collaborated on a book together titled *I'm Still Sexy So What's Up with Him?* about testosterone deficiency, his medical specialty. The couple has three children and lives in Amarillo.

"Our heart's definitely in Texas," said Teeple. "I'd love to raise my children the way I was raised. I can't see them going to LSU instead of UT!"

Hanslik lives in Houston; she married in 2001. ★

Emma Feld Mallan

MARFA
1988

Emma Feld Mallan (1906–2002), a native New Yorker, adopted Texas as her home in 1946. Her husband, a steel magnate, bred palomino horses, and the couple traveled to Marfa to buy breeding stock for their stable in New Jersey. Mallan chose to stay. The Texas weather suited her young son, who suffered from chronic pneumonia, and she fell in love with the land. In 1950 she inherited the landmark Paisano Hotel in Marfa—home to the cast and crew of the film *Giant* for six weeks in 1955. Headliners James Dean, Elizabeth Taylor, and Rock Hudson lived at the Paisano for a week, but peeled off from the rest of the group to move into private homes until filming ended. To manage the sixty-room, sixty-bath hotel—a job she held for sixteen years—Mallan called on her social experience in New York entertaining titans of the steel industry.

In later years, Mallan led a quiet life on a ranch with her dear friend Margaret Weyrauch until she was well into her nineties. The pair came into town regularly to visit the post office, have lunch, and get their hair done at Helena's Beauty Shop in the old hotel on Main Street, where framed photographs from *Giant* adorned the walls—a gift from Mallan to shop owner Helena Alsobrook. "It's a simple life," said Mallan, at ninety-three, "but we like it."

Alsobrook styled Mallan's hair nearly every Thursday morning for thirty years.

"She was a wonderful person, both as a customer and a friend," said Alsobrook. "She was a like a second mother to me. I'd tell her my problems and she'd pray with me. I miss her very much." ★

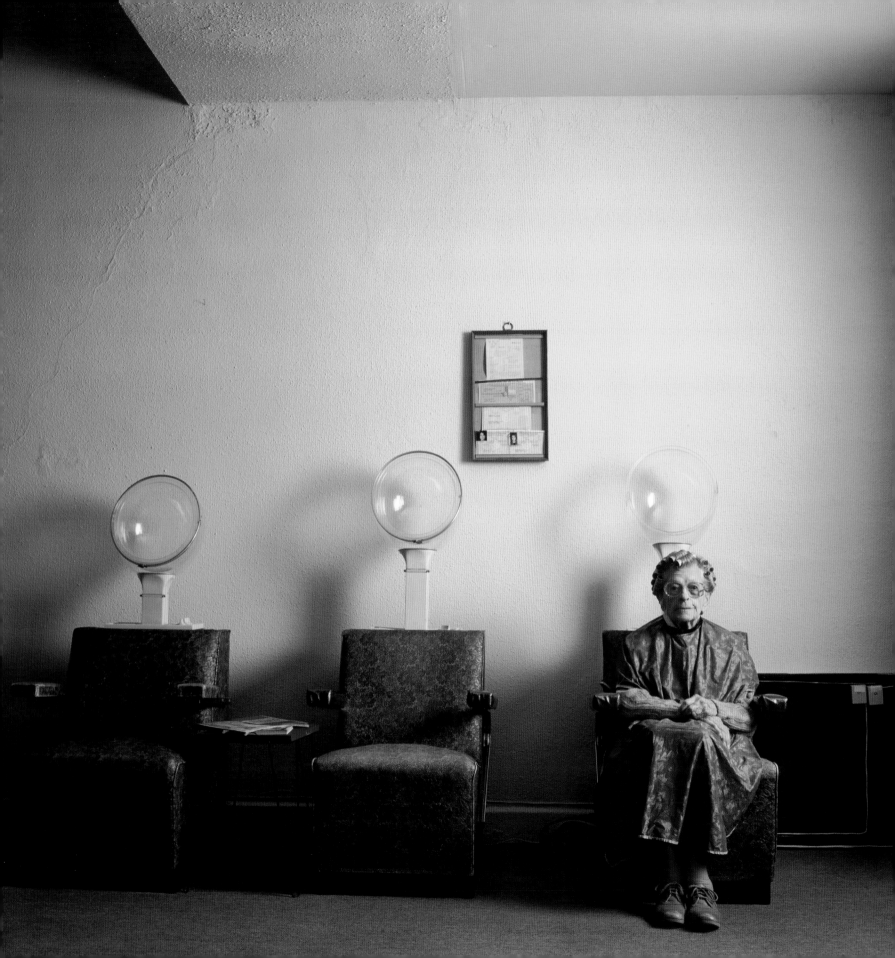

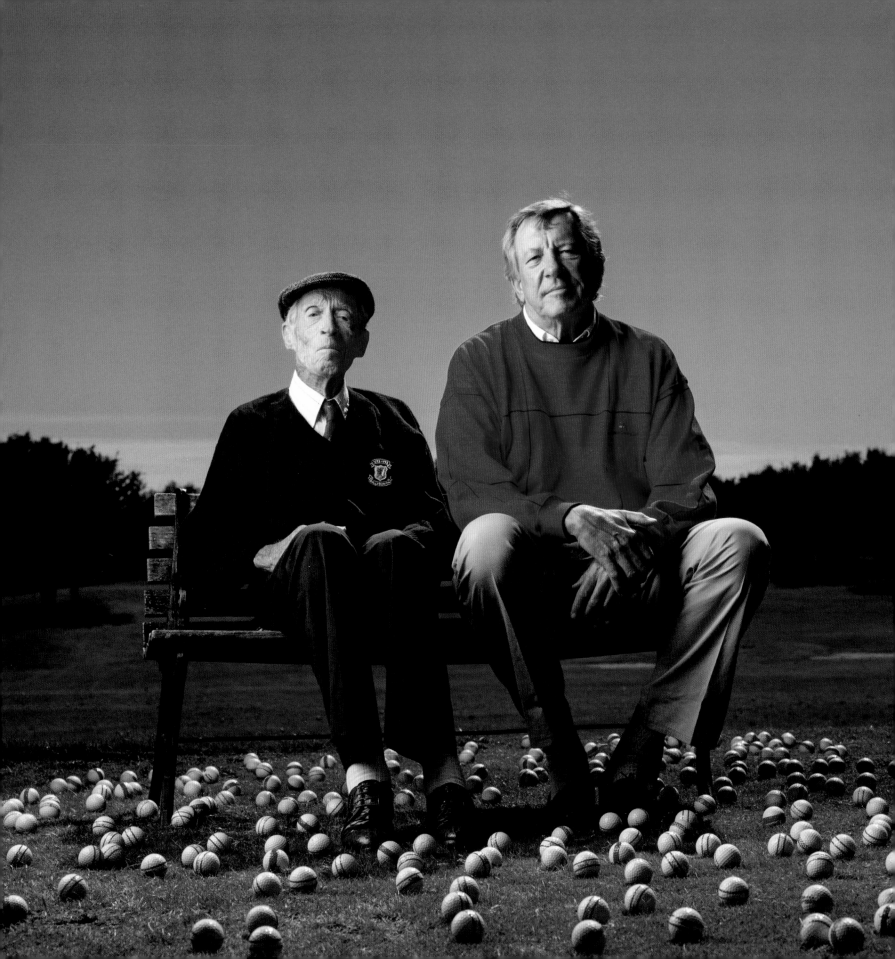

Harvey Penick
& Bud Shrake

AUSTIN

1993

Writer Bud Shrake (1931–2009) had known Harvey Penick (1904–1995) for years when Penick summoned him one fall day in 1991 to Austin Country Club. Shrake joined the eighty-six-year-old head golf professional emeritus in his golf cart under the trees. Shrake's brother who had been on Penick's team when Penick was golf coach at the University of Texas—a position he held for thirty-three years.

"I thought he wanted to talk about my brother," said Shrake, a former *Sports Illustrated* writer and the author of numerous books and screenplays.

But Penick—who started caddying at the Austin club when he was eight years old and held the head pro position for fifty years—dispensed with small talk.

"He reached into his attaché case and pulled out a five-by-seven, red scribble-text notebook," said Shrake. "He said he'd never shown it to anyone except his son, Tinsley."

With the writer's help, the notebook became the famed *Harvey Penick's Little Red Book*, a sixty-year compilation of Penick's considerable golf wisdom, plainly told, along with plenty of practical life philosophy. Shrake collaborated with Penick on writing the book and arranged a publishing deal with Simon & Schuster. The *Little Red Book* became the best-selling sports book of all time, and

four similar Penick/Shrake golf books followed. Penick's simple advice—"Take dead aim"—is legendary among golfers.

"I revered Harvey Penick," said Shrake, who begged off a movie commitment to take on the project. "At the time, I felt, 'I've been chosen by some divine force to do this.'"

The book is as much about life as it is about golf. When a New Yorker showed up at Austin Country Club one day for Penick's help, the man said, "If you're such a great teacher, teach me how to get out of sand traps," Penick relates in the book.

"Not so fast," Penick tells him. "I can teach you how to get out of sand traps. But I'm not going to do it until I teach you how to avoid getting into them in the first place."

Considered by many to be the greatest golf teacher in American history, Penick taught people, not methods. He said he never used the words "never" and "don't" with his students, who included such golf greats as Ben Crenshaw and Tom Kite. "I try to put everything in positive, constructive terms," he said.

When one of his less talented pupils would hit a fine shot, Penick got as excited as he did with a pro.

"I would get goose pimples on my arms and a prickly feeling on my neck from the joy of being able to help," he said.

"Harvey came closer than anyone I know to living life by the golden rule," said Shrake, whose novel *The Borderland* deals with the history of Austin. "People love[d] his soul as well as his teachings."

Penick died at the age of ninety in 1995. Shrake, also known as the longtime companion of the late Texas governor Ann Richards, died of lung cancer in 2009 at seventy-seven. He is buried beside Richards in the Texas State Cemetery in Austin. ★

Roosevelt Thomas Williams

His fans knew him as the Grey Ghost; the nickname came from his penchant for suddenly materializing at a gig, then vanishing just as quickly. Roosevelt Thomas Williams (1903–1996), considered the last of the original barrelhouse blues pianists, spent years performing at clubs located along the Texas and Pacific Railroad line between Dallas and El Paso. He would hop a freight, wearing overalls over his stage clothes, jump out at the appointed town, stash his overalls in the bushes, and steal to the gig under cover of darkness. When he finished playing, he would slip back to the depot, slide back into his overalls, then hop a train to the next town.

"I'm just like a ghost," he told his bewildered fans, who never saw him arrive or leave. "I come up out of the ground and then I go back in it."

Williams, who was named after Teddy Roosevelt, was born December 7, 1903, in Bastrop, Texas, and raised in Taylor, Texas. During a music career that spanned over seventy-five years, he supported himself by laboring in the cotton fields and cotton gins, bootlegging, gambling, working as a chauffeur, and driving an Austin school bus. Though he had brushes with fame when he was younger, it wasn't until Tary Owens—who had earlier recorded a collection of Williams's songs—tracked him down at eighty-three that the Ghost came back into the limelight. Williams spent the next several years traveling in style to prestigious gigs around the country. The mayor of Austin declared December 7, 1987, "Grey Ghost Day," and the following year Williams was voted into the Texas Music Hall of Fame.

But Williams is perhaps most famous for his regular happy-hour stint at Austin's Continental Club. When he was in his late eighties and early nineties, a whole new generation of fans flocked to the club to hear the first-generation Texas bluesman play and sing soulful tunes of a bygone era.

He spent the last year of his life in a nursing home, where he still enjoyed some of his old vices: eating barbecue, smoking cigars, and drinking a daily beer or whiskey before settling down to play the piano.

"I don't ever give up," Williams said. ★

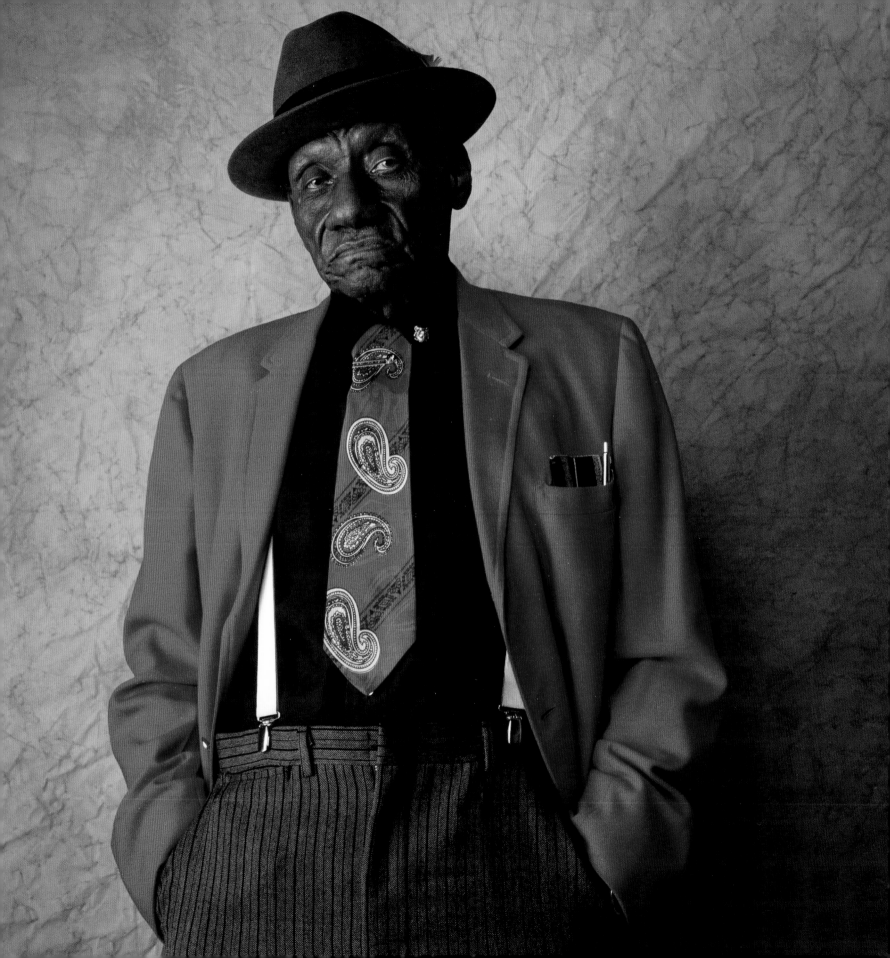

Carl
Lewis

HOUSTON
1993

Carl Lewis was literally born to run. On July 1, 1961, Frederick Carlton Lewis came into the world in Birmingham, Alabama, the newest member of a family of swift athletes. Though small as a boy, he experienced a teenage growth spurt so dramatic that he had to use crutches for several months until his body adjusted. By the time he graduated, he was the top-ranked high-school track athlete in the country and earned an athletic scholarship at the University of Houston.

Lewis, an outspoken critic of steroid use by athletes, went on to win nine Olympic gold medals and eight gold medals in the World Track and Field Championships, and to break the world record in four events. He won one of those Olympic golds in 1988 in Seoul, South Korea—in the 100-meter dash—after Ben Johnson tested positive for steroids and was stripped of his medal.

Lewis trained hard all his life but his talent was in the genes: his father, Bill Lewis, was a former track athlete and football star at Tuskegee Institute in Alabama; and his mother, Evelyn Lawler Lewis, represented the United States as a hurdler in the 1951 Pan American Games and was an Olympian in the 80-meter hurdles in Finland in 1952. Lewis's siblings were also athletes: his oldest brother, Mack, was a high-school sprinter; his brother Cleve played professional soccer; and his younger sister, Carol, was once the top-ranked woman long-jumper in the country, as well as an accomplished high-jumper, hurdler, and sprinter.

When Lewis was a boy, the family moved to Willingboro, New Jersey, where his parents became high-school teachers and founded the Willingboro Track Club. Lewis started running with the club when he was eight, but he was smaller than his siblings and regularly lost to his little sister in track events. When he was nine, he won the long-jump competition at a children's track meet and received his medal from Jesse Owens, a man whose career he would ultimately shadow.

"You're really talented," Owens told him. "You're a little guy, but you beat all the big guys."

Years later, at the 1984 Olympics, Lewis won the gold medal in the same four events—the 100-meter dash, the long jump, the 200-meter run, and the 400-meter relay—in which Owens had prevailed in Berlin in 1936. When his father died in 1987, Lewis buried his 100-meter gold medal from the 1984 Olympics with him.

Lewis, a United Nations Goodwill Ambassador, was inducted into the U.S. Olympic Hall of Fame in 1985. He continued to live in Houston after college for nearly two decades, briefly owning a restaurant and launching a line of sports clothing. For a time, he pursued acting in Los Angeles, appearing in several films and television productions. ★

Cat
Osterman

AUSTIN

2004

C at Osterman has a gift—beyond her general athletic prowess. The softball pitcher, who grew from 5'6" to 6'2" between junior high school and college, has very large hands. They are *so* large, in fact, that she can grip the ball with her fingers, without having to cradle it in her palm—giving her above-average spin. And she's a leftie to boot. She has command of six different pitches, though she claims she rarely throws her fastball. As a freshman in 2002 at the University of Texas, she struck out 554 batters, the second-best single season total in NCAA history at the time. She broke her own record in her junior and senior seasons.

Although Osterman retired at thirty from playing pro softball, she has not abandoned the game. The pitcher extraordinaire has moved on to coaching and mentoring. She works as assistant coach for St. Edward's University's Division II women's softball team, under her friend and former University of Texas teammate, head coach Lindsay Gardner. And she serves as board member and dedicated mentor and coach for youth in East Austin at Reviving Baseball in Inner Cities (RBI). RBI is a nonprofit that promotes mentor relationships in softball and baseball to "engage youth athletically, academically, and spiritually" with the goal of inspiring

them to transform their communities. The national organization has reached a million young inner-city athletes since it was established in 1989.

"I want to see softball grow," she has said.

Catherine Leigh Osterman comes from a family of teachers and coaches in various sports. Her father, uncle, and aunt have all coached basketball, and one of her younger brothers is becoming a swim coach. She sees her own future in coaching. As an athlete, she earned accolades too numerous to count. The highlights: two-time Olympian, two-time world champion, three-time National College Player of the Year, and four-time All-American. She has seven career NCAA Division I perfect games and 2,265 career NCAA Division I strikeouts.

Her drive began early. By the age of four, the Houston native had made up her mind to attend UT. Although she played various sports growing up, including basketball and soccer, she eventually decided to focus on softball. At the age of eleven, she asked for pitching lessons after filling in as a pitcher for her Little League softball team. She had a knack for the sport.

After her career at UT and with the national team, she played professional softball as part of a Japanese team, the Toyota Shokki, and with two U.S. National Pro Fastpitch organizations: the Rockford Thunder and the USSSA Pride, based in Florida.

But she never envisioned being a "lifer," and injuries and years of relentless intensity have taken their toll. She is transitioning into a phase of her life in which she wants to contribute and appreciate the game from a different perspective.

"I really enjoy giving back and seeing other athletes be able to fall in love with the game and get better with the game," she said. "I will always remain part of it." ★

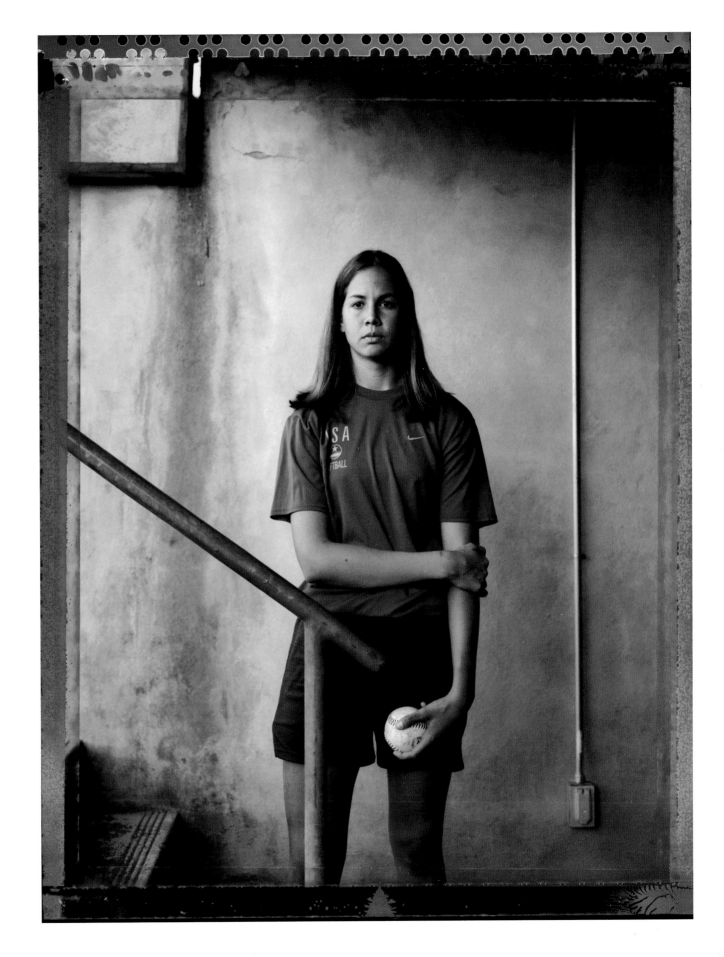

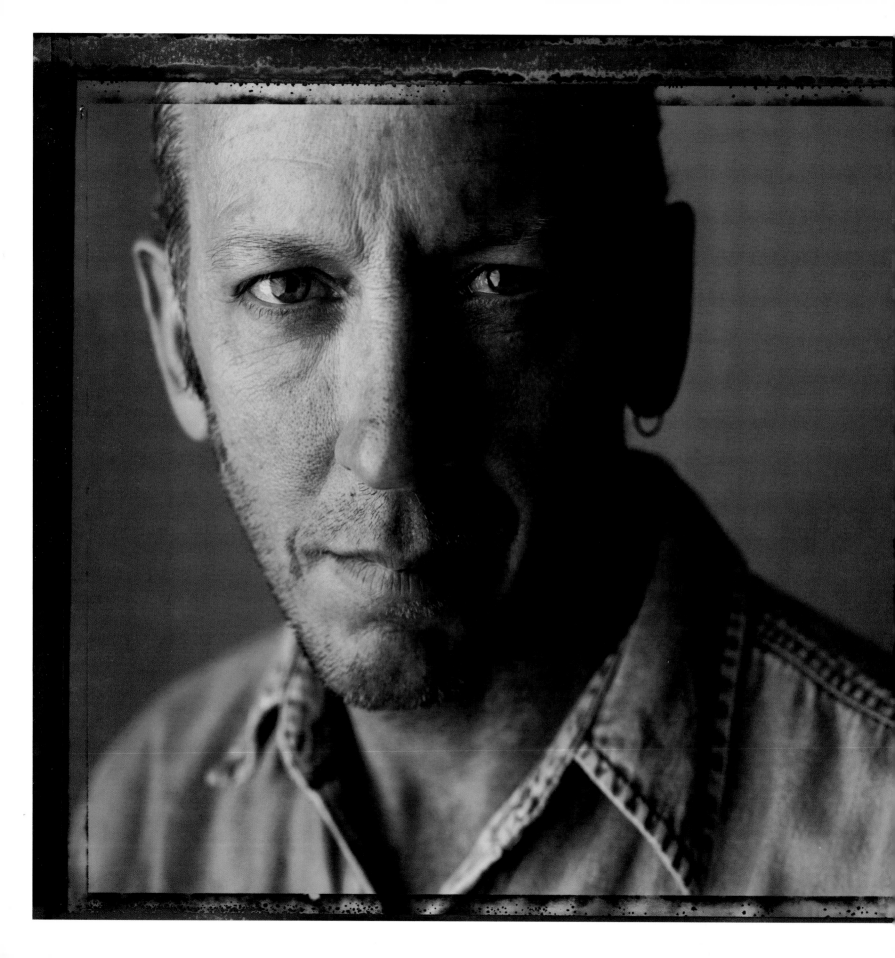

Darden Smith

AUSTIN
2009

When nine-year-old Darden Smith stepped on a scorpion, his mother sliced a homegrown tomato in half and slapped it on the wound. Later, when she was bitten on the finger by a copperhead, she used the same remedy, coring a tomato and jamming her finger in the spongy hole, until she could drive herself—two kids in tow—to the hospital. Smith grew up in the country outside Brenham, and though he lives in Austin now, he works at maintaining the same kind of simplicity in his life. He's cut down on touring, lives modestly, and has created some local music initiatives, recalibrating his music career so that he can spend more time with his two children, Willa and Eli.

"I've tried to move away from Texas several times but never could," said Smith, whose grandfather was a fiddler and square-dance caller. "I think it's because of the landscape. The geography here grounds me. I'm a Westerner."

The singer-songwriter, who opened his first checking account in third grade to save money from his fresh-egg business, started playing guitar at nine and wrote his first song at ten. But it wasn't until later that he hit his true creative stride.

"In eighth grade, my family moved from Brenham to a suburb of Houston," Smith said. "We went from a family farm to a condominium across from a golf course. It was culture shock! I started writing songs aggressively then."

Earning cash through a self-styled landscaping-and-odd-job business, Smith wormed his way into his older brother Dugan's band by becoming indispensable.

"They needed a mike and an amp, so I went out and bought the equipment," he said. "I told them that if they wanted to borrow it, I came with the deal."

Smith ended up taking over the band, and his brother, now a financial expert, moved on.

By 2013 Smith's life had changed again. Like most musicians, the Internet had disrupted his business. His response: the Be An Artist program in Austin schools, donor-supported songwriting workshops for young students. He lights a fire inside them.

"All those things you love to do now—you can find a way to do them the rest of your life!" he tells them. "You're creative, you're unstoppable, and you can do anything you want to do." Kids who arrive with blank, bored expressions come alive. After collaborating on setting their lyrics to music, they leave proudly clutching a CD of their efforts. More recently, Smith has expanded the workshops to returning war veterans. Several times a year, he and a couple of songwriter colleagues host Songwriting With Soldiers retreats, intensive weekend collaborations with soldiers featuring songs fueled by their emotional experiences. It is a powerful form of therapy—in Smith's words, "using songwriting in the service of something bigger than myself." "Angel Flight," a heartbreaking example, tells the story of the helicopter crews who transport the bodies of dead soldiers home to Texas.

Smith, who has produced thirteen albums in his nearly three-decade career, says that although he has traveled the world, he feels most authentic in Texas, where the landscape is mythic and Austin the ultimate musical "petri dish." "It's the root," he said, "of all my creativity." ★

Kelly Willis

TAYLOR

1993

Kelly Willis was new to Austin when she was "discovered" by singer Nanci Griffith. Willis was singing at Austin's Continental Club in 1990 when Griffith wandered in and caught the end of her set. Griffith was so impressed by the plaintive, sensual, country voice of the pretty, young singer that she headed for the phone and dialed MCA producer Tony Brown. A few months later, a record deal was struck, and Willis was on her way with her debut album, *Well Traveled Love*.

She's had lots of ups and downs since then—including a disappointing foray into the highly commercial Nashville music scene and a parting of the ways with MCA—but she got back on track with the album *What I Deserve*, released on the independent label Rykodisc to glowing reviews. She followed that up with *Easy*, which she co-produced. In all, she has recorded ten albums, the most recent of which, *Cheater's Game*, is a collaboration with husband Bruce Robison.

Willis is not a Texan by birth. She was born in Lawton, Oklahoma, the youngest of three children, and grew up in North Carolina and Virginia; her particular twang is resonant of these formative years. Influenced by her mother, who used to perform in local musicals, she started singing at the age of nine to comfort herself after her parents' divorce. After the marriage ended, Willis and her siblings lived with her father, an Army colonel, moving from place to place.

She got her first break in high school. One day at a beach arcade, she slipped into a coin-operated recording booth and sang Elvis Presley's "Teddy Bear." She took the demo and parlayed it into a spot in her boyfriend's rockabilly band. Kelly and the Fireballs became a moderate success around the Washington, D.C., area in the late eighties before they moved on to Austin.

Willis's reputation has been enhanced by some brushes with celebrity. She appeared in the film *Bob Roberts*, directed by and starring Tim Robbins. She was selected as one of *People* magazine's "50 Most Beautiful People." Her songs were featured in the films *Thelma & Louise* and *Boys*. She posed for some glossy magazine photo spreads—*Vogue* among them. And she performed at a mansion gala honoring President Clinton at one thousand dollars a plate.

But the singer, who is known among the local media as "the voice of Austin," seems determined now to concentrate on the basics: writing good songs, performing with musicians she admires, and maintaining artistic control of her career. If blockbuster success eludes the shy, ethereal artist, so be it.

"Since I was raised an Army brat . . . Texas was the first connection I had to any place," said Willis, who lives with husband Robison, a respected singer-songwriter, and their four children, including twins. "I feel lucky to be connected to the landscape of Texas—the earth—the dirt and rocks. It makes me feel whole, complete and peaceful." ★

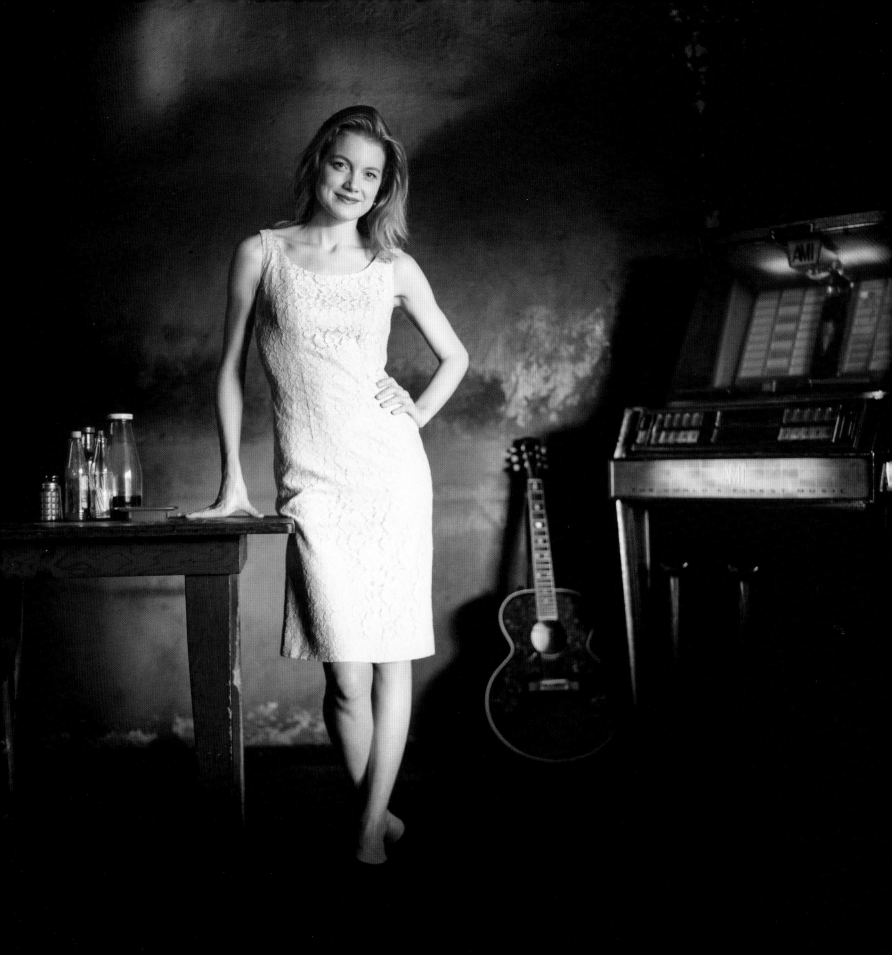

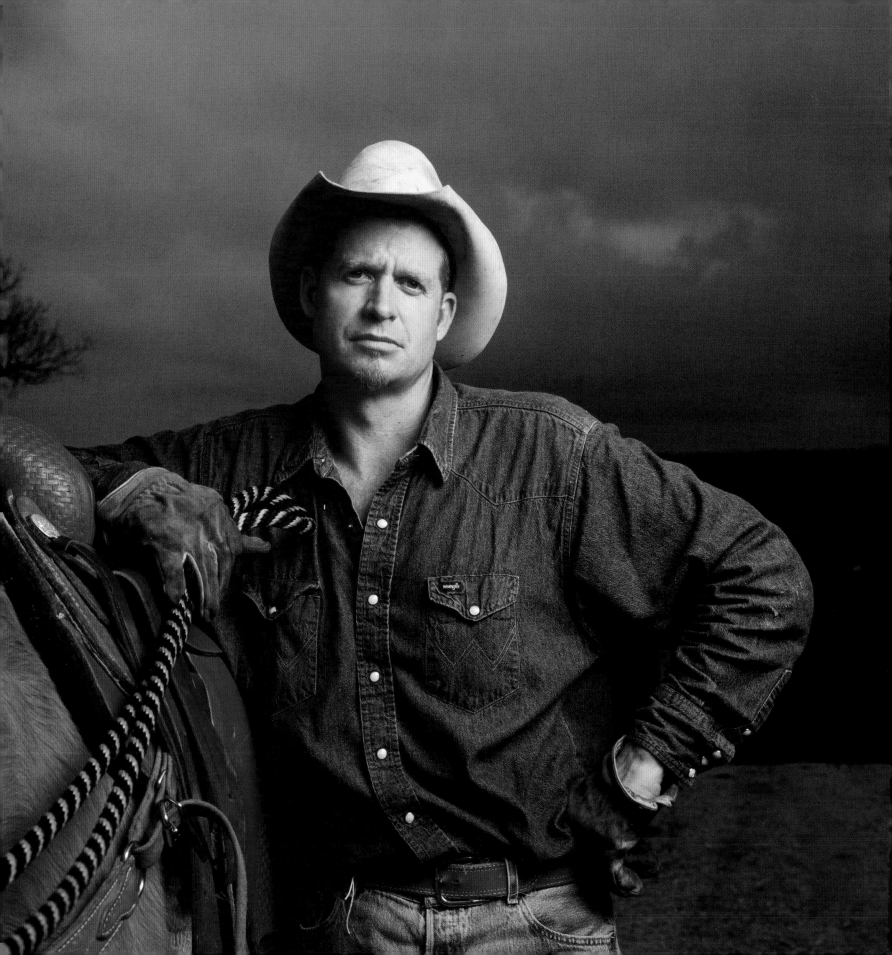

Charlie Robison

BANDERA

2001

Charlie Robison's mother, Martha Ben, tended bar at various watering holes around his hometown of Bandera, Texas; she managed the Purple Cow Saloon, and at the Mayan Dude Ranch, she poured drinks *and* played a "Pistol-Packin' Mama" in the bar's Wild West show. Robison was accustomed to honky-tonks and juke joints at an early age, and music was in his blood.

"It was in the early seventies, at the height of the outlaw movement when Willie had returned [from Nashville]," said Robison of the "cross-pollination" of rednecks and hippies that characterized the music scene then. "When I wasn't working on the ranch with my grandfather and father, I was sitting behind the bar listening to music at a grungy Texas honky-tonk."

Robison, originally a drummer by default, was only fifteen when he took to the stage himself. He first played in a band with his brother Bruce on bass and a friend on guitar. He got what was left—drums. The trio cut their musical teeth playing rodeos and school dances in their quaint Hill Country hometown, population 859, which was settled by Polish immigrants in the nineteenth century.

Later, Robison switched to guitar and singing and became so focused on music that college got in the way. He dropped out of Southwest Texas State, sacrificing football and baseball scholarships, and headed to Austin. He spent a few years establishing his music career—in bands like the Chaparrals, Two Hoots and a Holler, and the Millionaire Playboys—until the nineties, when he went solo. Off and on, he returns to Bandera and the land that inspires him.

"I always felt I was born a century too late," said Robison, who raises cattle and quarter horses on his family spread. "Texas is the only place you can lie to yourself that time has stood still . . . where you can play cowboys and Indians the rest of your life."

Robison and his ex-wife, Emily, the banjo player for the Dixie Chicks, are the parents of three children. The divorce was amicable, and Robison's album *Beautiful Day* chronicles the love, pain, and ultimate redemption of the experience.

His songs—gritty, robust—reflect the man himself, a native Texan whose family has ranched in Bandera for eight generations. Family, Texas history, and real life are the stuff of his music, and in Robison's case, you *can* go home again:

> If you're ever out west son,
> And you're feelin' like slowin' down,
> I'll see you around,
> 'Round my hometown.
>
> —"My Hometown," from
> *Life of the Party* ★

Mack Brown

AUSTIN

2000

Mack Brown laid the groundwork for his career on a road trip with his grandfather. At the age of five, Brown rode a yellow school bus through the rolling hills of middle Tennessee with his granddad, Eddie "Jelly" Watson, and the football team of Cookeville Central High. They were heading to an out-of-town game, where Watson, one of the most successful high school football coaches in the state, would try and rack up another win. The stage was set: though he didn't know it yet, young Brown was preparing for a life in football.

The future head coach at the University of Texas went on to play high school baseball, basketball, and football; but he turned down an offer by Paul "Bear" Bryant to play college ball at Alabama. He chose Vanderbilt instead, but transferred to Florida State, where he earned two letters. Afterward, he pursued the coaching track with head coaching jobs at Appalachian State, Tulane, and North Carolina, where he had a successful run.

Brown came to the troubled Longhorns in December 1997. Texas was looking for the man who could bring home the national title, and the search committee was unanimous in its choice. With his gift for recruiting, Brown set about rebuilding the UT program into a national power, establishing it as one of the nation's premier offensive teams and turning the struggling defense into a formidable force. His Longhorns won the national championship in 2005 and won seven of their ten bowl games. In 2006 Brown won the Paul "Bear" Bryant Award for Coach of the Year. On November 27, 2008, he reached his two hundredth career win—the first Texas coach to achieve that status. Brown's Longhorn squads featured a Heisman Trophy winner, twenty-three All-Americans, thirty-seven first-team All–Big 12 Selections, three Big 12 Offensive Players of the Year, two Big 12 Defensive Players of the Year, and seven Big 12 Freshmen of the Year.

But Brown's passion for football didn't affect his commitment to education and to developing his players as men of intellect and character. "Our goal is to win championships with nice kids who are graduating," he said. "We may be in the entertainment business on the weekends, but we are in the education business during the week."

Brown, a native of Cookeville, Tennessee, liked to say he'd been "dipped and vaccinated" in all things Texan. His spacious office overlooking the south end zone of the Darrell K Royal–UT Memorial Stadium was a shrine to Texas and the Longhorns. Besides steer-hide decor and assorted memorabilia, he kept a Native American dream catcher, a gift from Willie Nelson, to inspire him to dream of championships.

The players' lounge is a young jock's dream, and the locker room looks like something befitting the Cowboys. Every player's locker is outfitted with a personal action photo and the names of any all-conference Texas players who sported the same jersey number. Brown, whom his predecessor Darrell Royal called "a marketer, a coach, a politician, and a CEO" rolled into one, saw that the football complex, which he transformed, stayed immaculate and bespoke Texas pride. Even the elevators are fodder for the Longhorn image: visitors are serenaded with "Texas Fight" on the way up and "The Eyes of Texas" on the way down.

Brown stepped down as head coach for the Longhorns in 2014, but he plans to stay on as a special assistant to the UT Athletic Department. ★

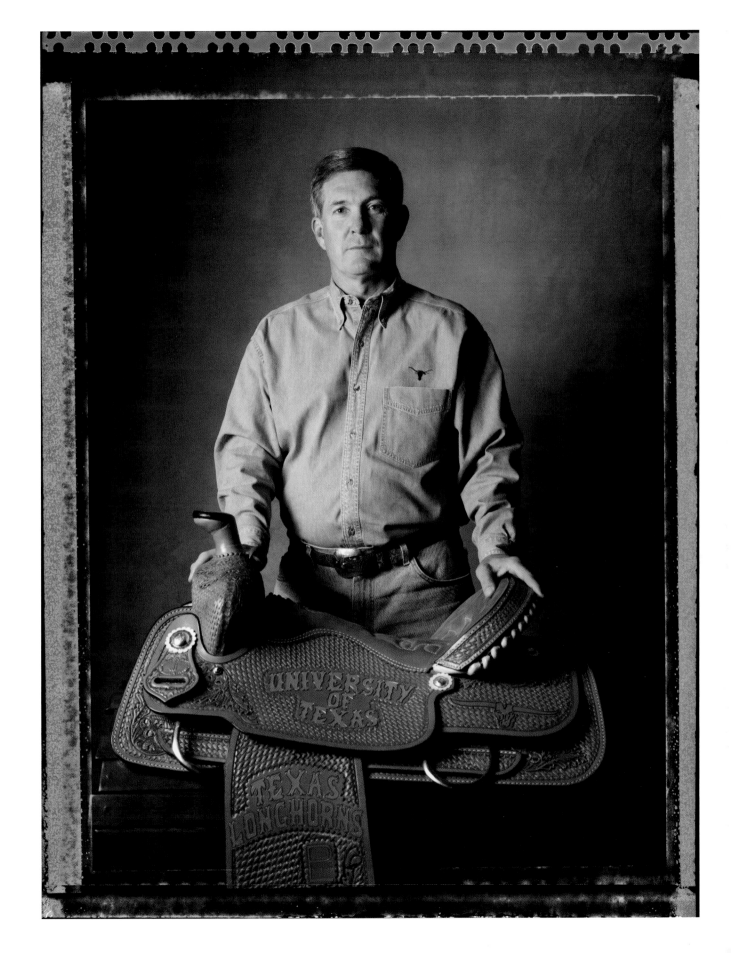

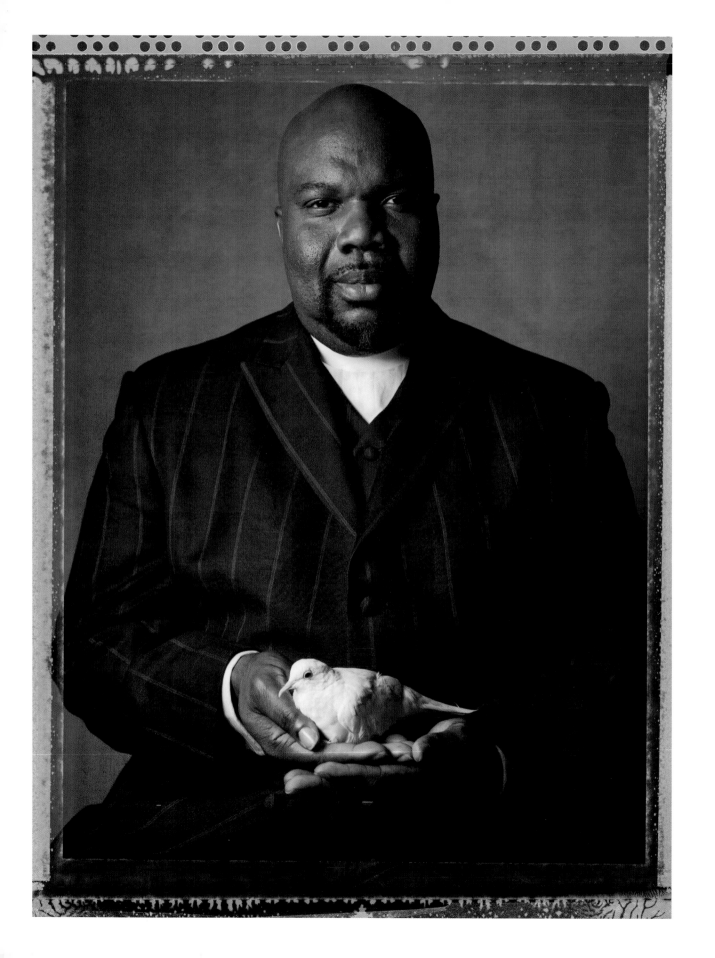

T. D.
Jakes

As a youth, Bishop T. D. Jakes was known as "Bible Boy." He earned the nickname from his habit of toting his Bible to school every day and preaching to an imaginary congregation. Jakes, senior pastor of The Potter's House, a multiracial, nondenominational church in Dallas with thirty thousand members and more than fifty outreach ministries, has now become "Bible Boy" for a real audience that numbers in the millions. His T. D. Jakes Ministries, founded in 1994, produces his inspirational conferences—some fifty-two thousand went to hear him at his Woman, Thou Art Loosed conference in August 1998—as well as a dynamic television ministry. His riveting show, *The Potter's House*, which airs on television and the Internet, reaches as far as Zimbabwe, Uganda, South Africa, and England.

Jakes was born and raised in South Charleston, West Virginia. His solid, loving parents taught him his work ethic. His mother, Odith, a home economics teacher, taught all three of her children how to cook, sew, and clean; and his father, Ernest, started his own janitorial company with a mop and a bucket, growing it to forty-two employees. Young Thomas Jakes worked hard as a boy, selling vegetables from the family garden, throwing newspapers, and selling Avon products door-to-door. When his father lay dying of kidney disease, Jakes helped his mother tend to him, mopping blood from the floor around the dialysis machine.

At seventeen, Jakes was called to the ministry. After preaching part-time while he attended college, he eventually founded his own church in Montgomery, West Virginia, with just ten members, and began preaching full-time. He became so popular, with his charismatic message of restoration, reconciliation, and healing, that he relocated to a refurbished bank building in Charleston, where the congregation was 40 percent Caucasian—a testament to his powerful, universal appeal. The congregation grew to one thousand before Jakes moved to Dallas. Since 1996 he has held forth from The Potter's House to an increasingly international crowd, some of whom haven't previously attended church.

Although he's compared with the Reverend Billy Graham—*Time* magazine dubbed him "Oprah-in-a-pulpit"—many consider Jakes to be the most gifted preacher on the globe. *Charisma* magazine's Ken Walker wrote that Jakes's message "is about God's supernatural ability, bestowed by a Lord who is color-blind and cares about each person. . . . [Bishop Jakes] delivers the Word in such a lightning-rod fashion that he makes you believe that all things are really possible with God." ★

Earl
Campbell

BLANCO

1993

Earl Campbell, one of the most powerful running backs in the history of college football, grew up among roses in Tyler, Texas. After his father died, Campbell's mother raised Earl and his six brothers and four sisters on her own by growing and selling the flowers—initially, for a mere seventy-five cents a dozen. Campbell worked in the family business until he was eighteen, and then set out to play football for the University of Texas in Austin.

"I always wanted to be an athlete," said Campbell, winner of the Heisman Trophy in 1977. "I never wanted to see another rose again."

After playing with the Longhorns, Campbell moved on to the NFL to play for seven years with the Houston Oilers—for whom he was the number one draft pick—then for another year and a half with the New Orleans Saints. His reputation as being virtually unstoppable on the field—for his speed as well as his strength—was unsurpassed; his powerful thighs were legendary. By the end of his professional football career, he had amassed a total of 9,407 yards rushing, 806 yards receiving, 74 touchdowns, and 10,213 total yards. Campbell, who appeared on the cover of *Sports Illustrated* six times, was inducted into the Pro Football Hall of Fame in '91.

But the "Tyler Rose," whose two sons also played football, says his most significant accomplishment is not as an athlete.

"I wanted to be the first one in my family to get a college education," said Campbell, who returned to UT to get his degree, a BA in speech communication, after his rookie year with the Oilers. "I'd vote that bigger than the Heisman and the Hall of Fame." Since then, several of his siblings have followed suit.

Campbell, a successful businessman in Austin, has run Earl Campbell Meat Products, which sells Earl Campbell's smoked sausage, barbecue sauce, and other food products, since 1988. He also briefly owned a restaurant, Earl Campbell's on Sixth.

"Everything Texans do is *big*," said Campbell, who tipped the scales at 230 pounds in his football prime, and who still actively supports University of Texas athletics. ★

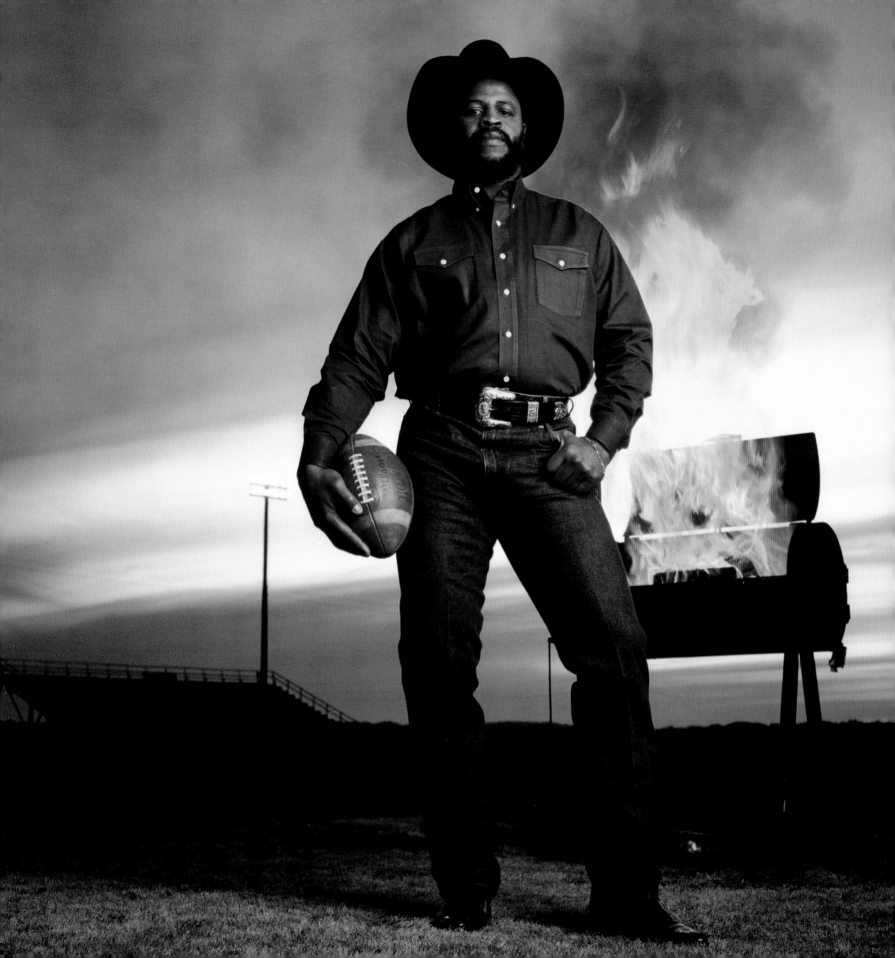

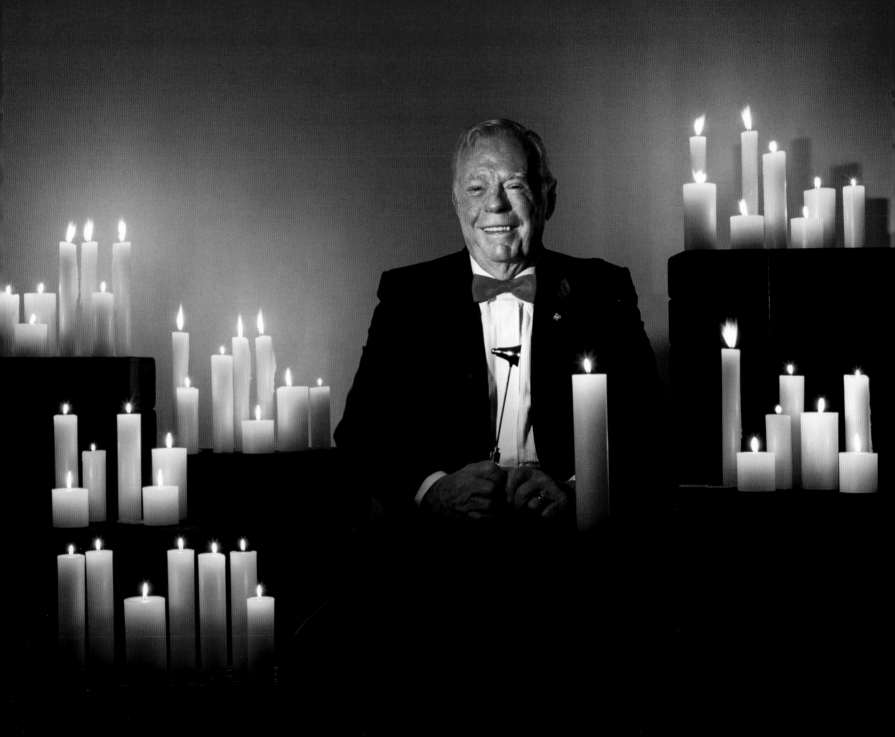

Red
Adair

BELLEVILLE
1993

Paul Neal "Red" Adair (1915–2004) was an old-fashioned American hero. Adair—who grew up in Houston, the son of an immigrant Irish blacksmith—was considered the king of the oil-well firefighting industry. Beginning in 1939 when he signed on with Myron Kinley, the original pioneer of oil-well fire and blowout control, Adair took on the fires of hell. His only training: the bomb disposal unit in World War II.

In 1959 he formed the Red Adair Company, and the rest is firefighting history. Over some three decades, he and his men—at great personal risk—extinguished some of the most notorious oil fires around the globe: the "Devil's Cigarette Lighter" blaze in the Sahara in 1962; the offshore fire at Bay Morehand, Louisiana, in 1970; the Ixtoc 1 blowout in the Gulf of Mexico in 1979; the fire on the Piper Alpha oil platform in 1988; and most famously, 117 flaming oil wells in Kuwait, set ablaze by Saddam Hussein's forces near the end of the Gulf War. Experts predicted the Kuwait firestorm would take three to five years to defeat; Adair and his men killed the fires in just nine months.

For his heroism, Adair—who dropped out of high school to help support his four brothers and three sisters—was honored by Presidents Carter, Johnson, and Bush; and he received numerous awards, including the Outstanding Houstonian Award, the American Academy of Achievement's Golden Plate Award, and the Franklin Institute's Walton Clark Medal.

But Adair's contributions extended beyond firefighting. He developed the most reliable firefighting equipment in the industry and is recognized as the pioneer of the semisubmersible firefighting vessels used by large oil companies to extinguish oil platform fires. In 1972 Adair founded the Red Adair Service and Marine Company to design, sell, and lease his equipment, dubbed the "Rolls-Royce of firefighting equipment."

Adair also served as an expert advisor for the John Wayne film *Hellfighters*, for which he and his men were the inspiration. After his firefighting days, he continued to work largely as a consultant.
★

Requests for permission to reproduce material
from this work should be sent to:
 Permissions
 University of Texas Press
 P.O. Box 7819
 Austin, TX 78713-7819
 http://utpress.utexas.edu/index.php/rp-form

The paper used in this book meets the minimum
requirements of ANSI/NISO Z39.48-1992 (R1997)
(Permanence of Paper). ∞

Design by Lindsay Starr

Cataloging data is available on request
from the Library of Congress.

ISBN 978-0-292-76109-4 (cl. : alk. paper)
ISBN 978-0-292-76313-5 (pbk. : alk. paper)

The publication of this book was supported in
part by The Eugene McDermott Foundation.

doi: 10.7560/761094